D0935990

THE METROPOLITAN MUSEUM OF ART

Asia

THE METROPOLITAN

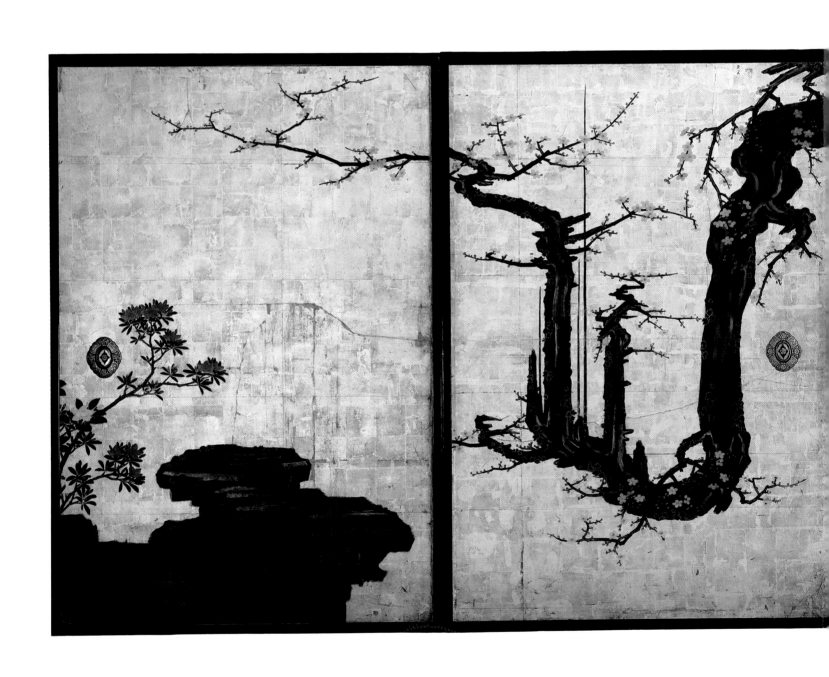

MUSEUM OF ART
Asia

INTRODUCTION

BY

Richard M. Barnhart
PROFESSOR OF ART HISTORY
YALE UNIVERSITY

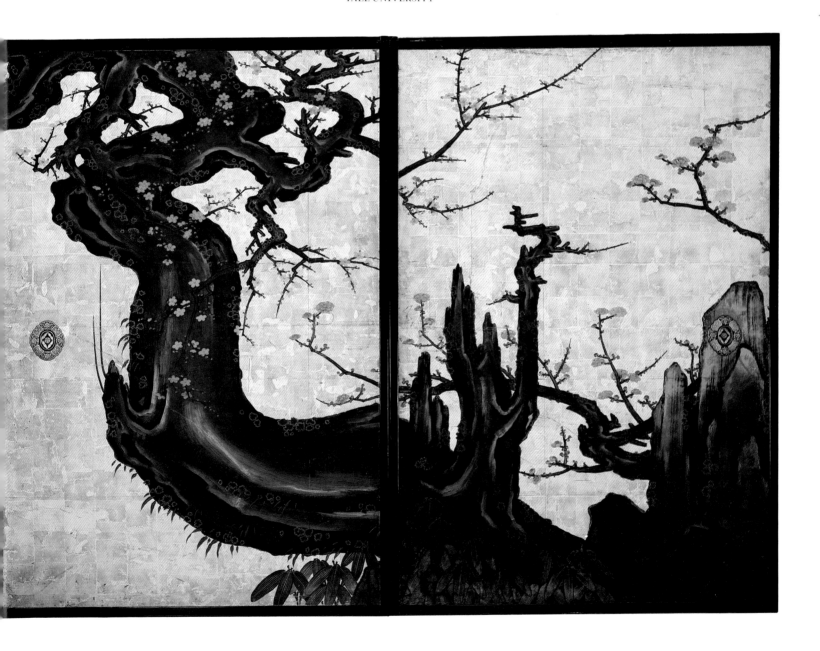

THE METROPOLITAN MUSEUM OF ART, NEW YORK

PUBLISHED BY

THE METROPOLITAN MUSEUM OF ART
New York

PUBLISHER
Bradford D. Kelleher

EDITOR IN CHIEF
John P. O'Neill

EXECUTIVE EDITOR
Mark D. Greenberg

EDITORIAL STAFF
Sarah C. McPhee

Josephine Novak

Lucy A. O'Brien

Robert McD. Parker

Michael A. Wolohojian

DESIGNER
Mary Ann Joulwan

———

Commentaries on objects from India and Southeast Asia written by Martin Lerner, curator, Department of Asian Art, The Metropolitan Museum of Art; all other commentaries written by the editorial staff.

Photography commissioned from Schecter Lee, assisted by Lesley Heathcote: Plates 9, 11, 23, 25a-d, 26–28, 30, 31, 33, 35, 37, 39–42, 48, 49, 51, 53, 54, 58, 60, 61, 64–67, 69, 73, 77, 80, 82, 86, 88, 89, 93, 94, 96, 97, 100, 101, 103, 104, 106, 107, 110. Photographs for Plates 75, 84, 95 by Peter Johnson, and for Plate 16 by Otto E. Nelson. All other photographs by The Photograph Studio, The Metropolitan Museum of Art.

Maps and time chart designed by Wilhelmina Reyinga-Amrhein.

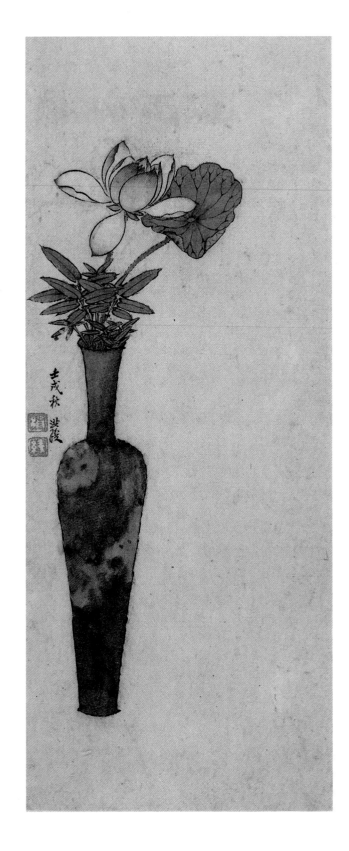

TITLE PAGE

Aged Plum, ca. 1650
Kano Sansetsu; Japanese; early Edo period
Ink, color, and gold leaf on paper;
68¾ x 9⅛ in. (174.6 x 485.5 cm.)
The Harry G.C. Packard Collection of Asian Art, Gift of Harry G.C. Packard and Purchase, Fletcher, Rogers, Harris Brisbane Dick and Louis V. Bell Funds, Jospeh Pulitzer Bequest and The Annenberg Fund, Inc. Gift, 1975 (1975.268.48)

THIS PAGE

Lotus and Bamboo in a Bronze Vase, 1622
Ch'en Hung-shou, 1598–1652; Chinese; late Ming dynasty
Album of 12 paintings; this leaf, ink and color on paper;
8¾ x 3⁹⁄₁₆ in. (22.2 x 9.1 cm.)
Purchase, Friends of Far Eastern Art Gifts, 1985 (1985.1211)

Library of Congress Cataloging-in-Publication Data

The Metropolitan Museum of Art (New York, N.Y.)
 Asia.

 1. Art, Asian—Catalogs. 2. Art—New York (N.Y.)—Catalogs. 3. Metropolitan Museum of Art (New York, N.Y.) —Catalogs. I. Title.
N7262.M47 1987 709'.5'07401471 86-12416
ISBN 0-87099-453-0 ISBN 0-87099-454-9 (pbk.)

Printed and bound by Dai Nippon Printing Co., Ltd., Tokyo. Composition by U.S. Lithograph, typographers, New York.

This series was conceived and originated jointly by The Metropolitan Museum of Art and Fukutake Publishing Co., Ltd. DNP (America) assisted in coordinating this project.

Copyright © 1987 by The Metropolitan Museum of Art

This publication, devoted to the arts of Asia, is the tenth volume in a series of twelve that, collectively, represent the scope of the Metropolitan Museum's holdings while selectively presenting the very finest objects from each of its curatorial departments.

This ambitious publication program was conceived as a way of presenting the collections of The Metropolitan Museum of Art to the widest possible audience. More detailed than a museum guide and broader in scope than the Museum's scholarly publications, this series presents paintings, drawings, prints, and photographs; sculpture, furniture, and the decorative arts; costumes, arms, and armor—all integrated in such a way as to offer a unified and coherent view of the periods and cultures represented by the Museum's collections. The objects that have been selected for inclusion constitute a small portion of the Metropolitan's holdings, but they admirably represent the range and excellence of the various curatorial departments. The texts relate each of the objects to the cultural milieu and period from which it derives, and incorporate the fruits of recent scholarship. The accompanying photographs, in many instances specially commissioned for this series, offer a splendid and detailed tour of the Museum.

We are particularly grateful to the late Mr. Tetsuhiko Fukutake, who, while president of Fukutake Publishing Company, Ltd., Japan, encouraged and supported this project. His dedication to the publication of this series contributed immeasurably to its success.

The Metropolitan Museum has been collecting Asian art since the late nineteenth century, when many of its early benefactors—the Havemeyers, the Altmans, John D. Rockefeller, Jr., and others —included Asian objects in their bequests to the Museum. In 1915 the Department of Far Eastern Art was established; in 1986 the name was changed to the Department of Asian Art. But the real impetus for creating a comprehensive collection of Asian art came from Douglas Dillon, who was named president of the Museum's Board of Trustees in 1970. In that year, Mr. Dillon invited Mrs. Vincent Astor to become chairman of the Visiting Committee to the Department of Far Eastern Art. In 1971, Professor Wen Fong of Princeton University, an authority on Chinese art, was invited to become special consultant for Far Eastern affairs and to plan and lead the expansion programs.

The collections of the Department of Asian Art range from the second millennium B.C. into the present century and include paintings, sculpture, ceramics, bronzes, jades, decorative arts, and textiles. The collection of monumental Chinese Buddhist sculpture ranks among the finest outside China, and a major Chinese painting collection is currently being assembled through the generous support of Douglas Dillon and The Dillon Fund. Recently, the gifts and promised gifts of John M. Crawford, Jr., from his collection of Chinese paintings and calligraphy—widely recognized as the finest of its kind— were added to the collections. The department also has notable holdings of Ming dynasty furniture, Japanese screens, lacquer ware, and prints, as well as Indian and Southeast Asian bronze sculpture.

In 1981 The Astor Chinese Garden Court and The Douglas Dillon Galleries for Chinese paintings were opened. Thanks to the help of the Japanese government and industry, as well as a committee of Japanese patrons in New York and generous American friends, galleries for a comprehensive survey of Japanese art are now under construction. Permanent installations of the arts of ancient China, Korea, India, and Southeast Asia are planned.

We are grateful to the curatorial staff of the Department of Asian Art for their help in preparing this volume, and especially to Alfreda Murck, Barbara Ford, Suzanna Valenstein, Martin Lerner, and Steven M. Kossak, and to Jean Mailey, curator of the Textile Study Room, for their invaluable assistance in making selections and reviewing the text and photographs.

Philippe de Montebello
Director

ASIA

Asia is a complex of distinct cultures and nations that share a common heritage. Two major religions, Buddhism and Islam, have provided a theme and purpose for much of the art of this area of the world. But the relationships among the various Asian artistic traditions are comparable to those of Europe both in their similarities and in their diversity: The differences, for example, between the artistic culture of India and that of Japan are as great as the differences between the art of Greece and of England. Throughout the centuries, the three great civilizations of Asia—India, China, and Japan—have each nurtured a distinctive artistic tradition that has maintained its coherence and integrity. Each has been influenced by foreign invasions, cultural or military, and each has been changed by these experiences while continuing to evolve in ways unique to itself. But throughout the changes in social and political domination, a tradition of esteem for art and artists has been maintained in Asia and has resulted in the careful preservation and study of ancient art and the production of a vast library of scholarship that records the lives of artists, theories of art, and the exchanges that typify the relationships between artists and patrons.

Within the large area of Asia, cultural associations and influences have passed back and forth. From the fourth century A.D. until the tenth, Buddhism united the area in a manner never repeated thereafter. Indeed, long after Buddhism became a dead religion in India, its birthplace, it remained a vital power in the rest of Asia. From the fourteenth century on, Islam remade the arts of India in fundamental ways, just as it had already changed Indian society. Confucianism spread from China to Japan, while Shinto remained alive only in its native Japan. With all their disparities, however, the civilizations of Asia have consistently been more closely related to each other than to cultures of other regions. The common attraction of each Asian religion toward mysticism and meditative philosophy is based on a veneration for the natural world, and distinguishes Asia from any other large region of the world.

This introductory essay is concerned primarily with works of art selected to illustrate the extraordinary collections of The Metropolitan Museum of Art. Given the limitations of any selection from so vast an area and span of time, intricate cultural contexts cannot be introduced, and historical continuity cannot be closely maintained. It is my hope, however, that a sense of the underlying principles and intentions of Asian art will be suggested and that those principles can be extended easily toward an understanding of other works of the area.

Historical and artistic formulations that typify the history of Western art are of little use in approaching the art of Asia. In the context of Asian art the use of the word "classical" is a time reference that carries no connection with ancient Greece and Rome. "Medieval" can be taken only to mean approximately the middle range of historical time, and it differs both chronologically and in content from country to country. There is no baroque period of art in Asia (though there is much art that can usefully be described as baroque in relationship to its antecedents), and no Renaissance (though there were many renaissances of ancient ideals). Therefore, except for an occasional descriptive metaphor, it is less misleading to suggest qualities by reference to the art form and its religious, philosophical, or national basis. Indian Buddhist sculpture, for example, or Chinese landscape painting, are descriptive categories that call to mind intrinsic features and stylistic characteristics common only to that category. The same applies to Japanese narrative painting—a world that has its own unique definition.

Continuous pictorial narrative is one of the distinguishing contributions of Asian art. With its roots in Indian narratives of the life of the Buddha, and in Chinese pictorial narratives of historical and moralistic subject matter of the Han dynasty, this format evolved in China and Japan into an eloquent, vivid, and colorful narrative mode that allows us to walk into Hell or glimpse a glowing Buddha rising from the earth. In Japan, dramatic narratives of these kinds were the highest achievement, while in China, landscape was the subject that lent itself most brilliantly to the handscroll and to continuous compositional development.

China and Japan were in constant communion throughout history, and an examination of early Japanese painting reveals the extent to which formative elements were imported from China. The strength of this influence, however, was tempered by the fact that Japanese artists never abandoned their own roots, but absorbed influences into the structure of their own deep-seated instincts. The highest achievements of Japanese painters can be measured in the contrasting genres of miniature narrative painting, on the one hand, and large-scale decorative painting on the other. Narrative painting in the Far East is defined by illustrated handscrolls (*emaki*), such as *The Miracles of Kannon* (Plate 6) and *Tenjin Engi* (Plate 7), both products of late thirteenth-century Japan. Unrolled from right to left, these handscrolls tell stories of the establishment and development of religious traditions and institutions by means of colorful pictures that are held in the hand and read like a

book. As the eye moves slowly from right to left, the viewer is drawn into a world with its own time and space, which changes as the scroll is unrolled and advanced. We are drawn through vast landscapes and across centuries, witnessing the lives of cultural avatars and of ordinary people caught up in the events of history, legend, and myth. *Tenjin Engi* reveals the experience of the wandering priest Nichizo as he approaches the gate of Hell, from beyond which flames belch forth, and which is guarded by a many-headed beast. *The Miracles of Kannon* unites the viewer with the Bodhisattva of Compassion, as he kneels before the golden figure of the Buddha, Shaka, set on a hillside by a river. The scrolls take us through adventure after adventure, in a form of space-time continuum that anticipates the modern cinema.

The artists who painted such works are rarely known by name. They were professional masters associated with temples, monasteries, and religious institutions—men who were trained and employed to carry out the various painting programs required for religious rituals, teaching, and historical records. They were skilled draftsmen, representing a Japanese tradition of fluid, lively brush drawing that remained constantly fine throughout the centuries. The flexible hair brush of the *emaki* artist was the common tool for the Asian painter, although rarely, in either India or China, was it used so fluently or so effectively to convey a lively movement, a gesture, or a character.

The same master artists who produced the *emaki* painted such images of the serene Buddhist spirit as the Metropolitan's *Eleven-Headed Kannon on Mount Potalaka* (Plate 8). Painting in gold, with gold leaf and additional colors on dark silk, the artist presented an image of the mystical Kannon who manifests eleven heads as a sign of spiritual power. The bodhisattva sits serenely atop his mythical home at the peak of Mount Potalaka, an island mountain in the sea, off the coast of India. Lotus blossoms, symbol of the Buddha, emerge from the vase he holds in his left hand, and he sits on a golden lotus throne. Limpid waterfalls cascade from the shadowed cliffs below, and there are brilliant flowers on the trees. Kannon sits serenely within the shadowed splendor, the perfect circle of a halo behind his head, far above the raging sea. Images such as this, of mystical balance and perfect form, are the expressions of Buddhist purity and faith throughout Asia. The serene Buddha, or the bodhisattva—images of circles and of stillness within movement—are as prevalent in the religious art of Asia as is the Crucifixion in Christian Europe, and the different emphases they so dramatically illustrate are worthy of examination. On the one hand is pain, struggle, anguish, blood, and suffering; on the other, is serenity, inward peace, repose, radiance, and grace. And whereas the Crucifixion seems to suggest that pain and suffering may bring release through faith, works such as the *Eleven-Headed Kannon on Mount Potalaka* suggest that faith can be attained through serenity and meditation. The circle and the lotus embody spiritual perfection; gold is the color of radiance; mountains and seas embody the cosmic universe. "Art is that which reveals to us the state of perfection," wrote a Japanese priest. It does not focus on the anguish, pain, and suffering that are the lot of all men, but on spiritual perfection, which is realized by only a few. This concept is common to Buddhist art throughout Asia, and it reveals to us a state of grace that would otherwise be concealed in the impenetrability of inner vision.

These differing strands evolve hand-in-hand through the history of the arts of Japan: the one of realism, narrative flow, brilliant draftsmanship; the other of pattern, decoration, bold color, and direct psychological impact. Japanese decoration is perhaps the most admired in the world, combined as it is with exquisite craftsmanship. This volume includes examples of this tradition: a mystical fourth-century stone talisman (Plate 2); a lacquer wine container of around 1600 (Plate 14), on which floral motifs have been elevated to the level of dazzling decorative emblems; a lacquer writing box (Plate 23); a Nō costume (Plate 20) and other textile creations (see Plates 19, 24); and a selection of ceramic ware (see Plates 15, 16) that confirms Japan's place among the most inventive of all pottery-producing nations. Through these objects we are given a unity of aesthetic elements that functions to enhance appreciation, enjoyment, and utility. Textures play an important role in this mixture, from the rough clay and cord markings of a Jōmon jar (Plate 1) to the rich, deep, glutinous surface of the lacquer box. Patterns are introduced in the form of floral motifs, leaves, or abstract design, as is color, ranging from gold and brilliant red, to pale umber or even plain clay. Shape may be functional, or it may be abstract (having, that is, no meaning that can now be identified), but in either case, it is aesthetically informed by nuance and subtlety, molded by the hands of an artist. "Is decorative art art?" is a question sometimes asked in the West. In Japan, decorative craftsmen are undoubtedly artists, and are acknowledged as such, some even known today as "Living Treasures."

Japanese painting clearly embodies this phenomenon: The most attractive achievement of post-thirteenth-century painters has been in the realm of what would, in the West, be called decorative painting. In these Japanese works the decorative qualities function not as design, but as expression. Color, design, form, and relationships act directly upon the viewer to arouse emotional responses, and these responses are directly tied to a literary and human association that is conveyed through them.

Consider Ogata Kōrin's six-fold screens, *Yatsuhashi* (Plate 18). Purple irises, green leaves, and a black plank bridge are arrayed against a field of gold, creating an affecting, striking, and moving composition, without even considering its artistic or metaphorical significance. The angle of the wooden bridge plays against the drifting bank of flowers, setting up an encounter of contrasts between the different elements. The gold surface allows no real illusion of interior space, nor is there any perspective, either atmospheric, as was common in China and Japan, or geometric, as in Western art. But the juxtaposition of the plants and the bridge succeeds in creating a sense of receding space, even though the bridge is uncompromisingly flat against the gold surface. As important as the pictorial element is the creation of patterns: the ribbonlike distribution of flower clusters, the green leaves that flare out from the gold background, crisscrossing the screens, and the gridlike black lines of the bridge supports below the stiff black lines of the planks. This art is aimed at the senses and can only be un-

derstood as a message couched in design that is nearly abstract, or, at least, so minimal in terms of concrete representation that its intention is mysterious. The whole subject matter is encompassed by the irises and the bridge, spread across twelve gold panels that cumulatively measure nearly twenty-five feet across, but the viewer responds to an aura of meaning that goes beyond this simple arrangement, and to the power of color, design, and spatial relationship.

There are, in fact, specific associations in the subject matter of *Yatsuhashi*. The irises and the bridge are references to a poem in the tenth-century *Tales of Ise*, telling of the courtier Narihira, who was banished for indiscretions. While crossing a bridge on his way to exile, he observed irises growing in the pond below, and they reminded him of lost friends whom he might not see again. The Eight-Plank Bridge immortalized by this work represents exile; the flowers, friendship and love; and the gold ground is the field on which time and memory act. The painter of these screens was himself in exile when he painted them.

Kōrin's large double screen *Rough Waves* (Plate 17) makes the crashing waves of the sea into a statement of cosmic force, of action and reaction, of becoming, being, and continuing. Again, he utilizes the inherent qualities of design; gold leaf forms the field upon which this earth-shaping power is displayed; ink wash is used to create a sculptural interior space so that the viewer can read density into the image. One wave has already crashed onto the shore, and the force of the encounter has propelled it into the air, ready to crash again; another gathers force as it approaches the shore, while by implication, others loom in the shadowed gold of the distance. Their motion is ceaseless, but they have been momentarily frozen by the artist in an instant of time that is meant to symbolize the eternal cosmic process. Painted for use inside palatial dwellings, these screens serve to bring indoors a reminder of the eternal process of nature.

In the same way, the superb *Aged Plum* (Plate 13), attributed to the early Edo master Kano Sansetsu, focuses on the visual expression of strength, endurance, and beauty. The four panels in the Metropolitan Museum are probably part of a set intended originally to cover the walls of a room with flowering plum trees in their four seasonal aspects. The Museum's tree, bent and broken by time and the elements, still grows powerfully amid rocks, and is once again producing tiny white blossoms from its gnarled black branches. The tree speaks of survival and rejuvenation: a promise that moral virtue will endure and flourish despite age, setbacks, and the ravages of existence. Again, the gold-leaf surface lends the image a timeless, almost ethereal quality that lifts it beyond reality.

These handsome screens and doors attempt to arouse human emotion and elicit a response by making implicit statements about human life, and its place in time and eternity. Time, in Asia, is not the time of Europe: Its measure may be closer to the aeon-long kalpa than to the year. Human life and actions are seen against a broader span, and there is a sense of events that join an endless stream of light. The pair of gold-leaf screens that illustrate the battles of the Hōgen and Heiji eras (Plate 10), though they deal with the very recent past, present these violent events in the history of Kyoto as if they are remembered across a great distance.

Following artistic convention for such themes, the action is seen from high up, so that the viewer hovers like a bird, peering down through a screen of broken clouds at the human lives passing below. Sometimes roofs and doors are open or removed to afford a glimpse of the individuals whose lives are affected by these events. Warfare, struggle, bloodshed, and heroic actions are portrayed as fleeting ripples in an ocean of time.

Japanese artists did not, however, avoid the actual. They were far more ready than most Chinese artists to show the harsh reality of existence. This realism is present both in Buddhist and Shinto sculpture, as exemplified by the *Fudō Myō-ō* (Plate 5) of the late Heian period, and it is a hallmark of Japanese sculpture throughout the Kamakura era. However, since it is often difficult to separate the realistic from the decorative in Japanese art, it may be inappropriate to use such terms. How, for example, would one categorize characteristics of the ukiyo-e—the color prints that swept Japan, and were especially popular with the developing urban working class in the seventeenth and eighteenth centuries? These prints were highly decorative—it was this element that intrigued nineteenth-century European painters—but they were also vividly expressive. They were melodramatic and exaggerated in gesture and expression, like scenes from a drama in which stylized movements and bold gestures have been choreographed so as to be visible from the back row of the theater. Their style and subject matter are often realistic—indeed ukiyo-e were often selected as the vehicle for topics formerly considered to be too vulgar for art. The ukiyo-e was, in fact, a low-class, vulgar, commercial product aimed at a popular market, but it came to be admired by art lovers throughout the world, largely because of its energy, raucousness, and showy vulgarity. The passionate embrace of Hishikawa Moronobu's lovers (Plate 21), and the slightly deranged expression of Utamaro's courtesan (Plate 22) are examples of the bold gesture and eccentric images that suited the tastes of a bohemian underworld of artists, actors, musicians, and courtiers.

Throughout the centuries, Japan and China drew together and apart, now in war and now in peace, influencing each other's customs and arts. But, despite exchanges of power and influence, China remained at all times distinct —influencing more than it was influenced—a major point of cultural and artistic gravity. It absorbed cultural invasions repeatedly, adapting or rejecting them, and then going its own way. The influence of Indian Buddhist sculpture on the early Buddhist art of China can be clearly detected. The same point could be made about the other arts, such as painting and ceramics, but in all these aspects, the Chinese ideal was ultimately central and unswerving in its evolution. Chinese art is one of a small number of high traditions of art in the world, and it is one that defines itself with primary reference to its own history. We will examine the great tradition of Chinese painting in these pages, but first we will glance at other aspects of Chinese art as seen in the collection of the Metropolitan Museum.

The glowing fifth-century Sakyamuni bronze figure (Plate 29) represents the Archaic style of Chinese Buddhist sculpture—the phase in which China absorbed the first and most

powerful wave of influence from India and Central Asia into its own efforts to convey in visual form the spirit of divinity. Chinese artists had not faced this challenge before, concerned as they had been with a didactic art in the context of Confucian moral teaching, and with the veneration of ancestral paragons. The human embodiment of divinity was a foreign concept that had to be adapted into a framework of Chinese humanism. This process is exemplified by two other examples of Chinese Buddhist sculpture: a bronze altar (Plate 26), dated to A.D. 524, and a dry-lacquer seated Buddha made in the seventh century (Plate 31).

The Indian influences from Mathura and Gandhara are evident in the altar, which, like the Sakyamuni figure, is in the Archaic style of the Six Dynasties era. It presents a fiery image of light in which tendrils of flame seem to emanate from the figure of Buddha in the center, and to flare among his attendants and worshipers. Chinese artists fashioned from these sources a linear geometrical style that here seems to seek to convey through light and fire the sense of a consuming, divine spirit, implied by both the golden bronze and the flamelike treatment of all forms.

The dry-lacquer Buddha is a purely Chinese image. The divinity is presented without radiance or glitter, without suprahuman capacity, as a quiet, meditative man, perhaps a monk. The only clues to his identity are the *usnisa* (cranial protuberance) and the long earlobes. His divinity is internalized, scarcely revealed at all. This is a man, a simple man who has attained understanding and serenity. Stylistically the work is straightforward; the folds of his robe are modeled realistically, and the figure has almost the quality of a portrait.

Later Chinese sculpture moved further in the direction of portraiture, reaching its most compelling stage in the Sung dynasty, during the Liao and Chin periods. Perhaps the greatest surviving masterworks of that era are the ceramic lohans from I-chou, of which two are in the Metropolitan's collection. Only a few of the original sixteen or eighteen figures are still intact, each a masterpiece of Buddhist portraiture. It is clear that each was modeled after an actual priest, probably from the I-chou temple. In the statue illustrated here (Plate 48), the lined face of the old master reveals wisdom, experience, gentleness, and strength. The wisdom seems to come from within, but it is etched in the lines of the priest's face and a keen spirit emerges from his eyes. We sense that his gestures were quiet and that he spoke softly. Nothing is known about him, but he comes alive, a wise teacher of the Sung dynasty who sits among us today and speaks silently of the sacred Buddhist teachings of the Dharma Law.

This same cerebral quality is found in the painting of China. A Chinese art historian called paintings "images of the mind." Painting, with calligraphy, was the highest art of China, and it is in the history of that art that we find the most eloquent traces of human thought, life, and emotion. Chinese painters ranged widely in subject matter, painting pictures of history, myth, legend, and daily life. They painted the colorful forms of birds and flowers, of the gods of Buddhism and Taoism. They painted portraits and historical narratives, too, but it was landscape that attracted the greatest artists through the centuries, and it is landscape that will

provide the focus of this introduction. If sculpture speaks most eloquently for the genius of Indian art, and narrative and decorative painting for the art of Japan, undoubtedly landscape is the comparable focus of China. This survey begins in the eleventh century and ends in the seventeenth.

Ch'ü Ting's *Summer Mountains* (Plate 34) and Kuo Hsi's *Trees Against a Flat Vista* (Plate 36) were painted in the eleventh century, during the Northern Sung dynasty, when the art of landscape painting reached its first great peak. Ch'ü was a member of the Imperial Academy of Painting, and, a generation later, Kuo was a painter to the emperor Shentsung. Other landscape masters of the time were Taoist eccentrics, Buddhist priests, and government officials. They cut across the fabric of society, drawn to the inexhaustible beauty and meaning of the natural world. "Mountains and rivers" is the Chinese term for landscape, and the images of landscape left to us by the great Northern Sung masters are monuments of individual response to the beauty of these natural features. We note the specificity of the titles of both pictures discussed here. *P'ing yuan*, or level distance (flat vista), is a natural reality of northern China; it is also a philosophical state, and a quality of the human mind, described as such a thousand years earlier during the Han dynasty. The mind of level distance is one of serenity, calmness, and tranquillity, a mind that sees far. Visual reality and mental state are thus interwoven from the outset, and we cannot merely see these images either as simple natural forms or as fanciful inventions. They cast the individual mind back across the earth and form it into images of the natural world that embody the mind of their maker. To paint, in China, was to partake of the same creative power that the Great Maker possessed—to paint a landscape was to make a world, and every world thus made was unique.

Kuo Hsi's landscape is a calm, mist-filled level plain from which gnarled trees grow, and across which men travel. The time is evening; the season, autumn. It is an autumn evening as I write, and out of my window in New Haven, looking toward the low hills, I see the same leafless trees, the same black branches etched against a darkening sky, the same pale gray colors of earth and hills, and sense the same mood of silvery mists and impending winter. Kuo Hsi has given us a reflection on his world that we can easily relate to our own.

Summer Mountains similarly preserves more than an image of forested hills as Ch'ü Ting saw them, around 1050. Summer is the season of flourishing greenery, of hot sun and cool shadow, when one seeks mountains and water, here presented as a paradigm of symbiotic interrelationship. In Ch'ü's painting, waterfalls cascade from the hills, streams wash the valleys, a river laps at the foothills and shoreline. From this interaction of earth and water springs life and growth. We can share their experience simply by joining them, reducing ourselves to their scale by a simple act of mind. All scale relationship is determined by this action, and it becomes possible, as Chinese painters wrote, "to convey a thousand miles in a single foot." It is also possible to suggest shadowed and mysterious depths of human history in the haunting image of a white horse being led through a deep mountain pass, as in *Emperor Ming-huang's Flight to Shu* (Plate 43), by an unknown Southern Sung painter, or to use

a single flower to represent all beauty and transience, as Ma Lin has done with *Orchids* (Plate 44).

These monuments of Sung painting form one of the most profound accomplishments, and also provide unique visions of Chinese history. The Sung dynasty was a moment of time in which artists achieved a vision that, while recognizably rooted in time and place, nonetheless transcended both limitations. Sung philosophy is a balance of metaphysical structure and microcosmic observation of phenomena. Cosmic existence is imagined from the structure of the physical universe. Each Sung painting seems to represent a discovery growing out of "the investigation of things," as the philosopher Chu Hsi described philosophical speculation.

In later times, as if satisfied that all things had been revealed as what they were, philosophy and art went on to codify and classify, to catalogue and order. There were no more discoveries about the natural order of the universe to be made, but what lay beyond was the uncharted territory of the individual mind. Psychology did not evolve in China as it did later in the West, but the history of later Chinese painting forms the structure of a psychology of art. Each painting is the product of an individual mind and sensibility; each major style is the style of a total personality; each is a glimpse of a man and a moment.

This system of indirect reference makes it less easy to respond with the same directness to an image. It may be necessary to have help in understanding the language of art, or the context of a time. A painting like Chao Meng-fu's *Twin Pines Against a Flat Vista* (Plate 47) may seem to be little more than a sketch of a model like Kuo Hsi's *Trees Against a Flat Vista*—to which, in fact, it is closely related by intention and design (Chao owned the Kuo Hsi painting). But Chao reduced the evocative atmosphere and design to a skeletal outline of rapid, sketchy strokes of ink, not actually imitating the picture, but suggesting its nature with simplified, calligraphic formulas. A viewer who knew nothing of Chao would respond only to the painting as art, having no way of realizing the additional references contained in the work. In this context, Chao's painting might appear to be a pale, inadequate reflection of a once-grand vision. But Chao did not want simply to paint a vision—he wanted to send a message, and his painting is more like brush writing than like painting as Kuo Hsi conceived the art. His message lies in archetypal forms: pine trees, rocks, water, distant mountains. But the subject of this picture is Chao Meng-fu, whose spirit is present in various ways: in the idiosyncratic strokes of his brush—no one else painted in quite this way—and in the sole human occupant of his picture, the lone fisherman far out on the river, dangling a line into the water. Friends and admirers of the painter, who added their comments in the form of poetry attached to the scroll, explain the meaning of this allusion. It is a reflection of Chao's life and mind in the troubled time in which he lived. The Mongols had just conquered and occupied China and were ruling the nation from Peking. The issue was loyalty: to serve the Mongols, to resist them, or to withdraw. Chao chose to serve, and his fisherman is the symbol of this lonely choice: one man going his own way, seeking to maintain integrity as the world changes around him.

Chao's friend and mentor, Ch'ien Hsüan, chose a very different language in his *Wang Hsi-chih Watching Geese* (Plate 45). Ch'ien employed a language of dreamlike color and distant, artificial forms, filtered out of time and reality until they were images of light shining across the centuries from the cultural avatars of China's past. Here the light gleams from Wang Hsi-chih, who invented the art of calligraphy in the fourth century A.D. He devised the natural, flowing movement by watching geese moving in the water, translating his discovery into movements of the brush. Ch'ien pictured him standing in a glittering pavilion beside a golden pond, surrounded by mountains that represent paradise and eternity. Ch'ien Hsüan chose to encapsulate the past, unchanged, whereas Chao Meng-fu struggled to reconcile it with his troubled present. Each man translated the contents of his mind into his art.

Most of the leading painters of the Yüan dynasty were followers of Chao, but only in the sense that the struggling individuality of his language drew generations of admirers. To emulate his style would be to deny individuality, so only his ideals could be emulated, and a succession of masters, though influenced by Chao, pursued individual expressions of mind in their art.

This relationship is suggested by Wu Chen's *Old Pine* (Plate 51). Wu was a Taoist hermit who chose to withdraw from society under the Mongols: Little is known of his life. His old tree, however, is presented in the same frank way as Chao's fisherman: a simple, graphic image quickly painted, almost stark in its simplicity, and eloquent in its message of life, struggle, survival, integrity. These old trees are nature's nearest parallel to human life. We read them almost as if they were images of Wu Chen himself, as he intended.

In *Woods and Valleys of Mount Yü* (Plate 52), Ni Tsan, a younger contemporary of Wu Chen, went still further in the utilization of landscape as an expression of the human mind. Landscape had hitherto nearly always required human presence, because the natural world is the environment of man. But Ni Tsan's world is empty, and the absence of human figures makes a statement that extends to the style and form of the landscape itself, a bleak, rubbed, worn, stripped-down skeleton of the world. This is a landscape of symbolic meanings, and, conditioned by the works of Chao Meng-fu and Wu Chen, we see Ni Tsan's world as an image of the artist's mind translated into brush and ink.

In these ways, each painter chose his image and his style, using such variety of techniques of brushstrokes and ink tonality as met his needs, as well as a number of appropriate compositional formulas, to create again and again landscape paintings that expressed or mirrored his personal concerns, his emotions, his state of mind, and the conditions of his time. If there is a gray and melancholy character to many of the pictures of the Yüan dynasty, it is because the times were bleak and troubled, and the artists who lived through them had little reason for optimism.

Figure painting long preceded landscape as a popular range of subject matter in Chinese painting, and never lost its attraction. The Metropolitan Museum owns a number of important works that illustrate a variety of subjects and techniques typical of the tradition of figure painting.

Li T'ang's *Duke Wen of Chin Recovering His State* (Plate 42) was painted in the twelfth century in a campaign of court-

sponsored projects that were aimed at creating a suitable historical and moral image for the emperor of a dynasty that had been shattere by Tartar invasion, seen its capital destroyed and its emperor and heir-apparent taken ignominiously as prisoners to the steppes, where they died. The state was precariously held by the Emperor Kao-tsung, who commissioned this painting. It tells of a statesman of fifteen hundred years earlier, the duke of Chin, who faced similar hardships. He, too, was exiled, but he, by force of will, strength, and careful strategy, finally succeeded in winning back his rule and becoming one of the most powerful figures in the ruling alliance of states. This, then, was what the Sung Emperor Kao-tsung wished to appropriate to himself —this image of a triumphant statesman uniting his country. It is a colorful and dramatic story, illustrated by the leading court painter as an adventure rich in emotional encounters, triumphs, and disappointments. The style is one of thin, strong, iron-wire outlines, and pale, transparent colors, lending an air of courtly restraint to the narrative and enhancing its dual reference to an ancient and hallowed historical period. It is also a good example of how the Chinese have traditionally used events and personages of the past to refer to the circumstances and issues of their own day.

The most boldly colorful and dramatic of figure paintings were undoubtedly those painted on the walls of palaces, temples, and monasteries throughout China, from the Han dynasty into the Ming. Many of these still exist in China today, most richly at the cave-temple complex at Tunhuang, in Kansu province. Among the small number of such paintings that have left China is the splendid *Assembly of the Buddha Sakyamuni* (Plate 50), painted in north-central China early in the fourteenth century, for a Buddhist temple in the Fen River valley of Shansi province, one of the major centers of wall painting in the Sung and Yüan dynasties.

This huge wall represents a Buddhist paradise, as it might have been imagined by the faithful: We are welcomed into the presence of the gods and goddesses of the Buddhist pantheon, a sight that is dazzling in its monumentality and its colorful splendor. They are gathered to await us; the Buddha Sakyamuni looms larger than the others, who range downward in scale. A strong, flowing line has been used to draw the figures—a line that goes back hundreds of years to the T'ang dynasty, and is related to the iron-wire line of Li T'ang. Bold colors have been applied over the black outlines, and in many wall paintings gold leaf was used. This regional tradition was maintained in Shansi province continuously from around the eighth century until the fifteenth, evolving very slowly, if at all, but maintaining a remarkably high level of achievement throughout that long period, even though, during and after the Sung dynasty, the status of such works declined rapidly, so that, as in this case, the name of the painter is not even known.

The influence of wall paintings can be found in works of a different nature. Wang Chen-p'eng's handscroll, *Vimalakīrti and the Single Doctrine* (Plate 49) was painted for the heir-apparent in the early fourteenth century and was approximately contemporary with the *Assembly of the Buddha Sakyamuni*, Wang was undoubtedly familiar with the wall paintings of northern China, and probably painted such pic-

tures himself. This handscroll was, in fact, based upon a wall painting cartoon that is still in the Palace Museum in Peking. Whatever subtle nuance the brush is capable of is found in Wang's work, which he created in black line and gray wash. It illustrates the popular legend of the encounter of the Chinese lay saint Vimalakīrti (the scholarly figure on the right) with the Bodhisattva Manjusri, who personified supreme wisdom. They engaged in a debate on the subtleties of the Dharma Law expounded by the Buddha Sakyamuni, and Vimalakīrti won. The technique used by Wang is called *pai-miao*, or plain line. Its origins lay in the wall paintings of the T'ang and Sung periods, but it remained highly popular over the centuries because of its simple elegance and fluid grace.

A final example of the figure-painting tradition, as represented in the collection of the Metropolitan, is T'ang Yin's colorful and rhythmic portrayal of the Moon Goddess Ch'ang O (Plate 55), painted at the beginning of the sixteenth century. She is shown holding a branch of cassia leaves, which she is about to present to a gifted scholar who has just passed an important examination, according to the painter's poem above. There is a careful irony in this, since T'ang Yin was one of the most brilliant young scholars of his day, but one who was disgraced in an examination scandal and passed the remainder of his short life as a bohemian artist. He used the brush with the effortless grace of a natural calligrapher, creating dashing images that were full of beauty. So many distinguished Chinese painters, like T'ang Yin, turned to the art of painting only after failing in loftier ambitions that one is led to suspect that they wanted to become artists all along. In any case, this gifted master personifies the natural virtuoso, a favorite type in the Chinese tradition of painting—as it is in the European tradition of music.

This fleeting glance at the art of China cannot conclude without mention of three paintings from one of China's golden ages of art, the seventeenth century. In this fertile period, one great dynasty, the Ming, came to an end, and another, the Ch'ing, replaced it by force of arms. The Ch'ing were a Manchu people, and the era was marked by all of the trauma that accompanies the conquest of one dynasty by another, already witnessed by the effects on the Sung painters discussed above. During such times in China the arts of painting, poetry, and calligraphy flourished, perhaps because they continued to be the most attractive form in which personal statements could be made. It is also probable that men who, in other times would have become scholar-officials of great probity, chose not to do so (or were disbarred) and were thus free to give expression to their lives through art.

Whatever the reasons, it is a fact that, during the seventeenth century, there were several hundred gifted painters in China, many of them among the greatest ever produced. Hung-jen, whose *Dragon Pine on Mount Huang* (Plate 59) is a work of great power and simplicity, was one such man—a Buddhist monk who lived quietly amid the mountains in Anhwei province, while armies met and people were displaced throughout China. Hung-jen's vision was limited to the mountain, its sights and sounds, its changing weather and atmosphere. In the dragon pine, he saw himself, living in an upside-down world, clinging to life on a high pinna-

cle. The pine, while symbolic in his painting, was also probably real and familiar to him in his limited world: The identity of man and pine grew from years of close contact.

The artist Tao-chi, a prince of the royal house, also became a monk as a result of the fall of the Ming dynasty, but as one of China's greatest artists, he regained the stature that he lost to foreign conquest. His paintings, such as *Bamboo in Wind and Rain* (Plate 67), are characterized by a richly exuberant celebration of the creative process. Tao-chi loved every nuance of atmosphere and light; he cherished the experiences of life in a cosmic universe, and he produced masterpiece after masterpiece in which he explored the many facets of creation. Here, it is bamboo swept by the elements, remaining pliant and strong, rich and flourishing, despite its battering, returning always to upright growth, like the painter himself.

Another genius of the period, the brooding, introspective master of ink, Kung Hsien, is represented here by *Ink Landscapes with Poems* (Plate 62). This work demonstrates a sensitivity to tonal and textural nuance akin to that of the nineteenth-century French artist Georges Seurat.

In ancient India, the most esteemed and influential art was sculpture. Princely patrons of Buddhism and Hinduism, the dominant religions of India until the spread of Islam, sponsored the construction of magnificent temples throughout the realm (which included parts of modern Pakistan and Afghanistan, beyond the borders of modern India). These temples, in turn, required monumental sculpture and painting, as well as miniature bronze altars. Places of worship were built throughout China, Japan, and Southeast Asia as well, following the spread of Buddhism. By the seventh century, Buddhism had succeeded, more than any force in history, in uniting East and South Asia. What has been called the East Asian International Style was, in fact, the style of Buddhist art that began in India and moved eastward like a tide. Just as the tenets of Buddhism grew from the life of the Indian teacher Gautama, who became the Buddha, so the elements and ideals of Buddhist art grew from the art of India.

In India, as in other parts of Asia, Buddhism joined the more ancient traditions of indigenous cultures. Thus, the stunning artifacts of the Indus Valley civilization of the second and third millennia B.C. consist of the same artistic elements that are found in the beginnings of Buddhist art two thousand years later. Like China and Japan, India repeatedly absorbed conquest and powerful foreign influences, while maintaining the consistency of its native heritage. Thus it is easy to see the relationship between a stone torso from Harappa, dating from around 2000 B.C., and the fragment of a Buddhist stele, from the early fourth century A.D. Both emphasize the human body in a distinct and sensual way, and this emphasis is in itself striking, since the portrayal of the human body as an ideal form that manifests the attributes of divinity is associated with only a few cultures of the world, among them Greece and India. Certainly, in China and Japan, the human body is rarely visible and does not count among the ideal forms.

Profound reasons no doubt exist to account for the identification of divinity and the ideal human form in ancient Greece and India, but there are also some easily accessible explanations. Both in ancient Greece and in India, the warmth of the climate led people to dress in lightly draped clothing that delineated the body beneath. In China, Japan, and also northern Europe, where hot weather was less constant, clothing generally muffled the body, diverting attention from its natural forms. Where the nude appears in the art of these colder regions, it is generally as a bow to the artistic standards of other cultures. Today, for example, the nude is painted in Japan as a result of interest in the academic traditions of art emanating from ancient Greece, but the Japanese still do not venerate the human body as a manifestation of divinity, or as the embodiment of ideal form.

Two superb standing Buddhas illustrate the two major forms of early Buddhist images. The Mathuran sandstone figure (Plate 78), from the fifth century A.D., is an embodiment of the ideal already described. A curving layer of delicately folded cloth falls over the breath-filled body, clinging to and molding the flowing form beneath, and creating a subtle pattern of line that acts like the rippling movement of a swelling wave. The Buddha smiles very slightly; his right hand is in the position symbolizing protection, and his left is in that of charity. A circular halo glows behind his head, representing both the Wheel of Dharma Law and the flame of spiritual knowledge. The *usnisa* protruding from his head symbolizes spiritual knowledge beyond human capacity.

The dazzling sixth-century Buddha surrounded by a flaming *mandorla* (Plate 79), comes from Gandhara, a region that included northwest India and Pakistan. This statue represents another prototype, one related to Roman art and the ideal, godlike form of Apollo. By the time of its making, art had already returned to an almost purely Indian state, in which the hanging drapery folds were not naturalistic, but patterned, like the delicate lines of the Mathura figure. A glowing fifth-century Chinese bronze Buddha (see Plate 29) clearly derives from both Indian prototypes. The Chinese artist adapted the heavy garment of Gandhara to the flaring body and rippling surface pattern of Mathura. In the Chinese figure, however, which stands on a lotus pedestal, the linear pattern is developed into a system far more assertive and rhythmically powerful than that of its prototypes.

The Gupta period of India, which ran from the beginning of the fourth to the beginning of the sixth century A.D., can be referred to as the classical age of Indian sculpture and painting. It was a period during which the traditions of Indian art seem to have been drawn together into a powerfully expressive ideal form. But it was only a moment in a continuing process of evolution that saw further exploration, throughout the subcontinent, of the same ancient tendencies. A Kashmiri bronze Lokeshvara (Plate 81) illustrates the development of this sinuous, flowing ideal into a process of seamlessly curving movement, as does a Parvati (Plate 89) from southern India, a Hindu goddess of dancing charm and beauty.

In all of Asia, Indian art has been the most direct in its frank acceptance and celebration of physical existence. Entire artistic programs of ritual decoration have been devoted to sexual congress, and the divinities that represent the forces of Hindu and Buddhist belief are nearly always conspicuously sexual manifestations.

The male principle of Hinduism is powerfully conveyed in a white marble *linga* from Afghanistan (Plate 85), bearing a single face of Shiva. The *linga* is a phallic symbol and was normally set into a base corresponding to the female opening, an obvious reference to the powerful forces of creation. It brings together in one object the physical and spiritual duality of existence.

There is, too, an ardent sexuality in the superb bronze image of Yashoda nursing the infant god Krishna (Plate 92). The child drinks from one breast, while fondling the rounded fullness of the other. Yashoda appears to be in a state of ecstasy as she nourishes divine life.

The Hindu cosmos embraces all of the forces of existence, from birth to death, from creation to destruction, and from saintliness to evil. These powers struggle ceaselessly in their eternal striving for dominance. Animals are a part of this cosmos, and their lives are as sacred (and as profane) as those of humans. The monkey king, Hanuman, was a devoted ally of Rama, and he represented courage, bravery, and loyalty. He is portrayed in the Museum's collection in an eleventh-century bronze statue from Tamil Nadu (see Plate 91). Similarly, Ganesha (see Plate 103), a god with a human body and an elephant head, represented auspiciousness—he functioned in Hindu mythology as a facilitator.

As the styles and standards of Indian art spread through Asia, following the paths of Buddhism and Hinduism, they took on new shapes as they were adapted to fit into regional traditions. A bronze Maitreya from Nepal (Plate 98) is closely related to the Indian Buddhist center of Nalanda and the Bengali Pala style, as is a standing bodhisattva (Plate 96). Both images explore the sinuous, elegant components of the earlier classical Gupta manner in a style that remains Nepalese in grace and refinement. Reflections of the same influence are also encountered in China, Japan, Central Asia, and most of the countries of Southeast Asia.

Among the Indian paintings included in this volume is the cover for a holy manuscript (Plate 95), almost certainly the *Ashtasahasrika Prajnaparamita*, or *Perfection of Wisdom in Eight Thousand Verses*, a Buddhist holy treatise. The painting is on the inside of the wooden cover that held the scroll. Indian painting is one of the glories of Asia, but in its earlier forms, prior to the rise of Islam, it is relatively little known outside India. That is because the great monuments of Indian painting are still *in situ* at Bagh, Ellora, and, above all, at Ajanta. As the sculpture of Gupta India was to the rest of Asia, so was the painting of India to the great cycles of Buddhist painting found throughout the East, from Central Asia to China and Japan. Ajanta, in the northern part of the Deccan, can be considered the fountainhead of Asian Buddhist painting.

The manuscript cover in the Metropolitan's collection provides a glimpse of the lost glories of Indian painting. It presents stories from the life of the Buddha that are similar in subject matter to many works in stone, but in painting, the effects are very different. Overall, however, from the Gupta period on, the tendencies of sculpture and painting were closely linked in India, as they were in China and Japan. Certainly, all of the characteristics of line, volume, movement, and gesture that we observe in Indian sculpture are also present in the paintings of Ajanta and elsewhere. Despite the differences of the properties of a stone relief stele and those of registral painting like that of the manuscript cover, the preparation for both was probably identical. It is safe to assume that the artist began with a line drawing that served equally well as a transfer cartoon for a wooden surface to be painted and for a stone surface to be carved. The identical composition and formal ends were intended; only the material and the tools differed.

Among the nations of Southeast Asia, Cambodia is especially well represented in the collection of the Metropolitan Museum. The statue of Ganesha already mentioned above is from Cambodia, as is a standing figure of Hari-Hara (Plate 102), fashioned with a similar bulk and heaviness, and a mighty image of Brahma from Prasat Prei (Plate 107). Typical of the syncretic development of Hinduism, these images convey esoteric powers. Hari-Hara is a combination of Vishnu, the sustainer of life, and Shiva, the destroyer—the two mighty forces of Hindu theology—and Brahma, with his four heads and four arms, personifies the powers of creation. Life and death are inseparably joined in the figure of Hari-Hara, and both figures—Vishnu and Shiva—represent all creation and existence.

Generally speaking, Cambodian art places greater emphasis upon the abstract than does its Indian prototype. Symmetry is favored over organic flow, and an almost geometric balance of forms predominates. This quality seems to suggest an esoteric, mystical system of thought and belief that differed from religious systems elsewhere. There is less sense of physical reality, less human grace, and a stronger implication of suprahuman, divine forces and structures that possess a colder, more distant perfection, beyond human understanding or perception. This is clearly illustrated by the beautiful and perfect forms of the Museum's kneeling goddess (Plate 108). This statue, perhaps from one of the temples at Angkor, is among the rarest bronze images in any museum. Photography fails to reveal fully the qualities of this work, since the figure must be seen three-dimensionally, if one is to appreciate its perfection of design. As one moves around it, it continues to reveal shifting balances and relationships within itself. It is a mathematical formulation in space, taking on first one balance and then another, constantly shifting into another reality as the viewer's position changes. It is a masterpiece of craftsmanship, but also a microcosmic manifestation of a ritual complexity and ever-shifting perfection that typifies the art and thought of Cambodia.

This introduction to the art of Asia is necessarily incomplete. Given the limitations of space, it has not been possible to include all the works of importance from each country represented in the Metropolitan's Asian holdings. It should, however, be clear from this overview that, despite the interwoven strands of cultural and religious development, each nation shaped its art according to its own inclinations, and that even where the subject matter was common to all, strong national characteristics imposed themselves upon its interpretation. "Asian" art, like "European" art, is the sum of many parts.

Richard M. Barnhart

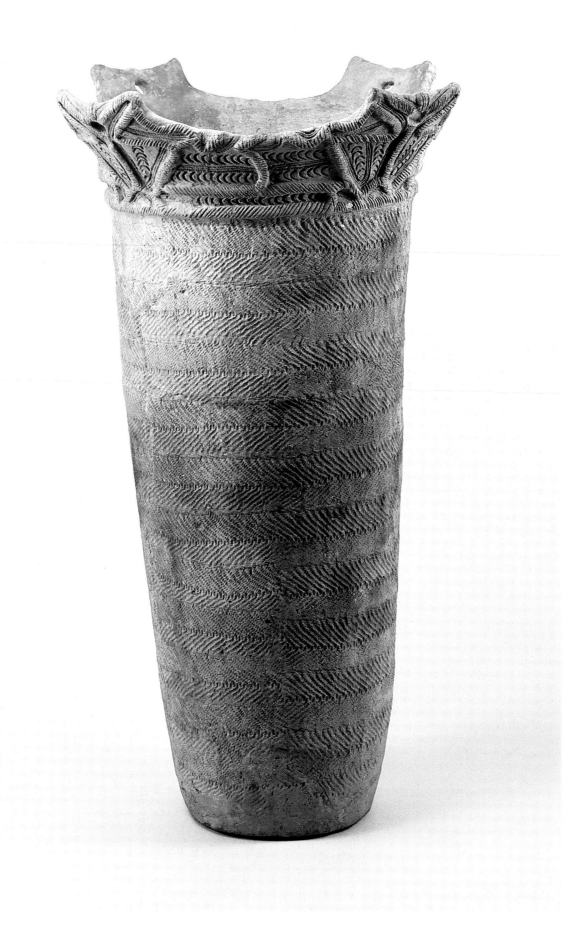

JŌMON JAR

The earliest ceramic ware produced by the inhabitants of the Japanese archipelago is known as Jōmon or "cord marked," after its distinctive textured surface decoration. Created by a Neolithic people that existed by fishing and hunting, examples of Jōmon pottery dating from the fifth millennium through the third century B.C. have been found throughout the Japanese islands. Although they range widely in type and style, all are built up from coiled rings and are unglazed. They are thought to have served for food storage, but their exact function is uncertain.

This earthenware food vessel, which came from Aomori Prefecture in northeastern Japan, is remarkable for the fine quality of its clay and for its sophisticated decoration. The herringbone pattern on its body was produced by cords knotted together and twisted in opposite directions. Slender strips of clay were applied to create the geometric relief pattern on its flared quatrefoil rim. Sharp sticks were used to make the linear incisions. Perhaps rope handles were once attached through the four holes. Such soaring, ornamented rims are typical of the wares of the mid-Jōmon period.

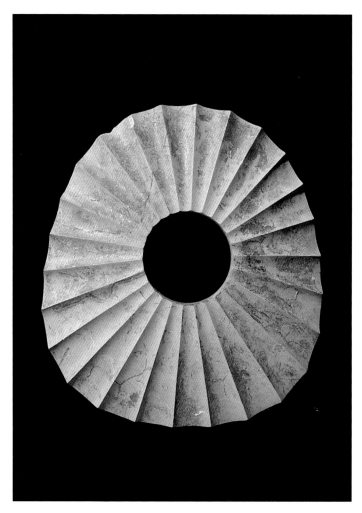

1 Jōmon Jar
Japanese; Middle Jōmon period
Earthenware with applied, incised,
and cord-marked decoration;
27½ x 16½ in. (69.8 x 41.9 cm.)
The Harry G. C. Packard Collection of
Asian Art, Gift of Harry G. C. Packard and
Purchase, Fletcher, Rogers, Harris
Brisbane Dick and Louis V. Bell Funds,
Joseph Pulitzer Bequest and The Annenberg
Fund, Inc. Gift, 1975 (1975.268.182)

TALISMAN

This irregular disk with smooth radial fluting is a fine example of a type of carved stone object found, along with grave goods of metal, clay, and precious stones, in the keyhole-shaped burial mounds of central Japan. Disks in this shape are called *sharinseki* (carriage wheel stones), and they are sometimes identified as stone bracelets. They seem, however, to be talismans with magical or religious significance.

The thousands of burial mounds found throughout Japan, some as large as the Egyptian pyramids, have given the name Tumulus to the period from A.D. 250 through 552. The culture of the Tumulus period shows especially close affinities with that flourishing contemporaneously on the Korean peninsula. Some grave goods also suggest connections with China. In China, similar flat disks called *p'i* were regarded as symbols of heaven. Whether or not an equivalent symbolic meaning also was attached to such objects in Japan is uncertain.

2 Talisman
Japanese; Tumulus period
Steatite; 2½ x ½ in. (6.5 x 1.2 cm.)
The Harry G. C. Packard Collection
of Asian Art, Gift of Harry G. C. Packard
and Purchase, Fletcher, Rogers, Harris
Brisbane Dick and Louis V. Bell Funds,
Joseph Pulitzer Bequest and The Annenberg
Fund, Inc. Gift, 1975 (1975.268.338)

3 *Section of* Kegon-kyō, ca. A.D. 774
Japanese; Nara period
Segment of handscroll mounted as
hanging scroll; silver ink on indigo paper;
9¾ x 20⅛ in. (24.8 x 51.1 cm.) Purchase,
Mrs. Jackson Burke Gift, 1981 (1981.75)

Opposite: detail

SECTION OF THE *KEGON-KYŌ*

This manuscript is a fragment of the *Kegon-kyō* or *Avatamsaka Sutra,* one of the most influential Buddhist scriptures in eighth-century Japan. Its doctrine of cosmological harmony in a universe governed by the cosmic Buddha Rocana or Mahāvairocana, appealed strongly to the government as a symbol of national unity. The set to which this segment belongs came from the Nigatsu-dō, a hall within the Tōdai-ji, a vast temple complex that served as national headquarters of Buddhism in the then capital of Nara. The text consists, on the right, of six lines with seven characters each of verse, and on the left, of six lines of seventeen characters each of prose. It is written with the short, unstressed brushstrokes and even spacing characteristic of the official clerical style practiced by scribes in the scriptorium in the Tōdai-ji compound. During its heyday, between A.D. 725 and 775, this government-sponsored scriptorium, with over two hundred and fifty scribes in its employ, copied a prodigious number of Buddhist texts for Tōdai-ji and other temples. All feature the high degree of discipline and clarity exhibited in this fragment.

普為三界一切眾

具足無量眾好色

佛身一切諸毛孔

ZAŌ GONGEN

Zaō Gongen is the tutelary deity of Mount Kimpu, which is located in the Yoshino mountains south of Nara, a region renowned for both its beauty and rich history. Initially, Zaō was only a minor local Shinto deity, but he took on national stature due to the prominent place held by Mount Kimpu in the syncretic religious beliefs and practices of the Heian period (794–1185). Zaō came to be identified as a local manifestation of the Future Buddha, Miroku (known elsewhere in the Far East as Maitreya), who, it was believed, would first appear atop Mount Kimpu. Many bronze images of Zaō were buried there to await the coming of the Future Buddha.

In this fine bronze statue, Zaō is depicted with a wrathful countenance—glaring eyes, fangs, and hair standing on end—inspired by the appearance of Esoteric Buddhist deities. (Esoteric Buddhism incorporated native gods into the Buddhist pantheon and emphasized magic and semimagic practices.) His ferocious expression is not intended to frighten the beholder but, like that of his Buddhist counterparts, (see Plate 5) to ward off evil. While expressing an intense spirituality, this image is a fine example of the elegance of the aristocratic Heian style.

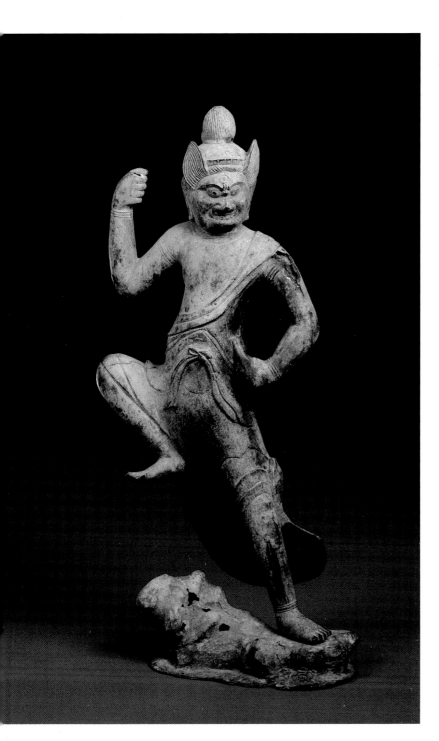

FUDŌ MYŌ-Ō

Fudō, whose name means "immovable," is a staunch guardian of the faith, warding off enemies of the Buddha with his sword of wisdom and binding evil forces with his lasso. A symbol of steadfastness in the face of temptation, he is one of the most commonly depicted of the Esoteric Buddhist deities known as Myō-ō, "Kings of Brightness." Here his youthful, chubby body and his skirt and scarf are modeled with the restrained, gentle curves typical of late Heian sculpture. Fudō's halo of red flames has been lost, and his rock pedestal is a nineteenth-century replacement. Enough pigment remains to show that his hair was once painted red and his flesh dark blue-green. His clothing was covered with delicate patterns of cut gold leaf.

This statue was the central icon of the Kuhon-ji Gomadō in Funasaka, some twenty miles northwest of Kyoto. A *gomadō* is a small auxiliary hall attached to temples of Esoteric sects of Buddhism and intended specifically for the ritual worship of Fudō with fire-burning ceremonies.

4 Zaō Gongen, 11th c.
Japanese; late Heian period
Gilt bronze with incised decoration;
H. 14¾ in. (37.5 cm.)
The Harry G. C. Packard Collection
of Asian Art, Gift of Harry G. C. Packard
and Purchase, Fletcher, Rogers, Harris
Brisbane Dick and Louis V. Bell Funds,
Joseph Pulitzer Bequest and The Annenberg
Fund, Inc. Gift, 1975 (1975.268.155)

5 Fudō Myō-ō, 12th c.
Japanese; late Heian period
Wood with color; Figure without base:
63¾ x 26¾ x 15 in. (161.9 x 67.9 x 38.1 cm.)
The Harry G. C. Packard Collection of
Asian Art, Gift of Harry G. C. Packard and
Purchase, Fletcher, Rogers, Harris Brisbane
Dick and Louis V. Bell Funds, Joseph
Pulitzer Bequest and The Annenberg Fund,
Inc. Gift, 1975 (1975.268.163)

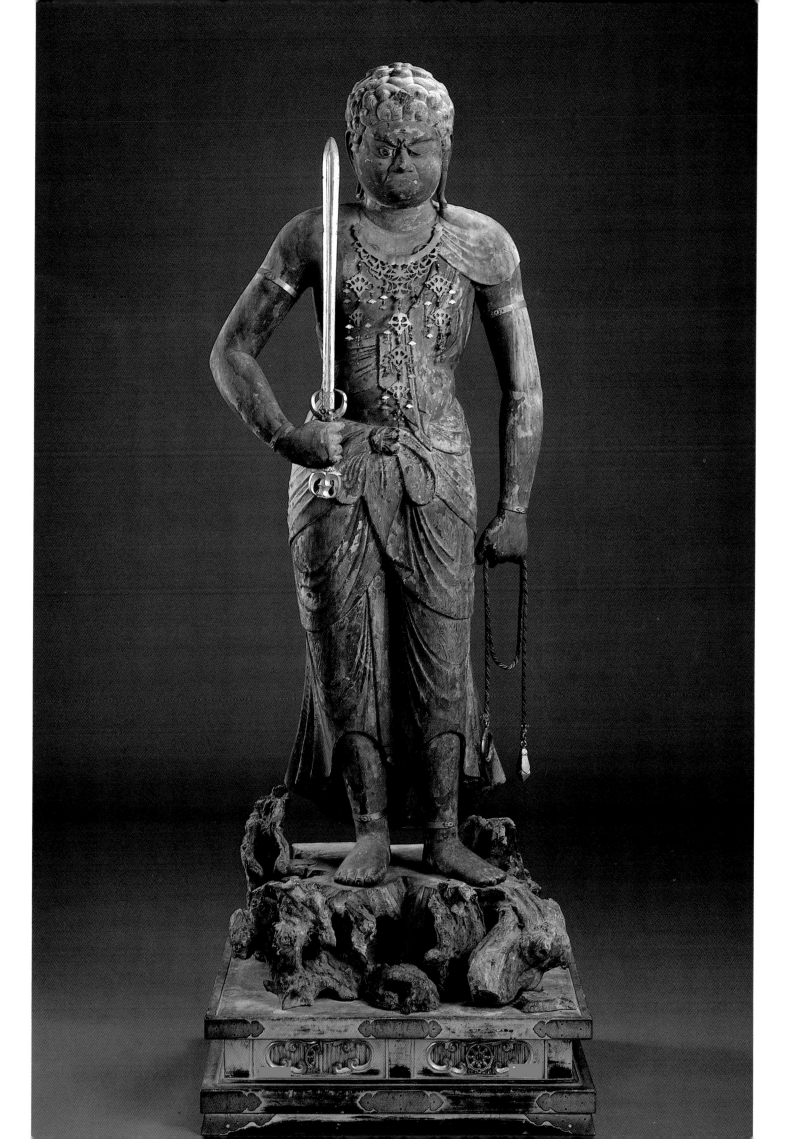

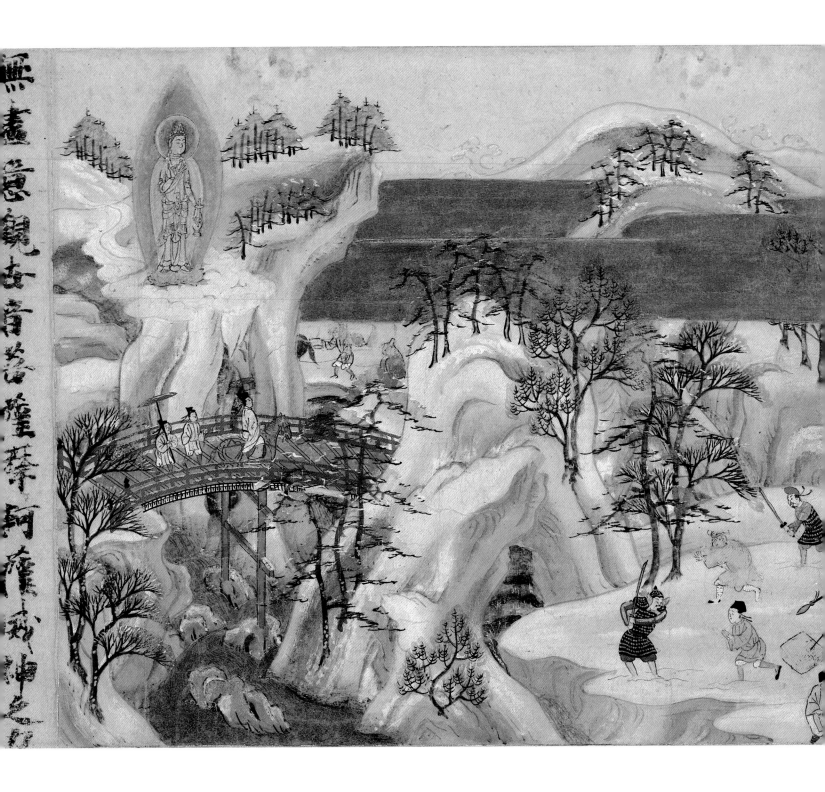

無畫思思觀安音多意薩恭奉阿魔小散神參門

THE MIRACLES OF KANNON

The Bodhisattva Kannon, known in China as Kuan Yin and in India as Avalokiteshvara, is the most beloved deity in East Asian Buddhism. The embodiment of compassion, he has the ability to manifest himself in many different forms to save mankind (see Plate 8). Inspired by the twenty-fifth chapter of the influential *Lotus Sutra*, this handscroll (*emaki*) shows Kannon saving the faithful from fire, flood, and other calamities. Both the text and the illustrations are modeled after a Chinese printed scroll said to have been made in the Sung dynasty. The text was transcribed by Sugawara Mitsushige, a thirteenth-century calligrapher who signed and dated it 1257 at the very end of the scroll. We do not, however, know the name of the fine painter who illustrated with superb color and gold each section of the thirty-three texts. While many of the scenes appear to be faithful to a Chinese model, the figures, landscape, and genre details here are painted in native Japanese style.

6 *The Miracles of Kannon*, 1257 (detail)
Japanese; Kamakura period
Handscroll; color and gold on paper;
Overall: 9½ x 384 in. (24.1 x 975.3 cm.)
Purchase, Louisa Eldridge McBurney
Gift, 1953 (53.7.3)

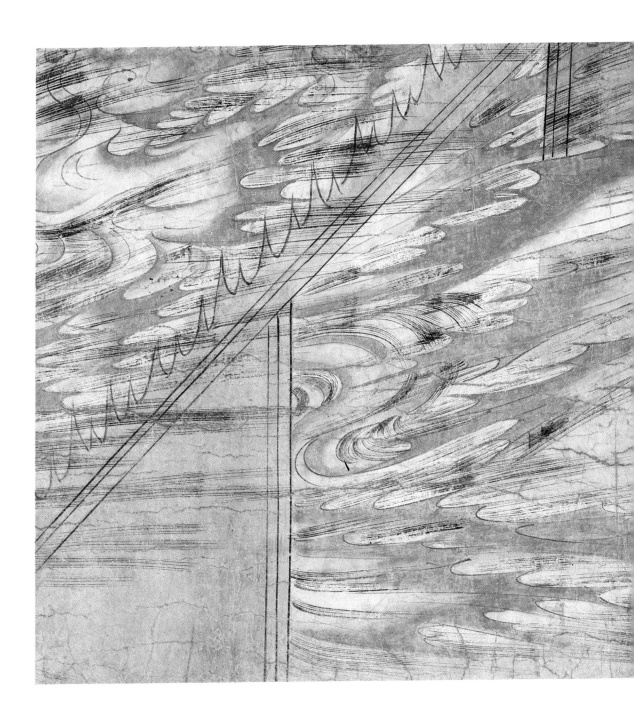

Tenjin Engi

This illustration is from a set of three scrolls (now remounted as five) that describe in words and images the deification of the poet-scholar Sugawara no Michizane (A.D. 845–903) as Tenjin, the patron saint of literature and learning. Unjustly maligned by his political rivals, Michizane had been exiled on the distant island of Kyushu, where he died. To pacify his angry spirit, which returned to seek vengeance, a shrine was dedicated to him in the Kitano district of Kyoto.

By the thirteenth century, devotion to Tenjin had spread throughout the country. These scrolls, which contain thirty-seven lively and evocative scenes, were created for didactic use in one of the many shrines devoted to this popular deity. The story begins with an account of Michizane's life and the havoc wrought by his vengeful spirit. Next follow the construction of his shrine and the miracles associated with it. The scrolls conclude with dramatic scenes of the priest Nichizō's journey through hell where he sees the torments suffered by Michizane's enemies. Here Nichizō is depicted entering the gates of hell, which are guarded by a colossal eight-headed beast.

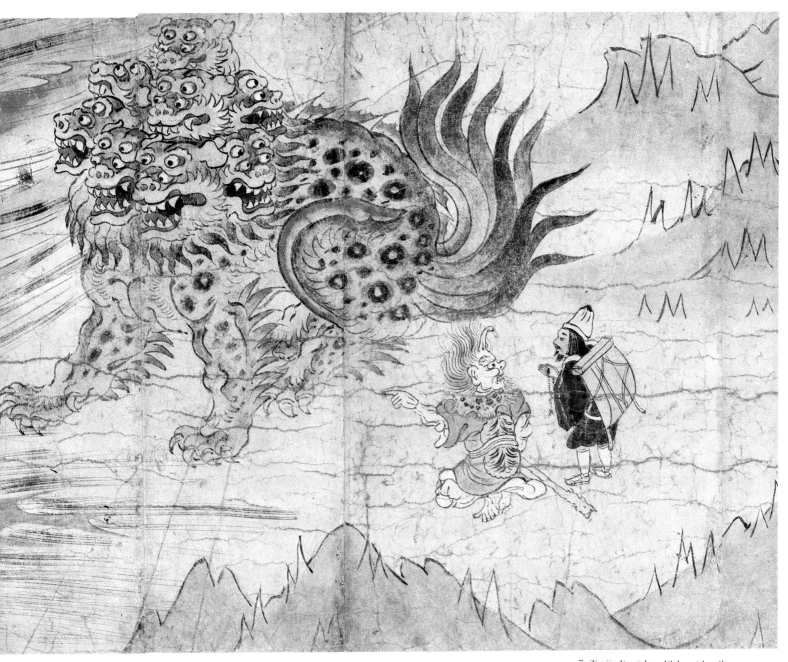

7 *Tenjin Engi*, late 13th c. (detail)
Japanese; Kamakura period
Handscroll; color on paper; Overall:
12¼ x 221⅞ in. (31.1 x 563.6 cm.)
Fletcher Fund, 1925 (25.224a-e)

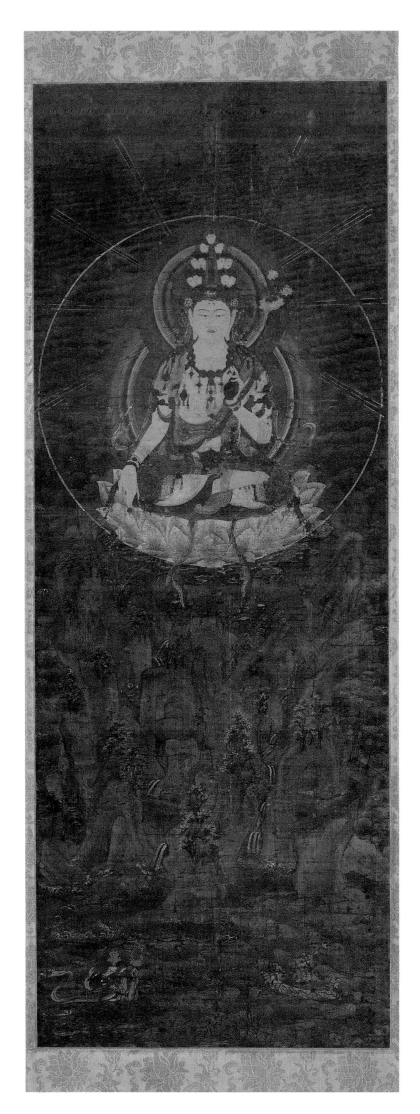

ELEVEN-HEADED KANNON ON MOUNT POTALAKA

This strikingly lyrical painting shows an Eleven-Headed Kannon enthroned on his mountain paradise, Potalaka, where glorious palaces and lakes lie amid fragrant trees and flowers. This multiheaded form of the compassionate Kannon was especially popular in the Esoteric sects of Buddhism. From the late twelfth century, devotion to images of Kannon on his island abode became widespread as specific locales throughout Japan, including Mount Nachi in Wakayama Prefecture and Mount Kasuga in Nara, were identified as his paradise.

Exceptional for its richly evocative landscape and deep-distance view of the sea, this painting exhibits a new interest in depicting deities within realistic settings—a hallmark of many Buddhist icons of the fourteenth century. The convincing representation of the waves receding behind Kannon, as well as the form and shading of his rocky promontory, indicate familiarity with Chinese painting of the Sung dynasty. The hieratic golden-hued figure of the deity, however, conforms to traditional Japanese style and iconography.

8 *Eleven-Headed Kannon on Mount Potalaka*, 13th c.
Japanese; Kamakura period
Hanging scroll; color on silk; 42¾ x 16¼ in.
(108.6 x 41.1 cm.) The Harry G. C. Packard
Collection of Asian Art, Gift of Harry G. C.
Packard and Purchase, Fletcher, Rogers,
Harris Brisbane Dick and Louis V. Bell Funds,
Joseph Pulitzer Bequest and The Annenberg
Fund, Inc. Gift, 1975 (1975.268.20)

JIZŌ BOSATSU

Jizō Bosatsu, like Kannon (see Plates 6, 8), is dedicated to bringing salvation to mankind. However, he is generally shown in the guise of a monk with shaven head and without the crown and jewelry of a bodhisattva. He holds a jewel in his left hand and a staff, now missing, in his right. Emerging as a popular deity at the end of the Heian period, Jizō came to be endowed with a wide range of protective powers: He is the protector of mothers in childbirth, of children, of warriors, and most importantly, of those unfortunate souls reborn in Hell.

This statue was created in the *yosegi-zukuri*, assembled woodblock technique, characteristic of statuary produced during the Kamakura period (1185–1333). First, small finely carved blocks of wood were joined together in jigsaw-puzzle fashion and crystal eyes were inserted. Next, the figure was covered with a lacquered cloth and painted. Finally, gold leaf (*kirikane*) was applied. The condition and variety of the finely cut gold leaf designs on this statue are exceptional.

9 *Jizō Bosatsu*, early 14th c.
Japanese; Kamakura period
Wood with lacquer, color, and cut gold;
Figure only: H. 19½ in. (49.5 cm.)
The Harry G. C. Packard Collection of Asian
Art, Gift of Harry G. C. Packard and Purchase,
Fletcher, Rogers, Harris Brisbane Dick and
Louis V. Bell Funds, Joseph Pulitzer Bequest,
and The Annenberg Fund, Inc. Gift, 1975
(1975.268.166a-d)

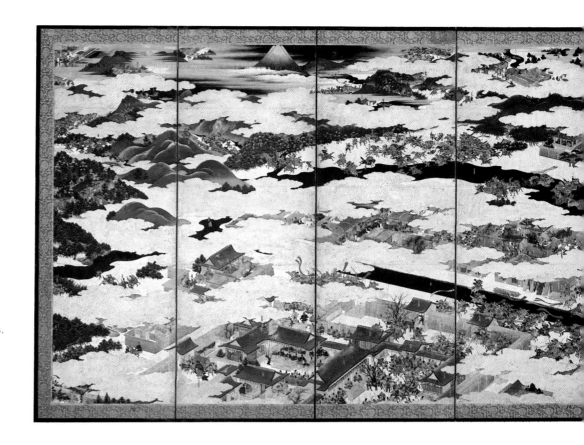

10 Battles of the Hōgen and Heiji Eras,
1573–1614
Japanese; Momoyama period
Pair of six-fold screens;
color and gold leaf on paper; each
60⅞ x 140⅛ in. (154.6 x 355.6 cm.)
Rogers Fund, 1957 (57.156.4,5)

Below left and right: details

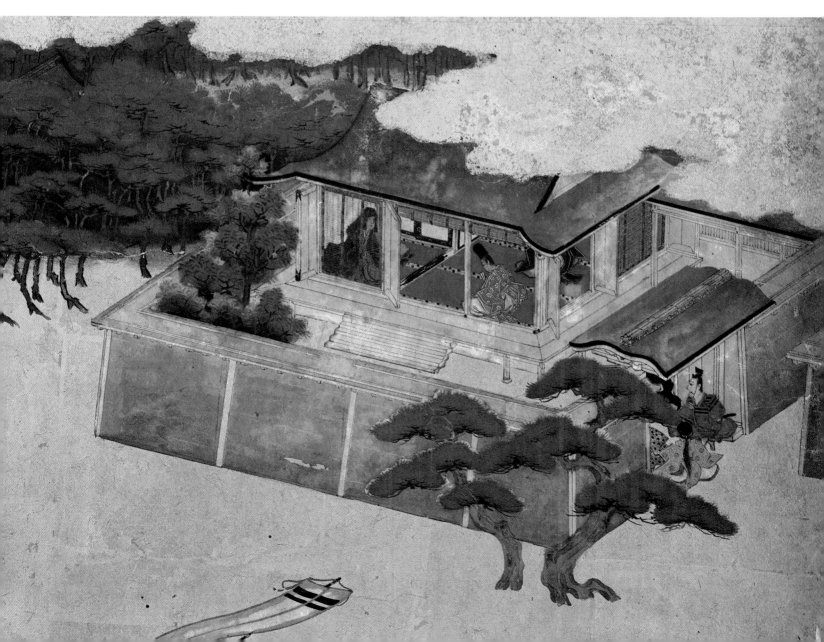

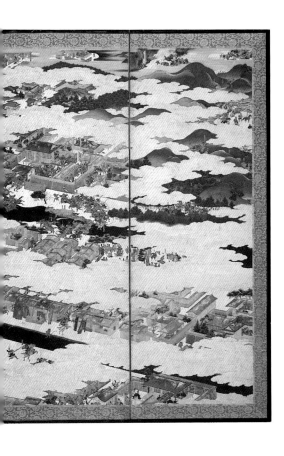

Battles of the Hōgen and Heiji Eras

The bloody uprisings that occurred during the Hōgen and Heiji eras in the latter half of the twelfth century served as sources of inspiration for generations of artists. Initially, these military dramas were recounted in the form of handscrolls, but from the late sixteenth century, they were often adapted and rearranged for use on large-scale screens with dazzling gold ground.

In these screens, attributed to an unknown artist of the Tosa school skilled in the traditional narrative handscroll style, the drama of the two insurrections is set before us, scene by scene. The locale for most of the action is Kyoto, but the artist did not hesitate to switch to Mount Fuji, located far to the north. Nor are the scenes placed chronologically; rather, the artist distributed his incidents as suited him best. The viewer gets a bird's-eye view of the action because of the Japanese technique of looking from above at an oblique angle. Sliding doors and roofs are pulled back so that we see the scene inside as well as outside the palace. As a further aid to the viewer, small labels identifying people and places were pasted onto the screens either by the artist or at a later date.

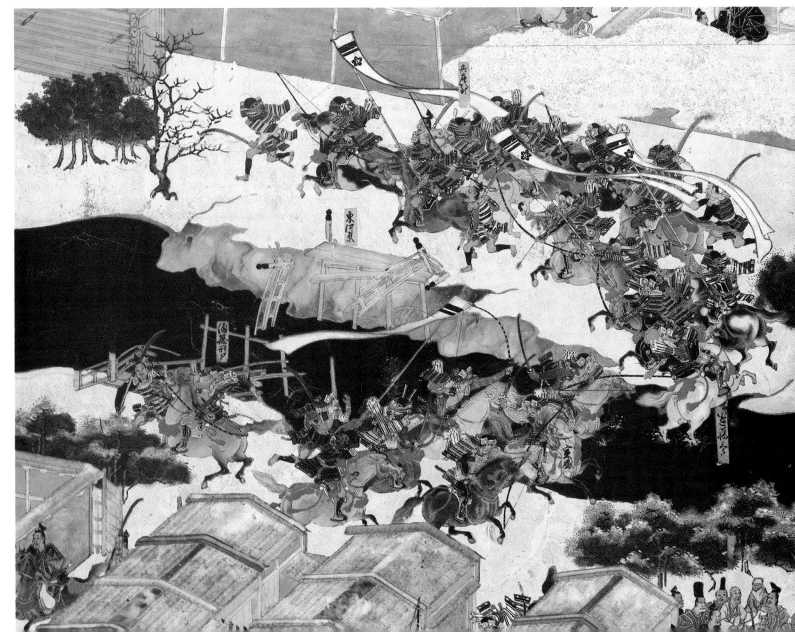

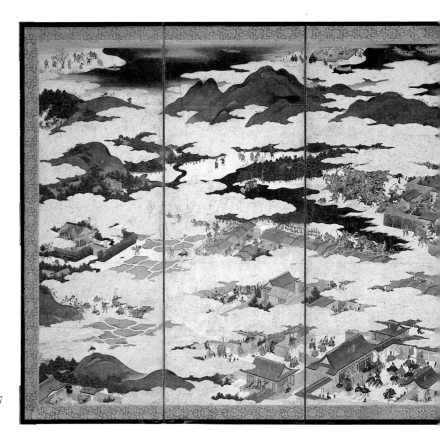

Battles of the Hōgen and Heiji Eras: see pages 26–27

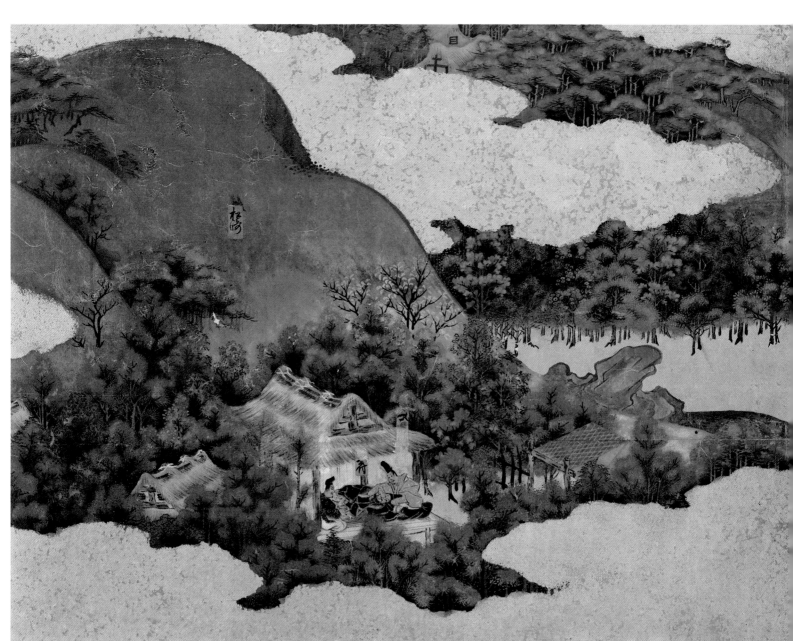

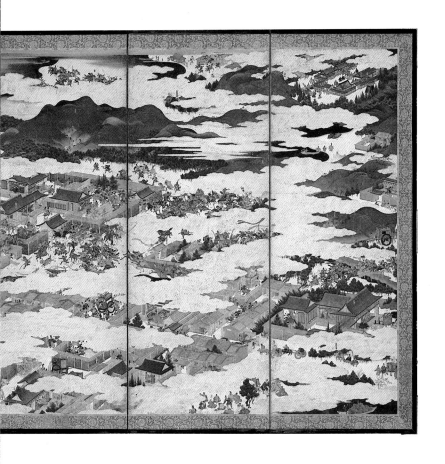

29

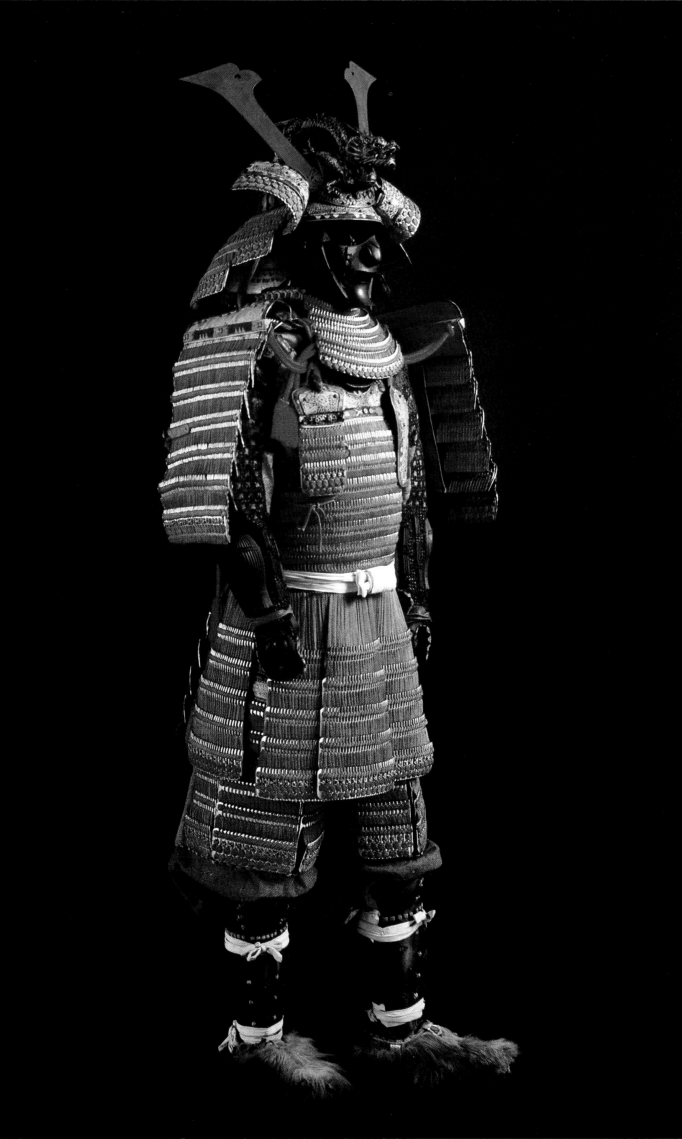

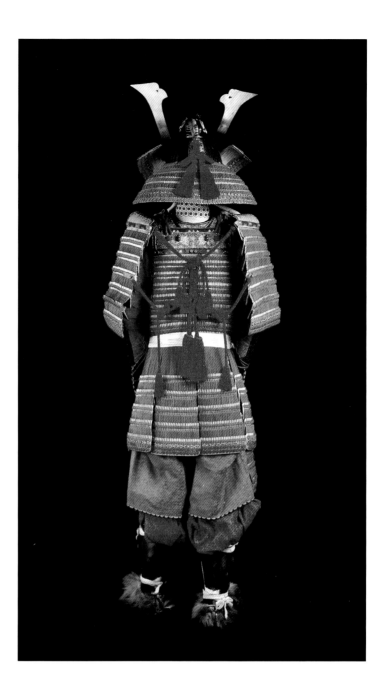

11 Suit of Armor, ca. 1550
Yoshihisa Matahachiro
Japanese; Muromachi period
Steel, blackened and gold-lacquered;
flame-colored silk braid, gilt bronze,
stenciled deerskin, bear pelt, gilt wood;
H. ca. 66 in. (167.6 cm.), Wt. ca. 48 lb.
(21.8 kg.) Rogers Fund, 1904 (04.4.2)

Right: back view

YOSHIHISA MATAHACHIRO
Suit of Armor

Unlike Western armor, which was composed of large steel plates fitted together in as few pieces as would still permit movement, Japanese armor was made up of thousands of lacquered iron or leather scales laced together to form a series of horizontal bands. The scales were held in place by metal rivets, and the surface of the armor was ornamented with brightly colored braid that identified the allegiance of a warrior to his daimyo, or feudal lord.

This armor design has a number of explanations. Though the Japanese warrior regularly fought on horseback, like his Western counterpart, he was an archer, not a lancer who needed armor that could withstand the tremendous impact of a lance-thrust from an opponent. Furthermore, because of the small body size of both horse and warrior, neither could support the great weight of Western armor. The warm climate of Japan also influenced the lighter design of the armor.

Where the armorer of the West was a master metalworker, the Japanese armorer had to be capable of working with effect in a variety of materials to produce a result that was artistic as well as protective. The Japanese warrior was judged as much for the lavish display of his armor as for his prowess in battle. Because of the crucial role armor played in feudal society, the finest artists in Japan were retained by daimyos for its production.

Though Western arms and armor had become all but obsolete by the sixteenth century, the armor of the Orient remained important to the feudal society of Japan well into the nineteenth century. Western armor kept pace with Western fashion and provides as many varieties and styles. In Japan, however, armor was made following the same essential patterns throughout the centuries.

The armor illustrated here belonged to a general who served under the daimyo of Sakai. It is composed of over forty-five hundred lames; almost a thousand rivets, eyelets, and bosses; and two hundred and sixty-five yards of silk braid. The rows of lames overlap from right to left, as a precaution against snagging the archer's bowstring. The helmet is crowned by an elaborately fashioned dragon of lacquered and gilded wood.

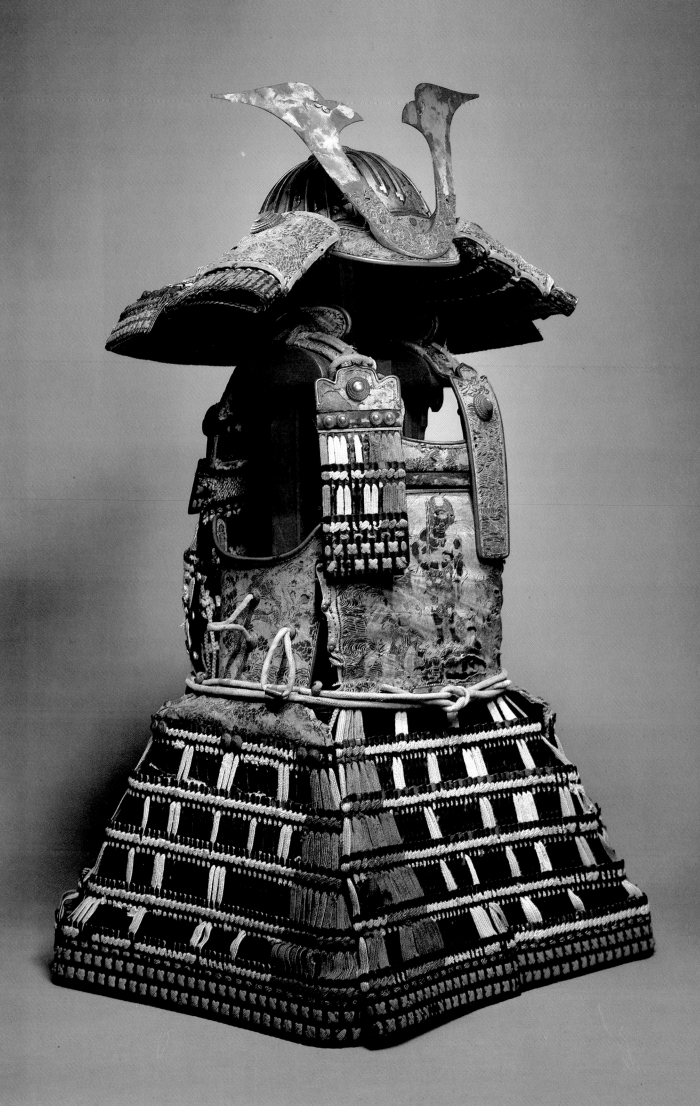

Anonymous Japanese Artisan
Half-Suit of a Nobleman

The rarity of surviving examples of early Japanese armor is largely due to the fact that armor continued to be worn by the descendants of the samurai for whom it was originally made, and many worn-out examples have passed through families into obscurity.

This half-suit of armor came from an ancient temple in the province of Tamba, fifty miles from Kyoto in central Japan. It is thought to have been the property of the first Ashikaga shogun, Ashikaga Takauji (1305–1358). The armor is in a remarkable state of preservation because it was lost for centuries in a secret pantry belonging to the temple and was discovered only in 1902, among its protective silken wrappings within a lacquered box. The silk braid retains its original brilliant color, and the corselet provides a rare example of early leatherwork. It is stencil-painted with a design showing Fudō Myō-ō (see Plate 5).

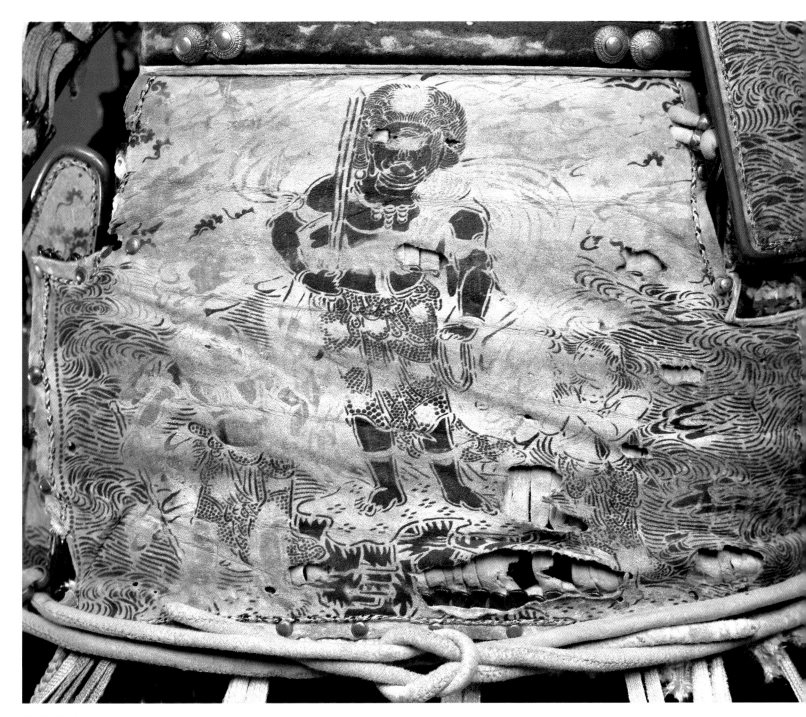

12 *Half-Suit of a Nobleman*
Japanese; 14th c.
Iron, leather, lacquer, silk;
H. (as mounted) 37½ in. (95.3 cm.),
W. 22 in. (55.9 cm.), Wt. (helmet) 12 lb. 4 oz.
(5.6 kg.), (cuirass) 25 lb. 15 oz. (11.8 kg.)
Gift of Bashford Dean, 1914 (14.100.121)

Above: detail

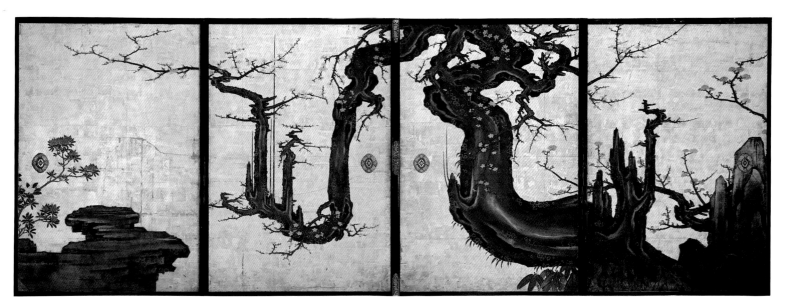

13 *Aged Plum*, ca. 1650
Kano Sansetsu
Japanese; early Edo period
Ink, color, and gold leaf on paper;
68¾ x 191⅛ in. (174.6 x. 485.5 cm.)
The Harry G. C. Packard Collection of
Asian Art, Gift of Harry G. C. Packard and
Purchase, Fletcher, Rogers, Harris Brisbane
Dick and Louis V. Bell Funds, Joseph
Pulitzer Bequest and The Annenberg Fund,
Inc. Gift, 1975 (1975.268.48)

Opposite: detail

KANO SANSETSU
Aged Plum

This set of four sliding doors (*fusuma*) separated two reception rooms in the abbot's quarters of the Tenshō-in, built in 1647, adjacent to the Tenkyū-in, a sub-temple of the Zen temple Myoshin-ji, in Kyoto. It probably formed part of a continuous painting that featured a dramatically enlarged tree on each of the four sides of the room. After being sold by the Tenshō-in, in the late nineteenth century the panels were cut down and new black lacquer frames and decorative metal fittings were added. The composition would have appeared less cramped in its original state.

The artist is thought to have been Kano Sansetsu (1590–1651), a member of one of the most prolific and influential schools of painting in the Edo period. Making the best use of the shape of the small rectangular room, the artist anchored his composition at the corners with massive rock clusters and filled the intervening expanse of gold leaf with the incredibly contorted image of an old, gnarled plum, symbol of fortitude and rejuvenation. The pink blossoms at the far right belong to a second plum tree that probably thrust in the opposite direction on the adjacent side of the room. The abstraction and stylized mannerism of the plum is characteristic of Sansetsu's late style.

WINE CONTAINER

This sake container (*chōshi*) is typical of the inlaid lacquer ware of the Momoyama period (1568–1615) known as Kōdaiji. This name derives from that of the Kyoto temple dedicated in 1605 by Kōdaiin to the memory of her husband, the warlord Toyotomi Hideyoshi (1536–98).

The decoration of this vessel comprises two uneven sections separated by a zigzag "lightning bolt" line. On one side is a naturalistic rendering of chrysanthemums against a plain black ground, and on the other, the more stylized paulownia-leaf crests adopted by Hideyoshi. These are set against a ground sprinkled with gold and silver particles. The resulting granular texture has given this lacquer technique the name *nashiji*, "pear ground." The striking device of dividing the surface decor into two contrasting areas, popular at the beginning of the seventeenth century, was employed not only in lacquer, but also in ceramics and textiles.

BOWL WITH LID

Only eight of these deep bowls, some missing their lids, are known at present. Most were found in Europe, no doubt produced for export toward the end of the seventeenth century under the influence of K'ang-hsi *famille verte* and, in all probability, originated from the same kiln. The symmetrical design painted on the lid and bowl, although slightly varied on each piece, is coordinated to show a pair of birds with chrysanthemums on one side and a pair of birds with peonies on the other.

14 Wine Container, ca. 1596
Japanese; Momoyama period,
Kodaiji style
Lacquered wood; H. 9⅞ in.
(25 cm.), Diam. 7 in. (17.8 cm.)
Purchase, Gift of Mrs. Russell Sage,
by exchange, 1980 (1980.6)

15 Bowl with Lid, late 17th c.
Japanese; early Edo period
Arita ware, Kakiemon type
Porcelain painted in underglaze blue
and overglaze enamels; H. 13¾ in.
(35 cm.), Diam. 12⅜ in. (31.4 cm.)
The Harry G. C. Packard Collection of
Asian Art, Gift of Harry G. C. Packard
and Purchase, Fletcher, Rogers, Harris
Brisbane Dick and Louis V. Bell Funds,
Joseph Pulitzer Bequest and The
Annenberg Fund, Inc. Gift, 1975
(1975.268.526)

16 *Wine Bottle*, 1670–80
Japanese; early Edo period
Arita ware, Kakiemon type
Porcelain painted in overglaze poly-
chrome enamels; H. 11¾ in. (29.9 cm.),
Diam. 6⅝ in. (16.8 cm.)
The Harry G. C. Packard Collection
of Asian Art, Gift of Harry G. C. Packard
and Purchase, Fletcher, Rogers, Harris
Brisbane Dick and Louis V. Bell Funds,
Joseph Pulitzer Bequest and The
Annenberg Fund, Inc. Gift, 1975
(1975.268.523)

WINE BOTTLE

The Japanese began to make porcelain in the first quarter of the seventeenth century, only one hundred years before the opening of the Meissen factory in Saxony. The center of Japanese porcelain production was the small town of Arita, on the island of Kyushu, the southernmost of the four Japanese islands. The earliest wares were simple and unpretentious underglaze blue and white, but enameled porcelains were exported to Holland as early as 1659.

Several families of potters in and around Arita in the third quarter of the seventeenth century were working in what we now call the Kakiemon style. The main characteristics are bird-and-flower designs loosely derived from contemporary Chinese K'ang-hsi wares and painted in very vivid and clear red, green, yellow, and blue enamels. This extraordinary sake bottle with a design of a kingfisher on a peony branch, perfectly harmonized with the swelling shape of the bottle, demonstrates the early experimental stages of Kakiemon. The large scale and color tones of the design exemplify a painterly freedom of expression that was suppressed in later wares.

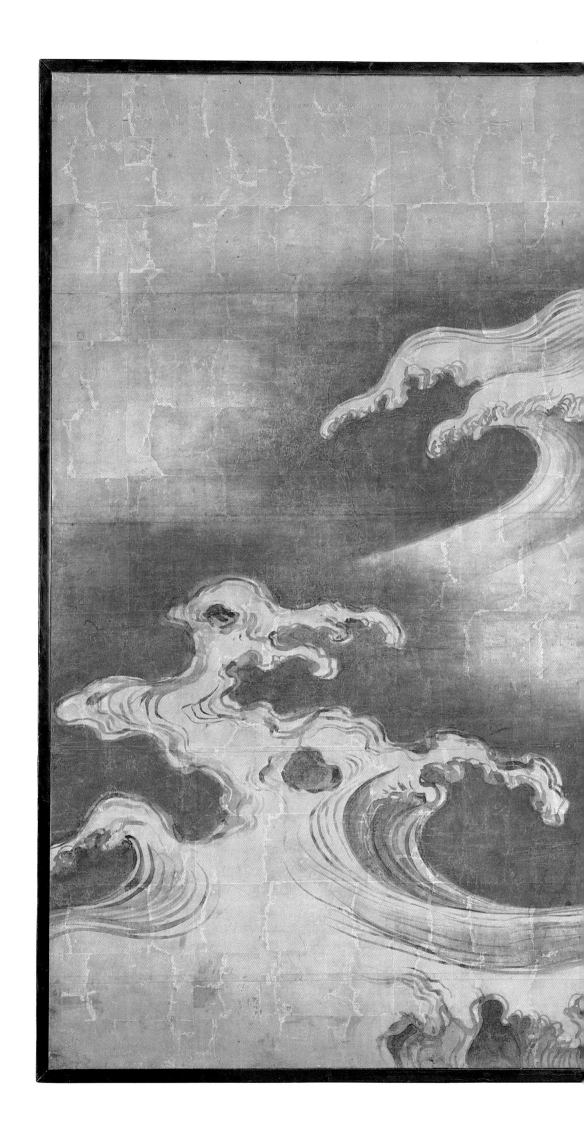

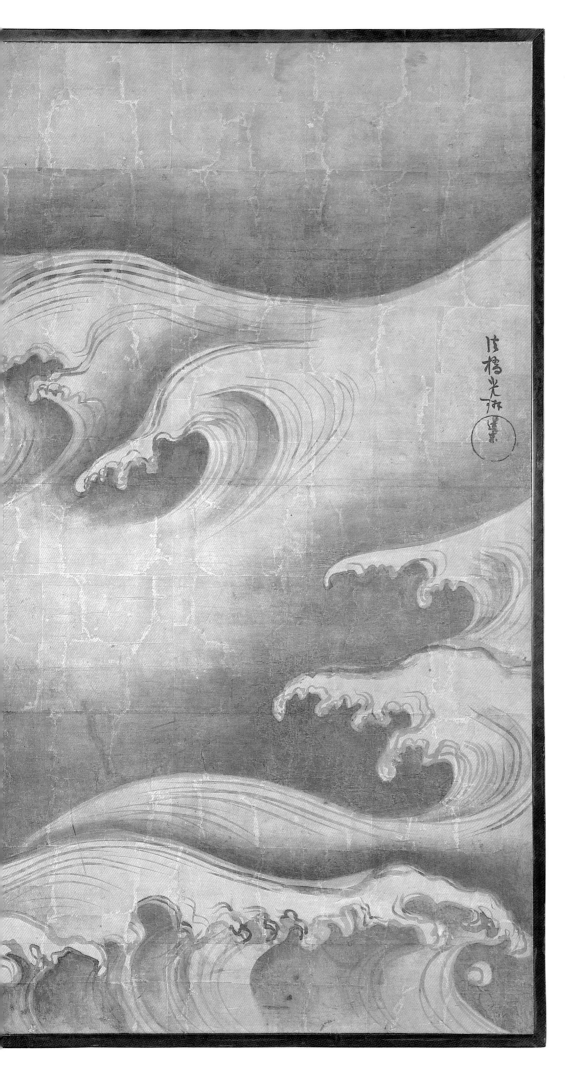

17 Rough Waves
Ogata Kōrin, 1658–1716
Japanese; Edo period
Two-fold screen; ink, color, and
gold leaf on paper;
57⅜ x 65⅛ in. (146.6 x 165.4 cm.)
Fletcher Fund, 1926 (26.117)

Page 40: text

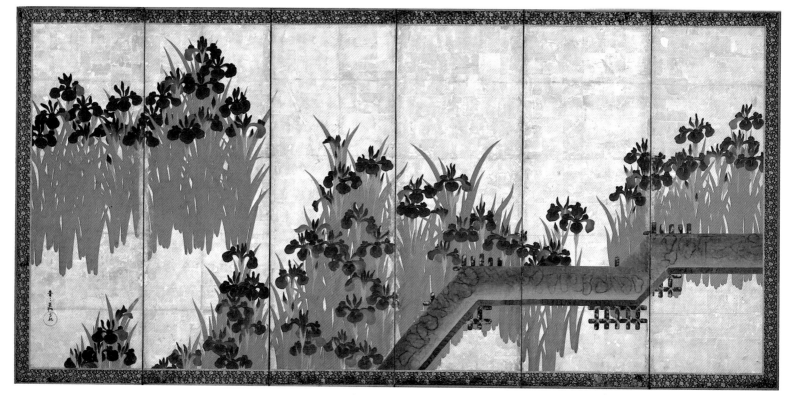

18 Yatsuhashi
Ogata Kōrin, 1658–1716
Japanese; Edo period
Pair of six-fold screens; ink, color,
and gold leaf on paper;
each 70½ x 146¼ in. (179 x 371.5 cm.)
Purchase, Louisa Eldridge McBurney
Gift, 1953 (53.7.1,2)

OGATA KŌRIN *(Pages 38–39)*
Rough Waves

Ogata Kōrin was born into a wealthy merchant-class family
in Kyoto. After squandering his inheritance, he turned to
painting for his livelihood. This two-fold screen illustrated
with mighty waves breaking in rough seas has long been
acclaimed as one of his greatest masterpieces. Using only a
few shapes, Kōrin has created a striking composition of ex-
quisite balance and control. A large wave with clawlike crests
silhouetted against a blue haze looms ominously in the cen-
ter distance. A smaller wave shaped like a Chinese garden
rock in the lower foreground seems to rise up in bold con-
frontation. The artist probably held two brushes at once to
make the sweeping parallel lines that give strength to the
water. Uneven outlines and loose wavering strokes suggest
the jumpy irregularity of waves in a storm.

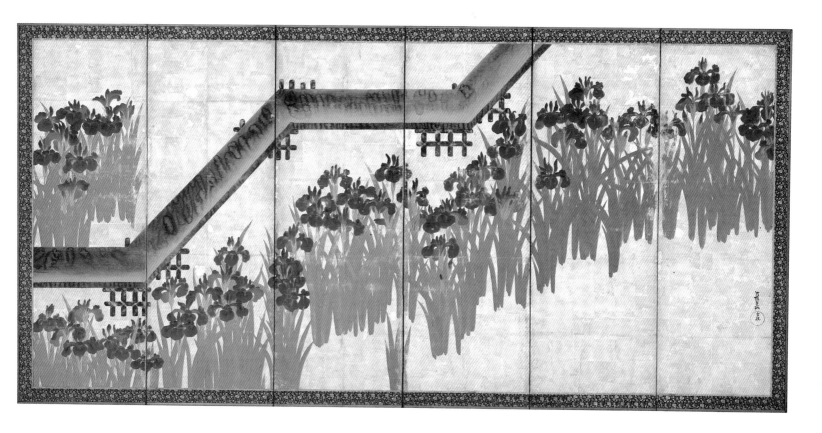

OGATA KŌRIN
Yatsuhashi

Ogata Kōrin (see Plate 17) was fascinated by irises, which he painted often in many variations and mediums. Here they are combined with a bridge, which is the clue to the painting's subject, one immediately familiar to a Japanese viewer. It alludes to a passage from the tenth-century *Tales of Ise*, a collection of poetic episodes about the courtier Narihira. Banished from Kyoto to the eastern provinces after an indiscretion with a high-ranking lady of the court, Narihira stopped en route at Yatsuhashi (Eight-Plank Bridge). There the sight of the blooming irises brought him nostalgic regret for friends left behind in the capital. Kōrin may have

seen in this story a parallel to his own condition. In search of clients, he was forced to leave Kyoto in 1704 and travel east to the Edo capital. There, restless and unhappy, he longed for the refined life of Kyoto.

The composition, which continues across two fanfold screens, is unified by the bridge dropping in a sweeping diagonal from the upper right to the lower left. When the panels are opened accordion style, the clever interplay between the in-and-out rhythm of the folds and the alternating diagonal and horizontal planks makes the bridge seem three dimensional.

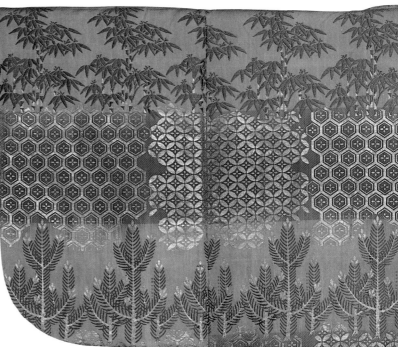

19 Woman's Robe, late 17th c.
Japanese; Edo period
Satin, tie-dyed, stitch-resisted, embroidered
with silks, couched with silk yarns
wrapped in gold; L. 53½ in. (135.9 cm.),
W. at sleeves 53 in. (134.6 cm.) Purchase,
Mary Livingston Griggs and Mary Griggs
Burke Foundation Gift, 1980 (1980.222)

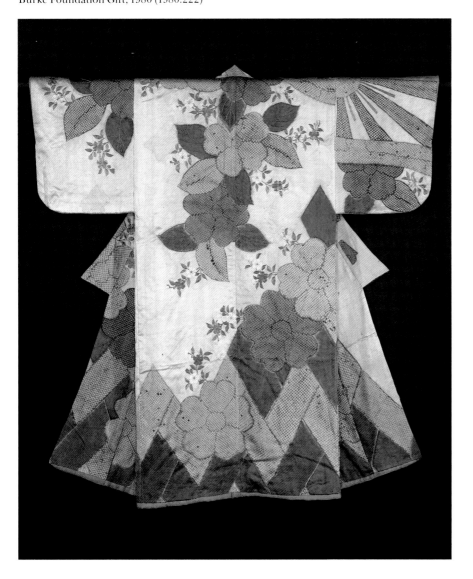

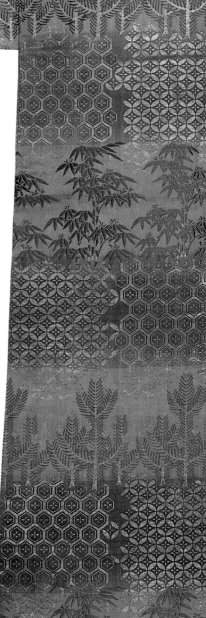

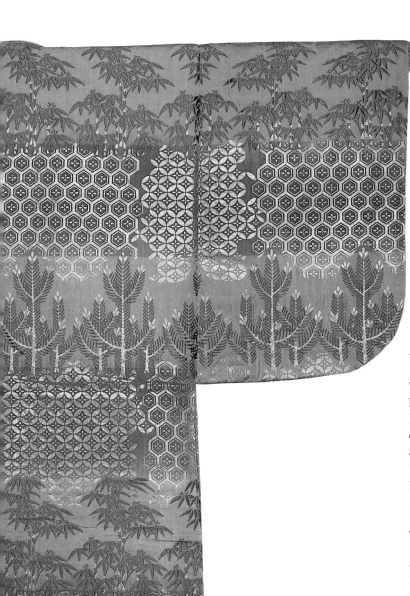

20 Nō Costume, early 18th c.
Japanese; Edo period
Silk and gold brocade; L. 59⅜ in.
(150.9 cm.)
Purchase, Gift of Mrs. Russell Sage,
by exchange, 1979 (1979.408)

WOMAN'S ROBE

The *kosode*, a garment with short hanging sleeves worn both by men and women, and widely adopted for daily use in the Muromachi period (1392–1568), is the precursor of the modern kimono. By the Edo period (1615–1868), it had become a vehicle for extravagant textile designs, its flat, ample shape providing an ideal surface for display. Many illustrious Edo painters of the period designed or influenced *kosode*.

This robe reflects the taste of the Genroku era (1680–1700), when the wealthy merchant class was beginning to dominate society, and artists such as Ogata Kōrin (see Plates 17, 18) were active. The bold asymmetrical design and soft, sumptuous colors are typical, as is the use of a variety of techniques to create a single garment. A branch with enormous cherry blossoms in tie-dye and stitch-resist hangs in the center of the robe's back. Below this branch, cherry blossoms float in front of zigzags suggesting the cypress slats of a garden fence. A section of a waterwheel appears on one sleeve, cherry blossoms on the other. The combination of cherry blossoms with the waterwheel and the garden fence undoubtedly is a poetic reference.

NŌ COSTUME

This dazzling, patterned brocade garment, called a *karaori*, was used for the female roles in Nō, a slow-moving, ritualistic form of drama with Buddhist overtones, popular during the rule of the Tokugawa Shoguns (1615–1868). *Karaori* means "Chinese weaving," but it was a native Japanese product whose stiff weave permitted the design of costumes with sharp contours that suited the stylized effects of Nō.

The silk ground of the garment is woven in a pattern of alternate bands of pale orange and cream by binding off the warp threads to reserve them for the dye. Loose binding allowed some of the dye to seep into adjacent areas, creating a softly shaded effect in the woven cloth. A felicitous design of pine and bamboo is woven in glossed green silk on the cream-colored bands of unglossed silk, and a hexagonal lattice pattern is woven against the pale orange ground. This juxtaposition of pictorial and geometric motifs is a feature of many Japanese decorative arts (see Plate 14).

HISHIKAWA MORONOBU
Lovers in a Garden

The consolidator of the styles of early genre painting and book illustration, Hishikawa Moronobu is considered the founder of the Ukiyo-e school of woodblock prints. Designers of ukiyo-e, literally, "pictures of the floating world," drew inspiration chiefly from the activities in the pleasure district. A substantial number of Moronobu's works, whether in the form of book illustration, paintings, or as here, single-sheet woodblock prints, treat *shunga*, erotic themes.

This striking black-and-white print is thought to be the first page of an album of twelve erotic prints; as was customary, the first in such a series is relatively restrained. A young couple embrace ecstatically in a garden corner. In the left foreground autumn plants in full bloom are drawn so large that they almost envelop the lovers. In contrast to the fine lines of the plants, however, the lovers' hair and garments are drawn in large masses, thus focusing the viewer's attention on the couple. The flowing lines of the lovers' garments are repeated in the rock and water, uniting the figures both physically and spiritually with the natural setting. Dating from the 1680s, when Moronobu's artistic powers were at their peak, this print typifies his solid, dynamic figural style and vigorous sense of line.

KITAGAWA UTAMARO
Courtesan Holding a Fan

Women of all walks of life—at home, at work, or at play with their children—form the chief theme of Kitagawa Utamaro, one of the most influential print designers of the late eighteenth and early nineteenth centuries. A careful observer of human psychology and physiognomy, Utamaro originated the *okubi-e*, "bust portrait," in which the head and torso of a beautiful woman is set against a luxurious mica background.

This print is believed to be one of a series depicting famous beauties of the "Southern Region," an allusion to the pleasure district located in Shinagawa, in the southern part of the Edo capital, present-day Tokyo. However, it is the only known print from this series. Typical of Utamaro's *okubi-e*, the courtesan is shown in three-quarter view, her head tilted lightly downward. The printing of her elaborate coiffure is so fine that each strand of hair can be distinguished. She holds a fan with a refreshing scene of Edo Bay, which was visible from the Shinagawa district. The poem inscribed on it reads roughly:

> Even as guests do,
> So do the summer breezes.
> Ever returning
> Come to Sodegaura,
> Place of Heavenly Coolness.

This device of a picture within a picture is often used by Utamaro to offset the elegant simplicity of the feminine visage. This print was once in the collection of Frank Lloyd Wright.

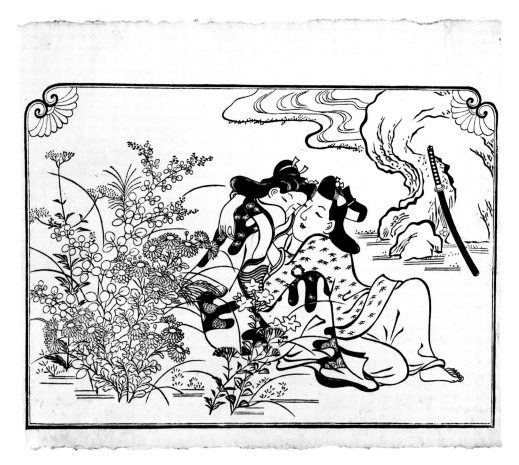

21 *Lovers in a Garden*, 1680s
Hishikawa Moronobu, 1625–94
Japanese; Edo period
Ink printed on paper;
9¼ x 13¼ in. (23.5 x 33.7 cm.)
Harris Brisbane Dick Fund
and Rogers Fund, 1949 (3069)

22 *Courtesan Holding a Fan*, ca. 1793
Kitagawa Utamaro, 1753(?)–1806
Japanese; Edo period
Woodcut; 14½ x 9⁵⁄₁₆ in.
(36.8 x 23.8 cm.)
Rogers Fund, 1922 (1367)

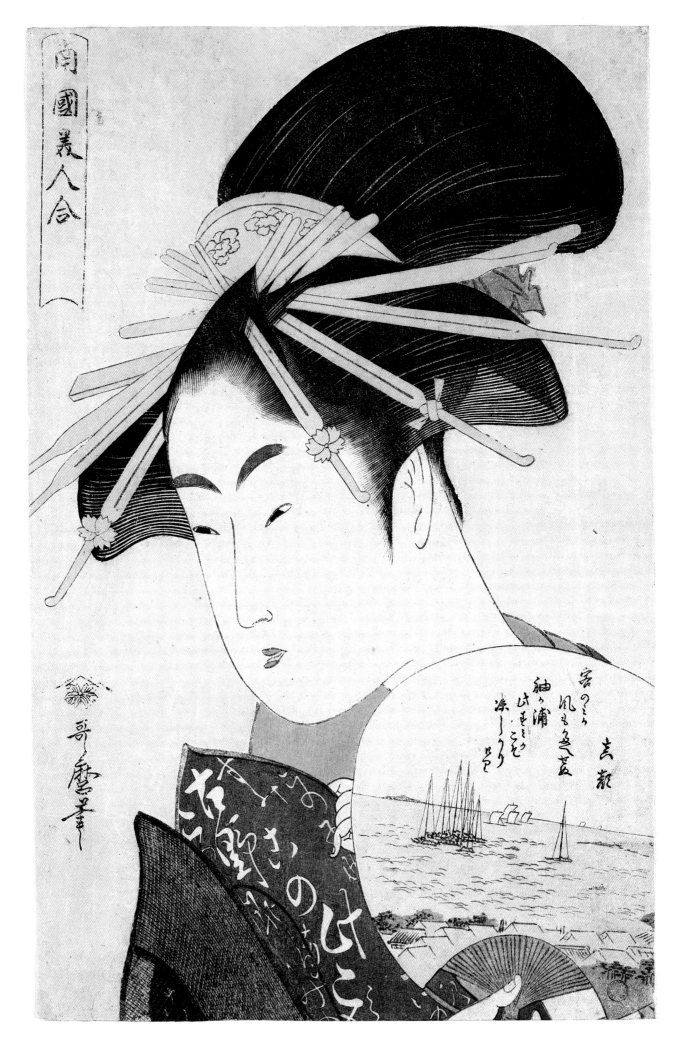

WRITING BOX WITH UTENSILS AND MATCHING STATIONERY BOX

This set of rectangular boxes with gently curved corners and slightly convex lids is designed to hold writing utensils —brushes, inkstone, inkstick, and inkwell—and papers or documents. The exteriors of both boxes are decorated with scenes skillfully executed in a variety of lacquer techniques. The designs are built up in several degrees of relief, higher for elements of the composition in the foreground, and somewhat lower for those in the distance. They cover not only the lids, but sweep around the sides; complementary motifs decorate the interiors. Thick strips of metal form the rocks, hills, trees, and clouds; these, in turn, are embellished with gold leaf cut into small squares and arranged to form

mosaiclike patterns, a technique called *okibirame*. The sharp relief and realism of the seashells dotting the shore highlight the contrast with the repeated, soothing pattern of undulating waves.

Lacquer ware frequently featured subtle allusions to classical poetry or literary themes with which both the artist and client were familiar. The boat, which has a giant drum of a type used in the courtly Bugaku dance perched on its prow, hints that the scene might derive from an episode in the *Tale of Genji*, a popular source of decorative designs for lacquer ware. However, the design is too general to be certain of this identification.

23 Writing Box with Utensils and Matching Stationery Box, 1830–40
Japanese; Edo period
Gold lacquer with raised sprinkled design; stationery box: H. 6¼ in. (16 cm.), W. 13¾ in. (35 cm.),
L. 17½ in. (44.5 cm.); writing box: H. 2 in. (5 cm.),
W. 9¼ in. (23.5 cm.), L. 10½ in. (26.7 cm.)
Anonymous Gift, 1981 (1981.243.1a-f) (1981.243.2a-m)

47

YOGI COVERLET

Yogi coverlets, bedding in kimono form padded with silk floss or cotton wool, are worn front to back on special occasions in place of the customary upper futon. Often they form part of a bridal trousseau. This one bears a striking design of auspicious motifs associated with the New Year. The lobster, sometimes called "the old man of the sea" because of its hunched back, is a symbol of longevity. The rice straw rope and fern leaves are frequently suspended over the doorway of a home to welcome the New Year. Above these tightly interwoven motifs is a family crest composed of three cloves.

With the exception of the straw rope, which was left white, the robe was dyed in bright colors using a paste-resist technique called *tsutsugaki* after the cylinder from which the paste is squeezed. Because this *tsutsugaki* technique is relatively simple and freehand, it is especially well suited to the large-scale designs required for bedding and other household furnishings.

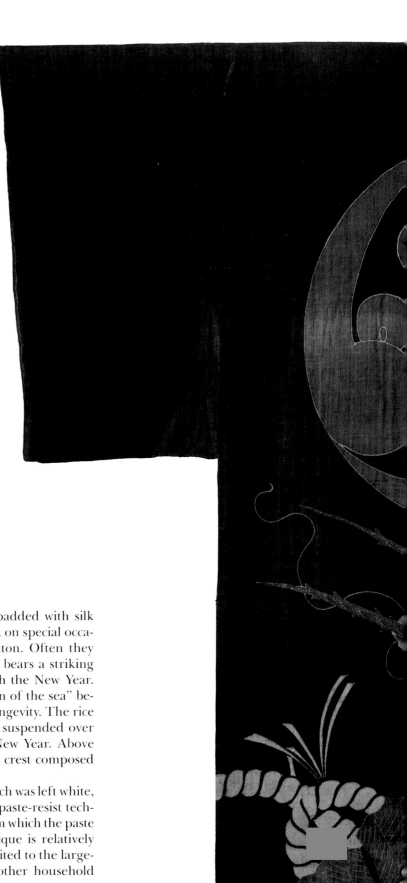

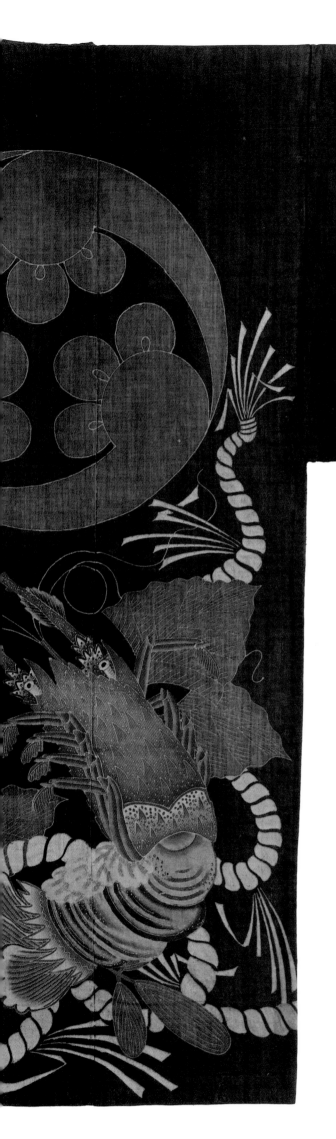

24 Yogi Coverlet
Japanese; 19th c.
Cotton tabby with cone-painted
resist, hand-painted pigments;
H. 63½ in. (161.3 cm.),
greatest W. 58½ in. (148.5 cm.)
Seymour Fund, 1966 (66.239.3)

25b Semicircular Pendant
Chinese; Late Chou dynasty,
Warring States period
Jade; L. 4⅞ in. (12.3 cm.) Gift of
Ernest Erickson Foundation,
Inc., 1985 (1985.214.98)

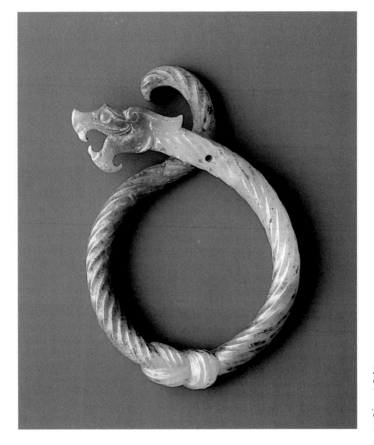

25c Tablet
Chinese; Western Chou dynasty
Jade; L. 10¼ in. (26.2 cm.)
Gift of Ernest Erickson Foundation,
Inc., 1985 (1985.214.96)

25a Pendant
Chinese; Late Chou dynasty,
Warring States period
Jade; largest diam. 3 in. (7.5 cm.)
Gift of Ernest Erickson Foundation,
Inc., 1985 (1985.214.99)

EARLY JADES

There are no known sources of jade in China, and yet it has been a highly valued medium in Chinese culture since neolithic times. It was probably imported from Central Asia, and since it is a sublimely impractical mineral—harder than steel but too brittle to serve a utilitarian purpose—it is presumed to have played a purely ceremonial role. It is a difficult stone to carve, both because of its fragility and its hardness. It had to be laboriously fashioned by means of slow abrasion with sand or quartz grit, so its continuous production is indicative of the importance placed upon it.

Throughout the Shang and Chou dynasties, jade gradually replaced bone fragments in the creation of ritualistic objects, in particular tokens of rank and symbolic aids for the celestial journey to be undertaken by the dead. Jade ornaments were worn first as talismanic pendants, and then, in the latter years of the Chou dynasty, as jewelry. The stone was prized for its soothing coolness to touch, the rich variety of colors—the purity of white being the most prized—and also for the sonorous tone it emits when struck. As a symbol of high rank and moral virtue it adorned the pommels and scabbards of swords. By the Late Chou period, new tools made finely detailed carvings possible.

The objects illustrated here were carved during the Chou dynasty, which was founded in about 1050 B.C. and which ended in 221 B.C. The increasing sophistication and changing techniques used for working with jade are witnessed by the increased complexity and subtlety of design in the later pieces.

25d Scabbard Slide
Chinese; Late Chou, Warring States
period, to early Western Han dynasty,
Jade; 4⅝ in. (11.7 cm.)
Gift of Ernest Erickson Foundation,
Inc., 1985 (1985.214.101)

OVERLEAF:

TUAN FANG ALTAR SET *(Pages 52–53)*

This wine service consists of an altar table and thirteen vessels for storing, heating, drinking, and mixing wine. Sets of this type were made to commemorate significant events and were used in ritual worship. The birds, antlered bulls, zoomorphic *t'ao-t'ieh* masks, and tiny dragons that abound on the surface of these vessels are part of a complex iconography of animal and abstract elements designed to influence the natural and spiritual forces called up by the occasion.

This set, remarkable for its completeness, was reportedly found in an Early Western Chou tomb at Tou-chi T'ai in Shensi. The Museum purchased the service from the heirs of Tuan Fang, the viceroy of Shensi, who acquired it when it came to light in 1901. Outlines on the altar table indicate that at least the two large buckets *(yu)*, the large beaker *(tsun)*, and the smaller beaker *(chih)* were part of the original burial. Stylistic differences suggest the pieces were cast at different times in the late Shang and Early Western Chou periods.

Behind these vessels lies an advanced knowledge of bronze metallurgy—mining, the refining of ores, and the making of alloys—and fine casting and finishing techniques. Unlike most cast artifacts from Bronze Age cultures of the West, which were made by the lost-wax process, Chinese bronzes were made using carved-clay piece molds.

26 Tuan Fang Altar Set
Chinese; Shang and Early Chou dynasties
Bronze (14 objects including table); table:
7⅓ x 35⅜ x 18¼ in. (18.7 x 89.9 x 46.4 cm.)
Munsey Fund, 1924 (24.72.1–14)

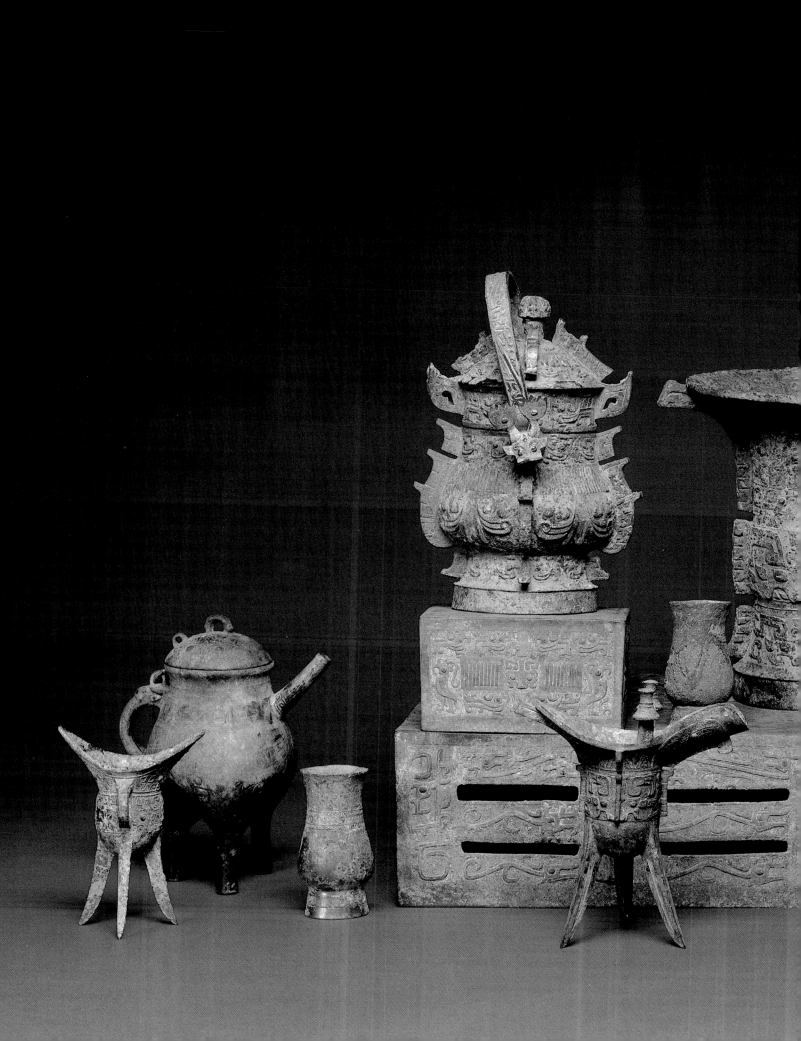

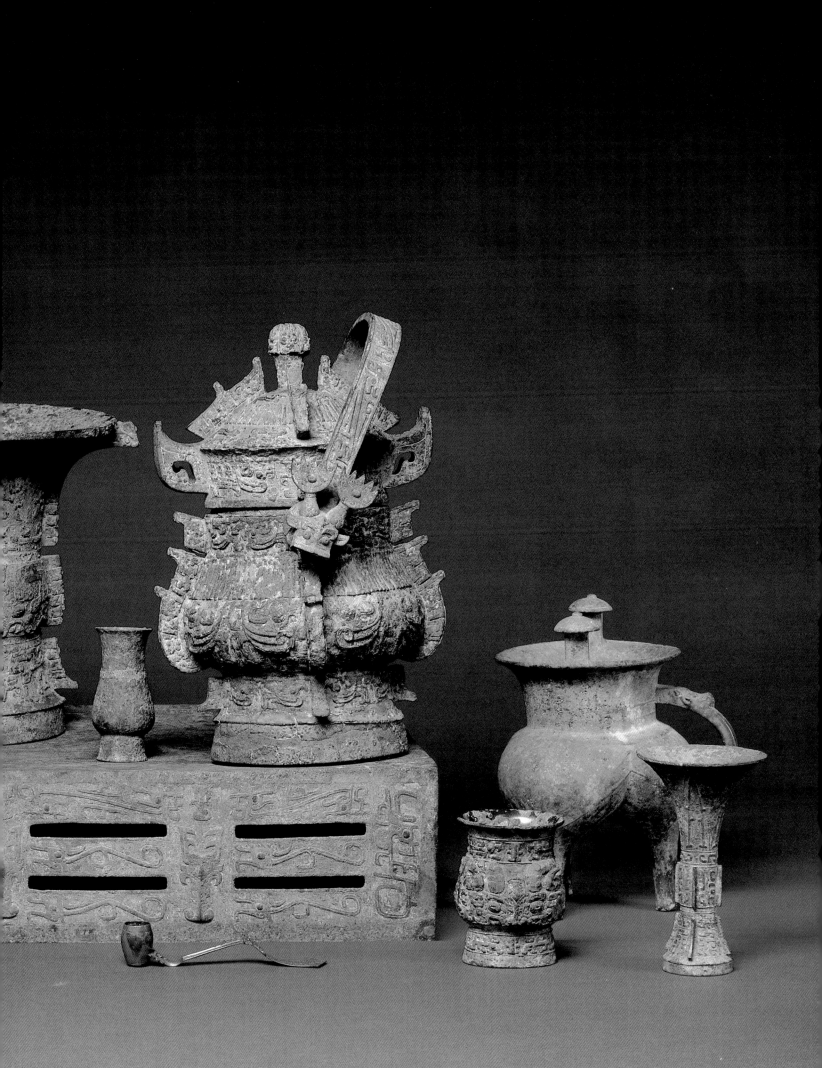

RITUAL VESSELS

The *tsun*, or ritual wine vessel (Plate 27), seen here is a fine example of ancient Chinese artisanship, dating from the latter part of the Shang dynasty. In earlier years, Shang bronzeworkers had imitated pottery shapes and decoration; later the compliment was returned when pottery began to imitate metalwork. This *tsun* reflects the influence of bronze ware: The shape, the small relief flanges and bosses on the incised decorative bands are an *hommage* to bronze works made on a grander scale.

The green-glazed vessel (Plate 28) is an important and beautiful example of the high-fired green-glazed wares produced in northern China. The glaze is typical of the family of green-glazed stoneware found in the northern Chinese tombs in the later sixth and early seventh centuries. Characteristic of this glaze are its glassiness, its crazing, and its tendency to run. The quality of the modeling is excellent. This fierce, crouching animal bears some resemblance to a lion. Its incorporation into the design of a domestic vessel is characteristic of the fondness for animals in Chinese art, as is the affectionate realism with which the craftsman has modeled the round body, the frowning brows, and the hairs on the neck, belly, and tail. Its actual intended purpose is the subject of speculation.

28 *Green-Glazed Vessel,*
second half of 6th c. to early 7th c. A.D.
Chinese; late Northern dynasties to Sui dynasty
Porcelaneous stoneware with celadon glaze;
L. 11⅞ in. (30.2 cm.)
Harris Brisbane Dick Fund, 1960 (60.75.2)

27 *Tsun* (Ritual Wine Vessel),
14th–11th c. B.C.
Chinese; late Shang dynasty
Earthenware with incised and relief
decoration; H. 10 in. (25.4 cm.)
Harris Brisbane Dick Fund, 1950
(50.61.5)

STANDING BUDDHA

The large gilt-bronze Buddha with beaming countenance and open arms radiates the message of hope that swept into China with the Buddhist faith after the collapse of the Han dynasty. An inscription on the lotus pedestal dating the piece to A.D. 447 and identifying the image as Maitreya, the Future Buddha, is thought by scholars to be a later addition. The piece is more probably an earlier fifth-century image of Sakyamuni, the historical Buddha, made in North China under the Wei dynasty.

Buddhism had its beginnings in India in the fourth century B.C. when Prince Siddhartha of the Sakya clan came to believe that only a Middle Path between asceticism and indulgence could bring clarity and inner peace.

This gilt-bronze figure is dressed as a monk, with an outer garment worn over a robe and an underskirt. A Chinese preference for symmetry is evident in the outer cloth disposed over both shoulders, and in the way the folds have been arranged as symmetrically as the gesture permits. The figure still shows the influence of Central Asian prototypes, however, in the swelling thighs and shoulders and the expansive gesture that later gave way to linear and less plastic vitality with the increasing Sinicization of Buddhist forms. The gesture, or *mudra*, is canonically prescribed, and although unusually open in this image, it is probably a version of the commonly paired "fear-not" or *abhaya mudra* with the right hand, and the "wish-granting" or *varada mudra* with the left hand. Identifying marks of a Buddha are clearly shown: the cranial swelling, elongated ears, and webbed fingers.

29 *Standing Buddha*
Chinese; Northern Wei dynasty
Gilt bronze; 55¼ x 19½ in.
(140.3 x 49.5 cm.)
John Stewart Kennedy Fund,
1926 (26.123)

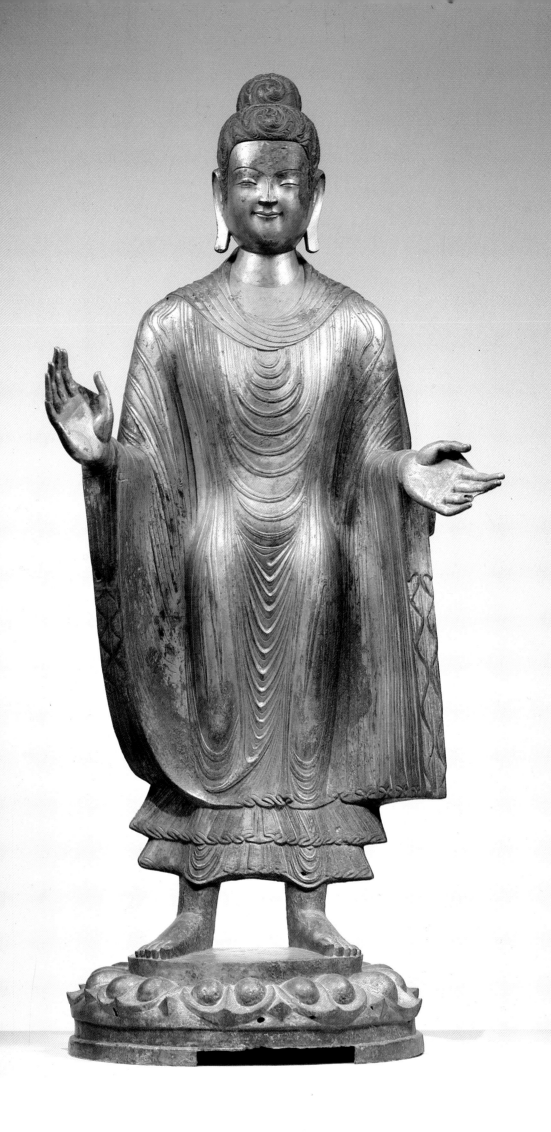

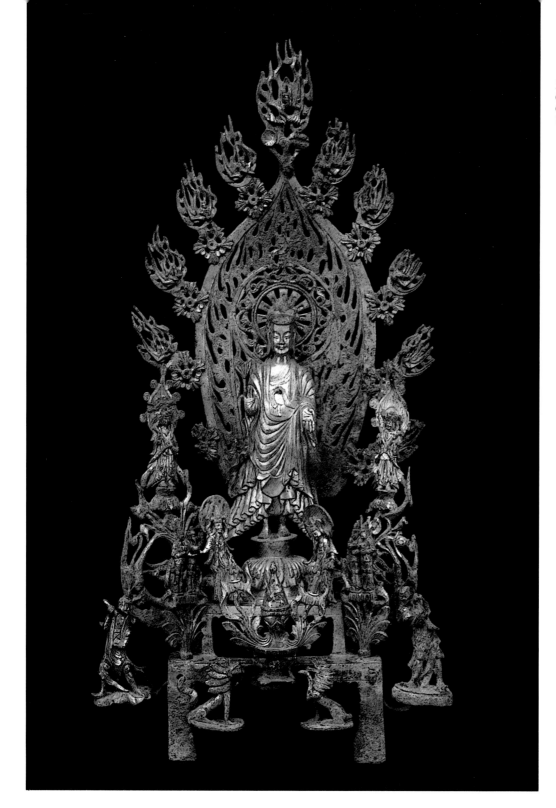

30 *Altar Shrine with Maitreya*, A.D. 524
Chinese; Northern Wei dynasty
Gilt bronze; H. 30¼ in. (76.8 cm.)
Rogers Fund, 1938 (38.158.1a-n)

31 *Seated Buddha*, 7th c. A.D.
Chinese; T'ang dynasty
Dry lacquer; H. 38 in. (96.5 cm.)
Rogers Fund, 1919 (19.186)

ALTAR SHRINE WITH MAITREYA

The historical Buddha, Sakyamuni, did not represent himself as a god or an object of worship, but rather as a teacher of a method to obtain the release from desire (nirvana) that might be practiced by those who wished to end the succession of rebirths. By the first century B.C., however, Sakyamuni had become one Buddha among many, all of whom could benefit the world by influencing the deeds or karma that accumulated to produce the cycle of rebirths. Maitreya, for example, was a Buddha who would come in a future world, just as Sakyamuni had come in a previous one. With intercession possible by Buddhas and bodhisattvas (holy beings who delayed their own salvation in order to guide others),

the pious directed pleas to particular deities, and objects such as this altar shrine were commissioned.

The inscription, dated 524, on the back of the stand for this shrine, reveals that the image was made at the request of a father to commemorate his dead son. The central figure of Maitreya stands in front of a leaf-shaped *mandorla* (the circle of light that surrounds him). Celestial maidens, or *apsarases*, with upswept scarves, alight on rosettes that surround the *mandorla*. The Buddha is flanked by bodhisattvas, monks, donors, and guardian figures. The delicate, linear energy of this beneficent group was a particularly Chinese contribution to the Buddhist arts.

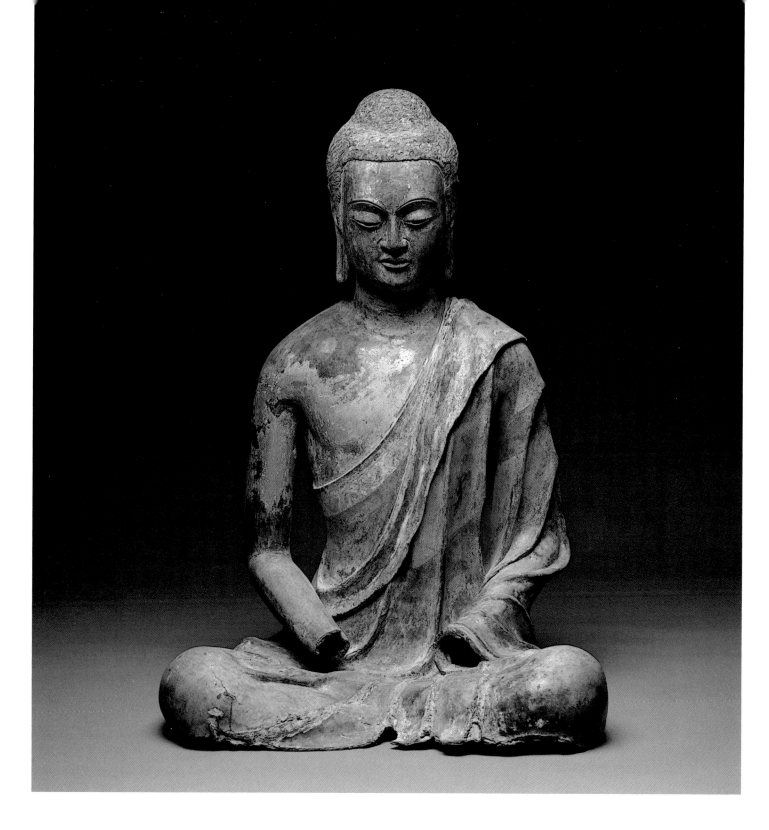

Seated Buddha

Chinese Buddhism flourished in the prosperous climate of early T'ang. Supported by lavish donations from the devout and legitimized by state orthodoxy, it attracted the most gifted artists and architects of the age. As cosmopolitan in its spiritual culture as in its material one, T'ang China blended Indian, Persian, Greco-Roman, Central Asian, and Chinese elements into the Sinified doctrines and arts of Buddhism.

This beautiful early lacquer figure is an example of the seamless fusion of diverse sources that Chinese artists had achieved by the early seventh century. The iconography is distinctly Indian; the bared shoulder called for by the cli-

mate of the Indian subcontinent, for example, has been preserved in the meditating figure. Chinese constraints on explicit physicality have transformed a Guptan idealistic figural style into more ethereal columnar forms. Sharply cut facial features are carried over from earlier Chinese styles.

Few early Chinese dry-lacquer figures have been preserved. For this technique, numerous layers of lacquer-soaked cloth are molded over a wooden armature until the statue reaches the desired thickness and form; the figure is then painted in gesso, polychrome, and gilt. Remnants of orange and gold still brighten the robes of this figure in the Metropolitan's collection.

HAN KAN
Night-Shining White

This handscroll portraying a magnificent steed is one of the most revered horse paintings in Chinese art. The strength and restless energy of the tethered charger are vividly conveyed by his bristling mane, wild eye, flaring nostrils, powerful flanks, and nervously prancing hooves.

An inscription on the right edge of the paper by Li Yu, emperor of the Southern T'ang kingdom (r. 940–56) says the painting portrays Night-Shining White, a favorite mount of the T'ang emperor Ming-huang (r. 712–56) (see Plate 43). Li Yu identifies the artist as Han Kan, the most celebrated horse painter at Ming-huang's court. Ming-huang ruled over a brilliantly cosmopolitan China whose sovereignty and trade routes stretched far to the west where the great Arabian and Central Asian horses could be had. The Chinese had long appreciated these western horses, so much larger and faster than their native ponies. Early histories spoke of "celestial steeds" who "sweated blood," and aes-

thetic terminology for judging the articulation, flesh, and muscle of horses is the same as that used in the arts of the brush.

Ming-huang's taste ran to flesh in his horses, and Han Kan's portrayal is all the more elegant for its sole reliance on brushline and shading in ink to convey the full-bodied strength of the steed. This method of achieving the effects of chiaroscuro is known as "white painting" or *pai-hua*.

The practice followed by Chinese connoisseurs and collectors of adding colophons, inscriptions, and seals to a painting results in a record that accompanies the work. This painting was owned by the ninth-century art historian Chang Yen-yüan (act. ca. 840), by the Southern T'ang emperor, by the Sung man of letters Mi Fu (1052–1107), and later connoisseurs, including the Ch'ien-lung emperor (r. 1736–95). A viewer can take pleasure not only in the painting itself, but in the company of those who have admired it in the past.

韓幹照夜白

不知誰向車前後應有人洗寬向窺乍悟黃沙紫

室叙正書字博歟獻肥時

以人秋顆仇吳畫多句也項得韓幹呈圍覺學力爭生一頭地幅旁

委賀古潤可愛因書於右嘉平我生明又識

古籍照眼白馬裹泰山
韓練絡莩誰老沙塲堂
賔寒友葇葇芡芡又戟

紹興戊午鄉林向平謹

32 Night-Shining White
Han Kan, act. A.D. 742–56
Chinese; T'ang dynasty
Handscroll; ink on paper;
12⅛ x 13⅜ in. (30.8 x 34 cm.)
Purchase, The Dillon Fund Gift,
1977 (1977.78)

T'ANG DYNASTY FLASK

The dramatic beauty of this T'ang dynasty flask results from the splashes of contrasting color created by two layers of glaze, the lighter-colored one dripping curdlike over the dark undercoat. The variations in color produced by this dual glaze when the piece was fired range from shades of cream through gray, blue, and lavender to the dark brown of the underglaze. At the base there is even a rim of unglazed pottery to complete the spectrum. Stoneware of this type was produced at several kilns in northern China, including one at Huang-tao in Honan province from which this piece probably originates.

The unusual shape of the flask was probably based on a leather prototype. In the manner of the original, the design of the pottery flask accommodates a cord that passes up the sides of the piece in a channel formed by two raised flanges, and through the loops near the neck. The back of the flask is flat, in imitation of the leather that would have molded to the body when carried, and the lip of the flask is dimpled to resemble the contours of a softer material.

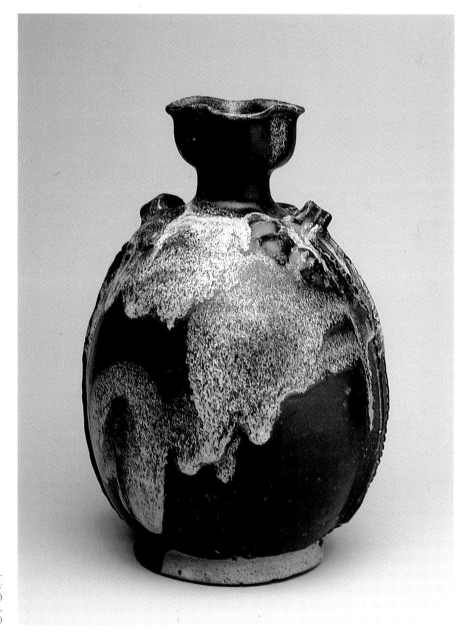

33 T'ang Dynasty Flask, ca. 9th c. A.D.
Chinese; T'ang dynasty
Stoneware; H. 11½ in. (29.2 cm.)
Gift of Mr. and Mrs. John R. Menke,
1972 (1972.274)

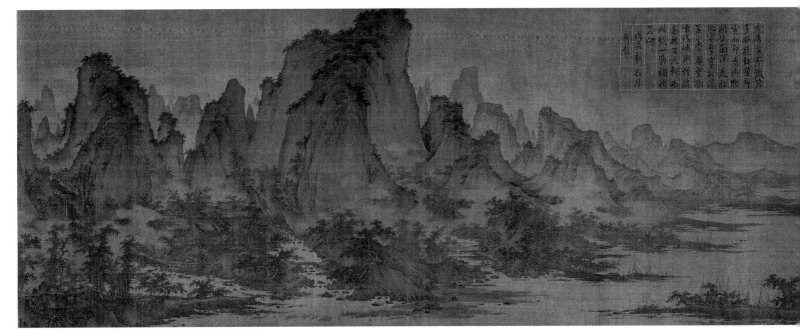

34 *Summer Mountains*, 11th c.
Attributed to Ch'ü Ting
Chinese; Northern Sung dynasty
Handscroll; ink and light color on silk;
17¾ x 45¼ in. (45.2 x 114.9 cm.) Gift
of The Dillon Fund, 1973 (1973.120.1)
Below and opposite: details

NORTHERN SUNG ARTIST
Summer Mountains

Landscape in the style of the early eleventh-century master Yen Wen-kuei was praised for its grasp of the "vastness and multiplicity" of the natural world. In this sublime handscroll in the Yen Wen-kuei manner, a lofty range cresting in a central peak presides over the activity along a river on a summer evening. The rhythm of rising and falling peaks is accented by deep ravines, where temples and waterfalls appear half concealed by mists. Luxuriant trees harbor villages and way stations where travelers and fishermen, concluding the day's affairs, take refreshment or put to port. The unfolding at every scale of pattern-principles, or *li*, inherent in things is manifest, from the wavelike undulations of the massive range to the shallow rivulets of a depleted summer stream, to precise details of masts and rigging. This depiction of detail without loss of grandeur and harmony in the whole was the unsurpassed achievement of Chinese landscape painting in the Northern Sung.

Varied texture strokes and the liberal use of scaled ink wash suggest the painting was done a generation or two later than Yen Wen-kuei's time. Seals on the painting confirm that it was in the collection of the Sung emperor Hui-tsung (r. 1101–1125). Three works entitled *Summer Scenery* by Yen's mid-eleventh century follower Ch'ü Ting are listed in Hui-tsung's painting catalogue, and the Metropolitan handscroll is possibly one of them. The inscription added to the surface of the silk is by the Ch'ien-lung emperor (r. 1736–95).

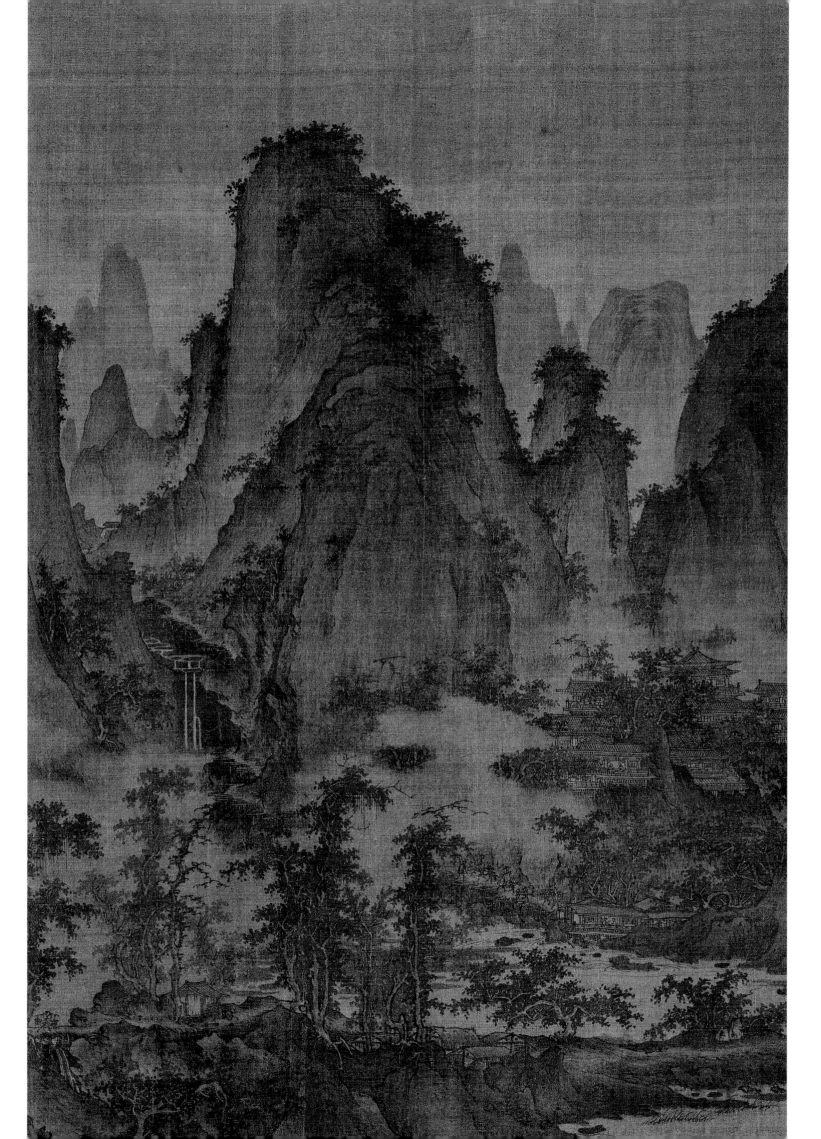

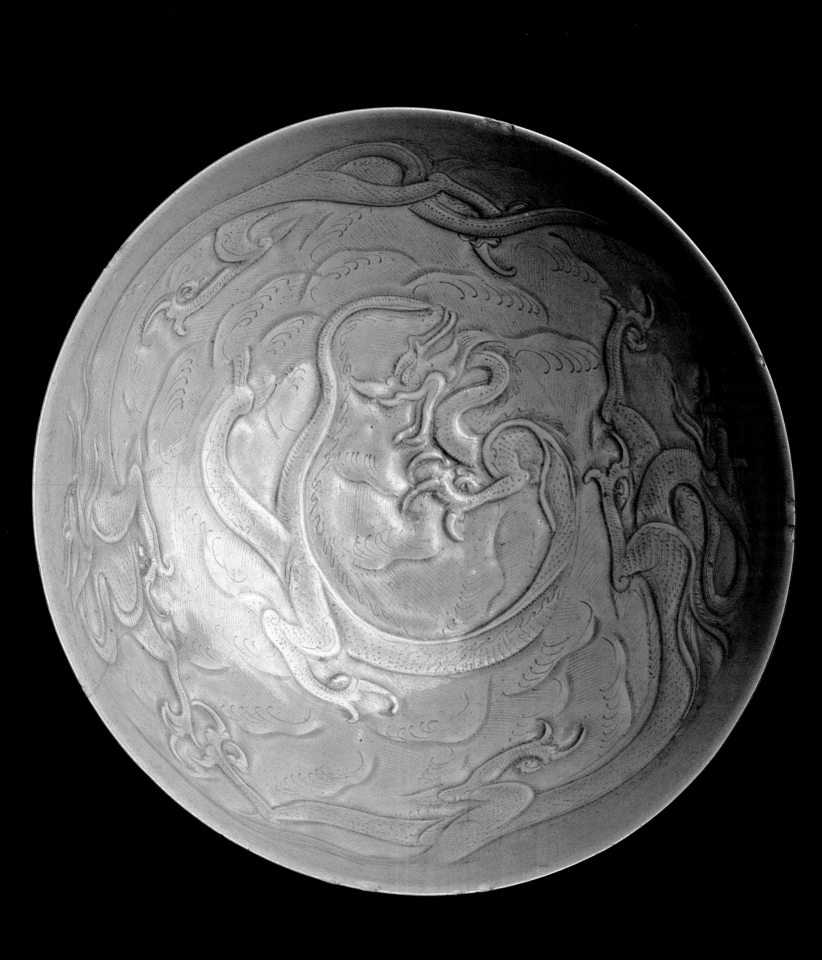

GREEN-GLAZED BOWL

The quality of potting and the production of fine ceramic ware seem to have been unaffected by the political turbulence that gripped China as the T'ang dynasty lost its preeminence at the beginning of the tenth century. Indeed, the output of the Yüeh kilns in the northern part of Chekiang province seems to have peaked during the upheavals of the Five Dynasties period, which occurred throughout most of the first sixty years of the century.

This tenth-century bowl, with carved and incised dragons under a lustrous green glaze, is one of the great treasures in the Museum's collection. The high-fired clay has vitrified so that it is resonant when struck, although it is not true porcelain in the Western sense, since it is neither white nor translucent. This type of refined stoneware is often referred to as "porcelaneous stoneware" in the West. Some Yüeh ware was known at the time as "*pi-se yao*" (which literally means "prohibited" or "private color ware"). According to literary sources, it was reserved for the exclusive use of the princes of Wu-Yüeh, and the high quality of the workmanship indicates that this piece was produced for royal use at the Yüeh kilns. The craftsman has carved three lively dragons into the wet clay of the bowl, and as a further indication of its provenance, one of the creatures carries his tail tucked beneath his hind leg, a design that was a trademark of the Yüeh kilns.

35 *Green-Glazed Bowl*, 10th c.
Chinese; Five Dynasties period
Porcelaneous stoneware;
Diam. 10⅝ in. (27 cm.)
Rogers Fund, 1918 (18.56.36)

OVERLEAF:

KUO HSI *(Pages 64–65)*
Trees Against a Flat Vista

During the late eleventh century, landscape painters began to turn away from minutely descriptive portrayals of nature to explore evocations of a specific mood, a past style, or temporal phenomena, such as changing seasons, hours of the day, or the varied effects of weather. This change in the pictorial conception of landscape, from a display of yin and yang in polar fluctuation to a unified visual field, coupled with a shift in technique from tactile to painterly descriptions, began a trend in landscape art that would make isolated moments of sensation a frequently painted subject during the subsequent Southern Sung period.

In this handscroll, bare branches and dense mist suggest an autumn evening; the inclusion of travelers enhances the feeling that the moment is transitory. Blurred ink washes and freely brushed outline strokes create an illusion of moisture-laden atmosphere that imparts an introspective mood to the scene. The value of companionship in a vast and desolate landscape is highlighted by the passing boatmen, who take the opportunity to exchange a few words, and by the bent traveler, who is supported by a servant as he crosses the narrow bridge, his resting place prepared by attendants who have hurried on ahead.

36 *Trees Against a Flat Vista* (detail)
Kuo Hsi, ca. 1020–ca. 1090
Chinese; Northern Sung dynasty
Handscroll; ink and pale color on silk;
Overall: 13¾ x 41¼ in. (34.9 x 104.8 cm.)
Gift of John M. Crawford, Jr., in honor
of Douglas Dillon, 1981 (1981.276)

Mi Fu
Sailing on the Wu River

Mi Fu was a master painter and calligrapher, as well as an art critic and connoisseur, who was equally known for his erudition and irascibility. Surviving examples of his large calligraphy are extremely rare.

The dramatic expressive potential of calligraphy is realized in this poem in five-character meter that Mi wrote while on a journey along the Wu River in south China. The first few lines in running script that speak of an easy passage and favorable currents are written in a light and relaxed hand. As Mi tells of encountering contrary winds and hiring quarreling workmen to tow the boat, strokes are violently executed. Ink tone, character structure, and script

37 Sailing on the Wu River (detail)
Mi Fu, 1052–1107
Chinese; Northern Sung dynasty
Handscroll; ink on paper;
Overall: 12⁵⁄₁₆ x 220¼ in.
(31.3 x 559.4 cm.)
Gift of John M. Crawford, Jr.,
in honor of Professor Wen Fong,
1984 (1984.174)

Opposite: detail

type change as his boat runs aground and his frustration rises. A single character, "pulleys," in dry smoky ink, fills an entire line as he describes the unsuccessful attempts to free the boat from the mud. With the payment of additional money, however, the boatmen rally. The calligraphy culminates in the enormous character "battle," a visual equivalent to the battle cry the men shout as they free the boat. The writing then takes up the rhythm of unimpeded progress.

Mi's study of ancient masters of calligraphy, particularly Yen Chen-ch'ing of the T'ang and the two Wangs of the Chin dynasty was profound, enabling him to enlist the achievements of the past in his highly personal style.

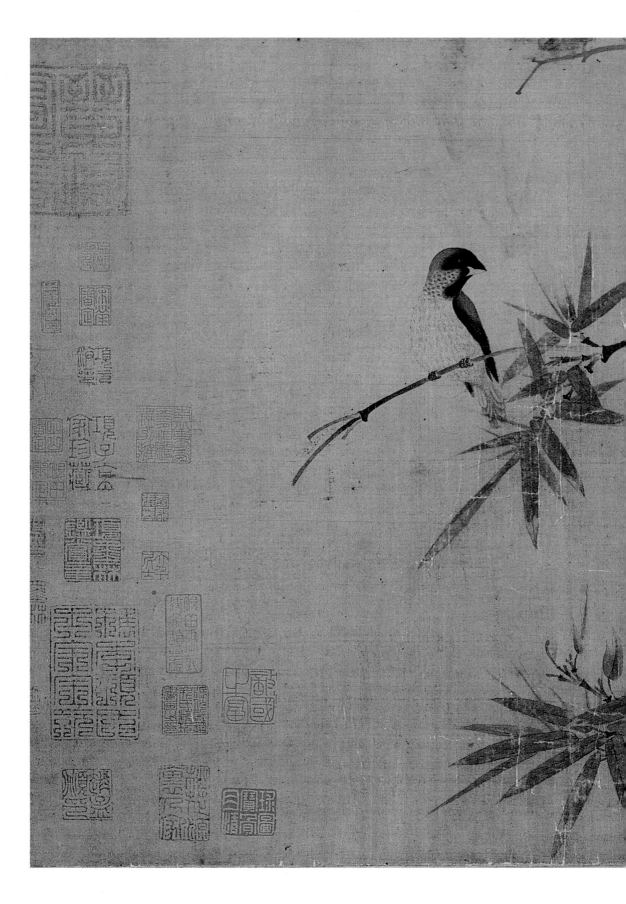

EMPEROR HUI-TSUNG
Finches and Bamboo

"What good fortune for these insignificant birds to have been painted by this sage," mused the noted connoisseur Chao Meng-fu (1254–1322) in a colophon attached to this exquisite painting. The sage referred to is the Northern Sung emperor Hui-tsung (r. 1101–1125), whose avid patronage of the arts supported a painting academy at court and an imperial collection that set new standards of excellence and extravagance. The emperor was an accomplished painter, particularly of birds and flowers, and set his cipher, as well, to works by court painters in his style. *Finches and Bamboo* bears a cipher used by Hui-tsung over a seal that reads "imperial writing." The work reflects the elegant style for which

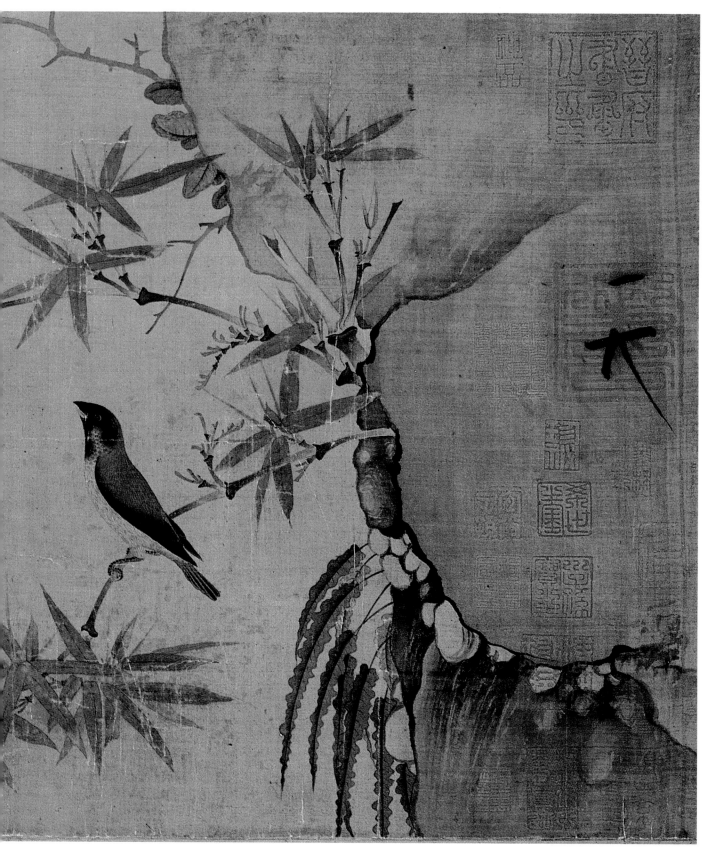

38 Finches and Bamboo
Emperor Hui-tsung, 1082–1135
Chinese; Northern Sung dynasty
Handscroll; ink and color on silk;
11 x 18 in. (27.9 x 45.7 cm.)
John M. Crawford, Jr. Collection,
Purchase, Douglas Dillon Gift,
1981 (1981.278)

this cultivated emperor and connoisseur was known.

Meticulously drawn and shaded, the birds are suprarealistic. Dots of lacquer give their eyes the moist appearance of life. This realism is combined with a consciously aesthetic arrangement of the birds and branches against the silk, and a pairing of soft color and subtle shades of ink.

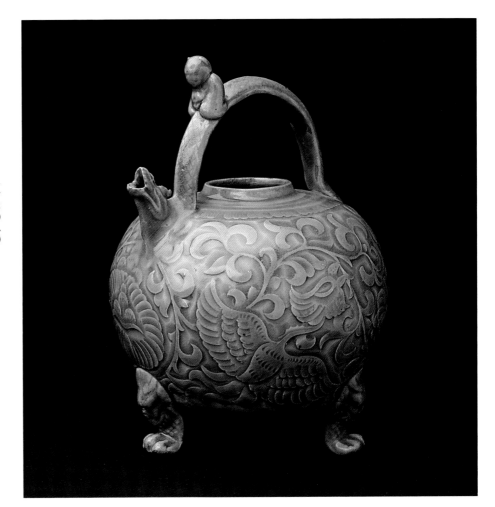

39 *Sung Dynasty Ewer*, 11th–12th c.
Chinese; Northern Sung dynasty
Porcelaneous stoneware;
H. 8¼ in. (21 cm.)
Gift of Mrs. Samuel T. Peters,
1926 (26.292.73)

SUNG DYNASTY EWER

In accordance with the prevailing taste of the Sung dynasty, the shape and glaze of this fine vessel are the dominant qualities, taking precedence over ornamentation. This is one of the finest examples of the type of ware known as Northern celadon ware. The swelling body, the important but subtle glaze, and the complex design that covers the surface of this elegant ewer made of porcelaneous stoneware comple-ment one another. The glaze, which derives its color from iron, collects in thicker pools where more clay has been hollowed out to create the carved pattern, and this serves to accent the design beneath. The ewer stands on three scowling-mask legs that terminate in paws. The handle is a serpentlike dragon whose head forms the spout, and is straddled by a diminutive rider.

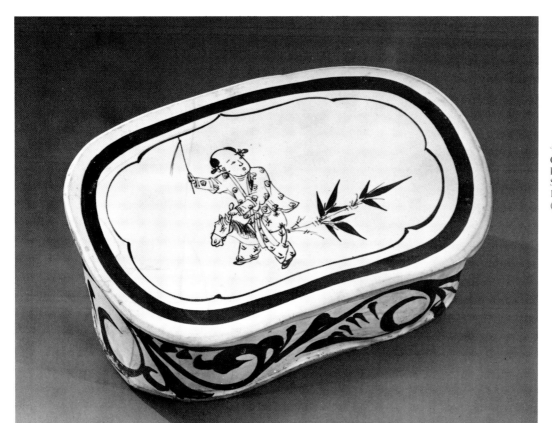

40 *Stoneware Pillow*, 12th–13th c.
Chinese;
late Northern Sung to Chin dynasty
Stoneware; L. 11¼ in. (28.6 cm.)
Harris Brisbane Dick Fund, 1960
(60.73.2)

STONEWARE PILLOW

Kilns producing the Tz'u Chou type of ware are found in several northern Chinese provinces. They produced a popular line of stoneware, starting in the later years of the T'ang dynasty. This small stoneware pillow is an excellent example of why Tz'u Chou wares had such an enduring appeal. Among the various designs was the type seen here, painted in black or brown on a ground of white or, occasionally, green. The drawing is often full of imagination and confidence, as in this piece, where a small boy is seen riding his bamboo hobbyhorse. The boy's expression, which is a mixture of challenging defiance and nervous anticipation, is a realistic portrayal of a child caught up in the excitement of a game. The figure is surrounded by a simple cartouche set within a brushline frame that conforms to the contour of the pillow, and a continuous band of stylized leaf-scroll runs around the sides.

GOURD-SHAPED KORYO EWER

Mandarin ducks, traditional symbols of conjugal harmony, sport amid a tangle of flowering reeds on one side of this elegant Korean ewer dating from the end of the eleventh or start of the twelfth century. Above them, a pair of geese ascend into the sky, and on the other side, chrysanthemums in bloom indicate that this is an autumnal scene. The carved and incised design of this ewer is delicately overlaid with a subtle gray-green glaze, thin and transparent, which, though learned from Chinese potters, is unmistakably characteristic of early Koryo dynasty ceramic ware. The double-gourd shape is traditional, but is usually more slender. In this piece, the artist has used more ample curves to create a convincing illusion of depth and space in his picture. The geese on the receding plane seem to be flying into the distance, whereas the ducks at the base appear to be closer, as if nearer to the viewer's vantage point. The carving is executed with precision and attention to detail, and the spout and handle have been left unadorned, as if the artist had decided to focus attention on the picture without distracting sidelights. The vessel's lid might have served to confirm or belie this supposition, but it is missing.

By the eleventh century, the trade relationship between Korea and China had been vigorous for many centuries and Koryo dynasty potters were familiar with Chinese ceramic techniques and designs dating as far back as the T'ang dynasty. By the end of the tenth century, Korean potters were producing celadon wares, but it is hard to generalize about the quality or usual style of work, since so few pieces remain. The Museum's ewer is an elegant example of the masterful work produced in Korea at the time.

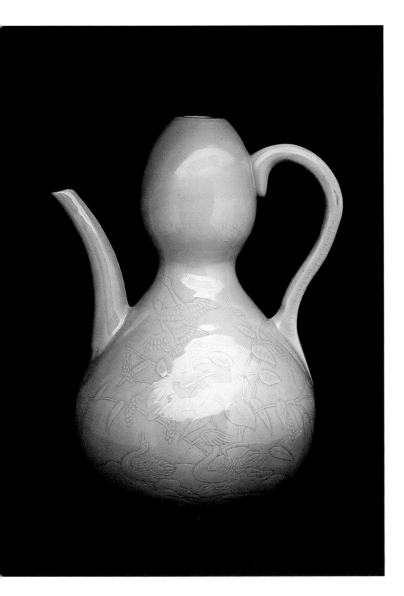

41 Gourd-Shaped Koryo Ewer,
late 11th to early 12th c.
Korean; Koryo dynasty
Porcelaneous stoneware with
celadon glaze; H. 10½ in.
(26.6 cm.) Fletcher Fund, 1927
(27.119.2)

42 Duke Wen of Chin Recovering His State (detail)
Li T'ang, act. ca. 1120–40
Chinese;
late Northern to early Southern Sung dynasty
Text by Sung emperor Kao-tsung (r. 1127-62)
Handscroll; ink and color on silk;
Overall: 11⅝ x 325⅜ in. (29.5 x 827 cm.)
Gift of The Dillon Fund, 1973 (1973.120.2)

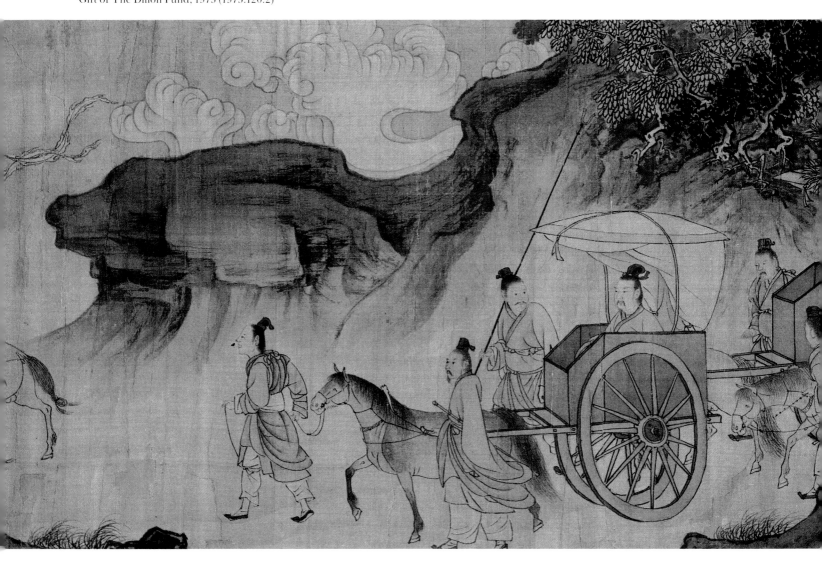

LI T'ANG
Duke Wen of Chin Recovering His State

The subject of this narrative handscroll tells of a worthy monarch's quest for the allegiance of other feudal princes in the Spring and Autumn period. It was particularly significant for the Southern Sung court, which had lost control over the Chinese heartland to the invading Tartars. Chou Mi (1232–after 1308) records that the Sung emperor Kao-tsung himself wrote the text for a handscroll on the subject painted by Li T'ang, the leading master of Kao-tsung's Southern Sung academy. The Museum's scroll displays the distinctive cursive script of Emperor Kao-tsung and the large-figure style with which Li T'ang is credited in several attributions.

The narrative sequences follow Duke Wen on a tour as he seeks support as future leader of the alliance of states that constituted China in the seventh century B.C. Heads of some states, such as Sung, are courteous and courtly, while the leader of Cheng is less than civil. In Ch'u, Duke Wen repulses the attempt of the militant leader to exact a ransom, and in Ch'in he enjoys the attentions of beautiful ladies. The drama climaxes in an affirmation of loyalty to the duke by his trusted minister, and the reciprocal magnanimity of the ruler. The scroll ends with the triumphant return of the duke to Chin on the eve of his succession to the leadership of the federation.

The staging of episodes in the handscroll is theatrical. Space is narrowly defined; rocks and trees are set like props to frame the chief characters, whose interaction is the central focus of the piece.

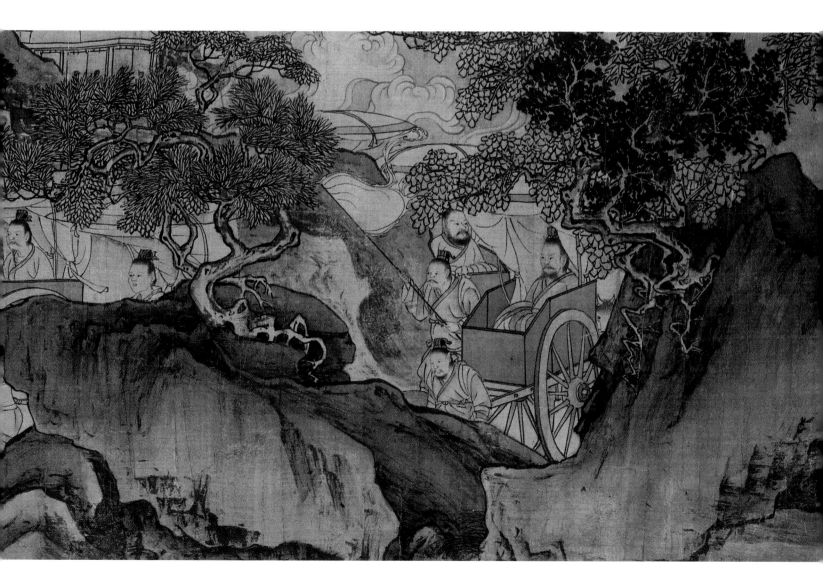

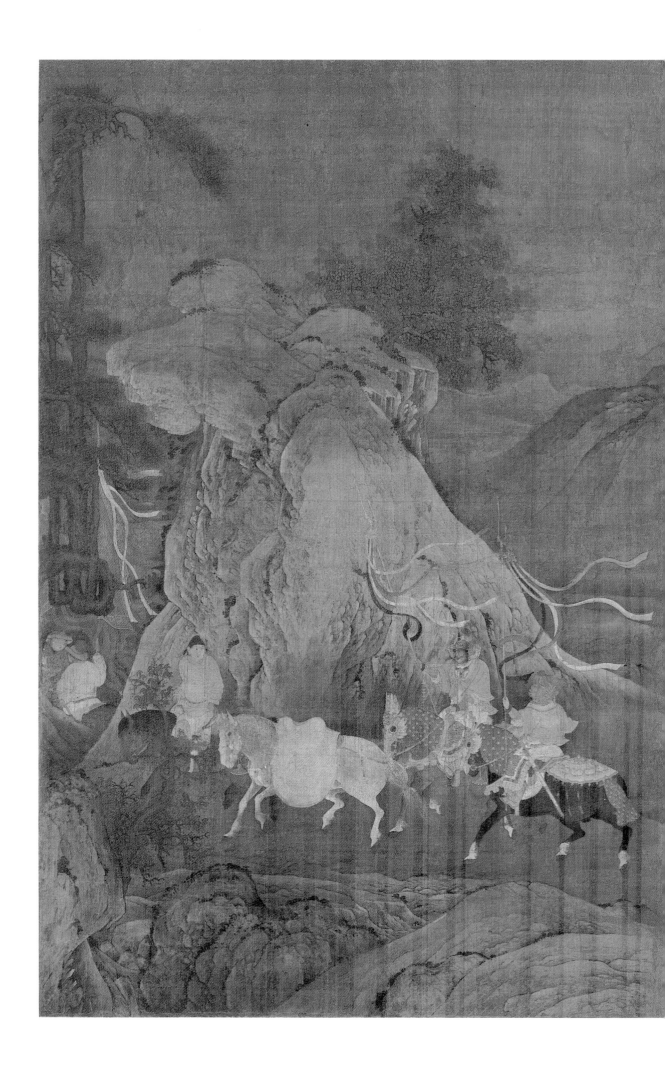

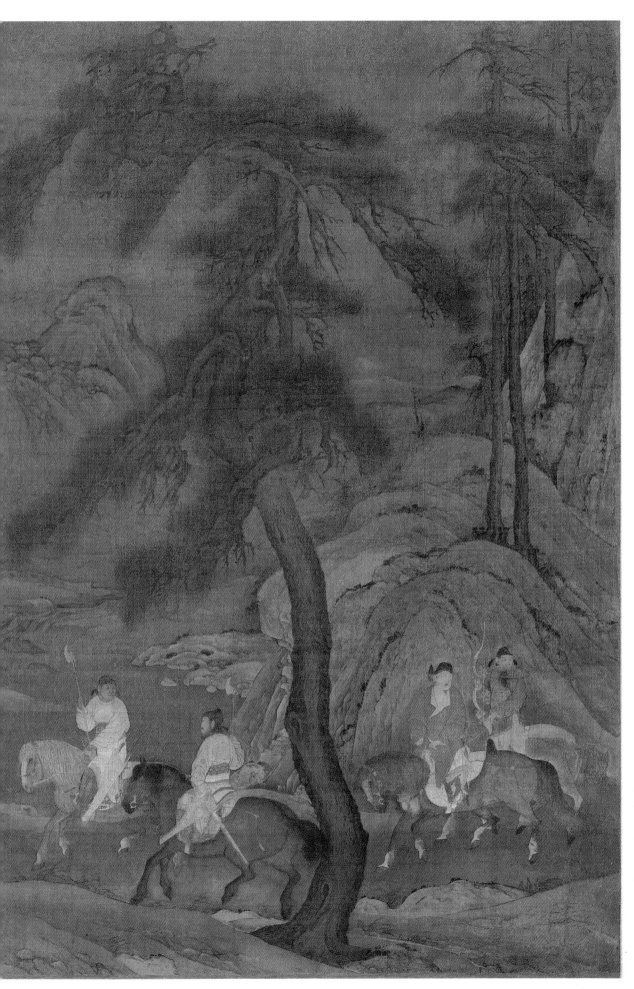

43 *Emperor Ming-huang's*
Flight to Shu, 12th c.
Chinese; Southern Sung dynasty
Hanging scroll; ink and colors
on silk; 32⅝ x 44¾ in.
(82.9 x 113.7 cm.)
Rogers Fund, 1941 (41.138)

Page 76: text

44 Orchids
Ma Lin, act. 1216 55
Chinese; Southern Sung dynasty
Album leaf; ink and color on silk;
10⁵⁄₁₆ x 8¹³⁄₁₆ in. (26.4 x 22.5 cm.)
Gift of The Dillon Fund, 1973
(1973.120.10)

SUNG DYNASTY ARTIST *(Pages 74–75)*
Emperor Ming-huang's Flight to Shu

In A.D. 745, after thirty-three years of able rule, the T'ang emperor Ming-huang (r. 712–56) fell in love with the concubine Yang Kuei-fei. As he grew indifferent to his duties, court intrigues multiplied, and open rebellion broke out in 755. The emperor and his court were compelled to flee the capital through the difficult mountain passes, for the safety of Shu (Szechwan province). During the flight, Ming-huang was confronted by mutinous troops who accused Yang Kuei-fei of complicity in the rebellion. The emperor was forced to assent to her execution.

This painting may depict the imperial entourage moving through a somber landscape after the execution. This interpretation is suggested by an informally dressed imperial figure at the right, who appears to be the disconsolate Ming-huang, and the grinning palace guard, following the riderless horse, who seems to be gloating in victory. The mountain behind the white steed glows with an ethereal luminosity created by a lighter use of ink wash and highlights of gold pigment. Touches of gold on the rocky facets and costumes lend regal splendor. Although traditionally ascribed to a Southern Sung artist, this painting may represent the continuation of the monumental landscape tradition in northern China under the Chin Tartars.

The silk panels forming this painting, previously mounted as a low screen, have recently been restored and remounted by the Museum's Far Eastern conservation studio. There have been some losses of silk, but no significant repainting.

MA LIN
Orchids

A fifth-generation member of a distinguished family of painters, Ma Lin worked in southern China in the mid-thirteenth century. His *Orchids* is one of the finest Sung flower paintings in existence, as well as being one of the first known Chinese orchid paintings. In China, the orchid is an autumnal flower, which, because it grows naturally in inaccessible places, is regarded as a symbol of unappreciated virtue and beauty. In the Southern Sung period, like most flowers, it also personified female beauty, especially that of courtesans and neglected palace women. It is understandable, therefore, that Ma Lin's orchids evoke a sense of melancholy, regret, and loneliness.

An examination of the composition of the work reveals the subtle uses of parallel rhythms and counterrhythms, and the principle of yin and yang asymmetrical balance. The leaves and petals twist gracefully against the still background. The artist first outlined the flowers in ink, then colored them delicately, adding whitish highlights. The leaves, in sharp contrast to the soft tones of the petals, were painted with a hard, mineral green color, the composition of which has caused some disintegration of the silk support material.

Ma Lin has combined the traditional style of flower painting derived from the Painting Academy of the Northern Sung period with the atmospheric vibrancy of the Southern Sung Academy. The result is an exquisitely expressive work painted within a framework of formal realism that catered to the taste of aristocratic patrons.

76

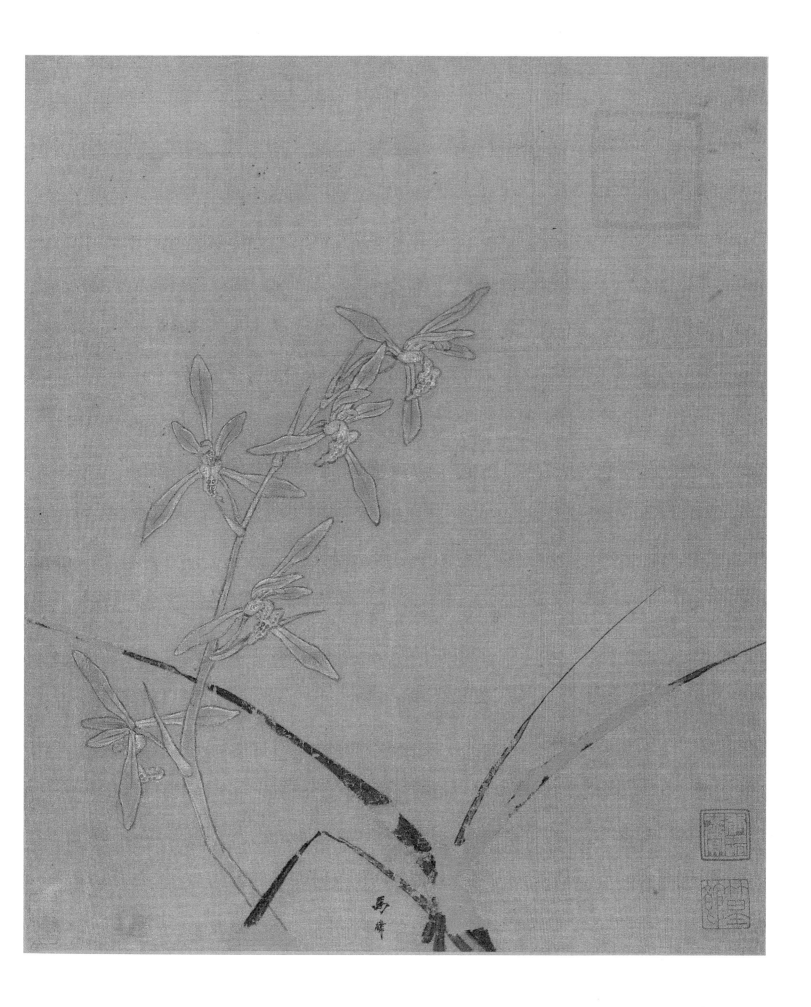

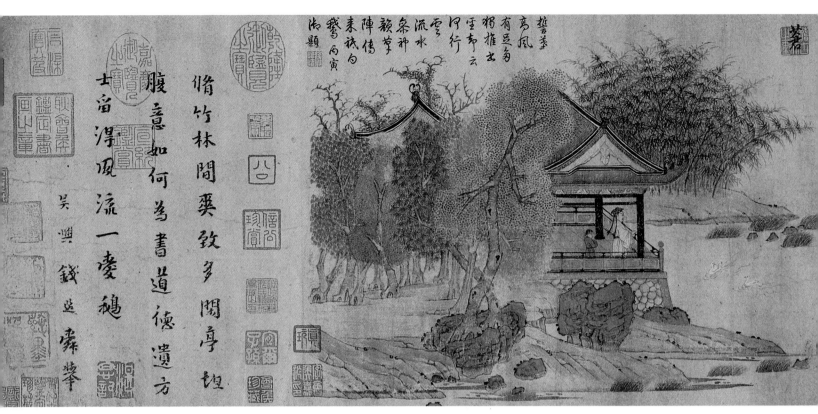

45 *Wang Hsi-chih Watching Geese* (detail)
Ch'ien Hsüan, ca. 1235–after 1300
Chinese;
late Southern Sung to early Yüan dynasty
Handscroll; ink, color, and gold on paper;
Overall: 9⅛ x 36½ in. (23.2 x 92.7 cm.)
Gift of The Dillon Fund, 1973 (1973.120.6)

Opposite: detail of Plate 45

CH'IEN HSÜAN
Wang Hsi-chih Watching Geese

The Mongol conquest of China in 1279 caused many Sung scholars to withdraw from official service and to retire despairingly into private life. Among these was Ch'ien Hsüan, who declined to work for the new Yüan administration and went into retirement in Wu-hsing, in southern China. He painted popular subjects, such as flowers, birds, insects, and fruits, with professional skill. In violation of the social code of the scholar-gentleman, which restricted painting to a pastime for cultivated minds, he sold his works to augment his living.

Wang Hsi-chih Watching Geese, however, seems part of a more personal oeuvre. The painting was done in a consciously archaistic manner, invoking the past in both content and style. The subject is a classical story of China's greatest calligrapher, Wang Hsi-chih (321–79), who found inspiration for his calligraphic style in the movements of long-necked geese. The blue-and-green mineral colors and flat schematized forms used in the picture are a style associated with paradisiacal landscapes at least since the T'ang. The image is like a dreamed imprint of the cultural consciousness: A quintessential scholar-gentleman in a strangely disjointed pavilion that is brushed by softly textured trees, gazes across a stretch of water toward jewel-colored hills. Forecasting a new interest in paintings accompanied by verse, Ch'ien composed the picture so as to allow for his poem at the left end of the paper, following the image.

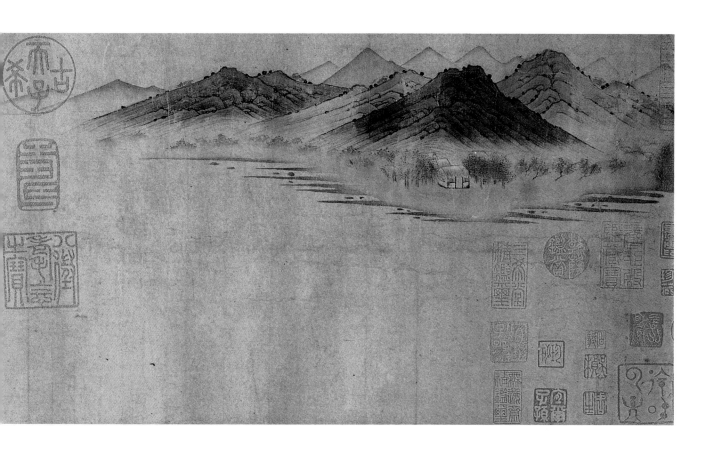

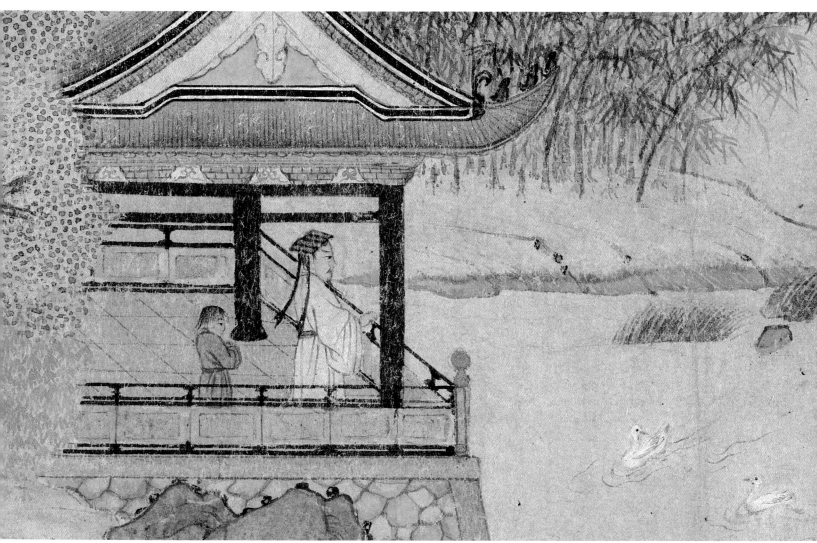

46 *Welcoming the New Year*,
late 13th or early 14th c.
Chinese; Yüan dynasty
Panel; silk embroidery and plant
fiber (some originally gold wrapped)
on silk gauze; 84 x 25 in.
(213.4 x 63.5 cm.) Purchase,
The Dillon Fund Gift, 1981 (1981.410)

WELCOMING THE NEW YEAR

During the Sung and Yüan dynasties, the art of embroidery reached a peak of refinement and complexity, with decorative compositions frequently imitating paintings both in format and in subject matter. Embroidered hangings were displayed in palace halls or residences to mark the changing seasons or to celebrate a birthday or the New Year.

This large embroidered panel combines a number of auspicious symbols appropriate for the celebration of the New Year. Young male children in Mongol costume sport among sheep and goats in a landscape scattered with pine, plum blossoms, bamboo, fungus, and other plants. The young males symbolize a promise of new life and the continuation of the family line. Sheep and goats are emblems of good fortune. The word for sheep and goats (*yang*) is also a homophone of yang, the energy associated with growth, warmth, and light that gains ascendancy over dark yin energies at the beginning of the year. The plum flowers at the New Year defy the cold with their message of renewal. The "Three Friends of Winter"—pine, plum, and bamboo—which became an increasingly popular subject in the Yüan, are emblems of endurance and continuity through adversity.

The panel's workmanship is extraordinary. The composition is worked in silk on fine gauze in a combination of matte close-set vertical stitches and longer gleaming float stitches. Motifs are further embellished with laid work in descriptive patterns, such as those of the curls in the ram's coat, and the concentric circles of float stitches that radiate light from the eyes of the sheep and goats.

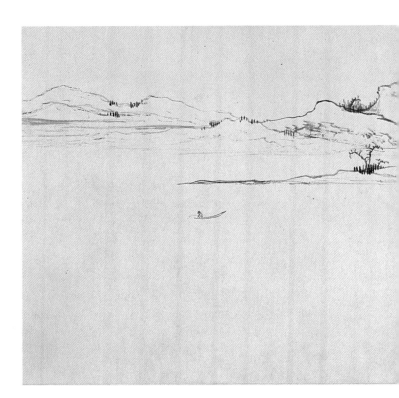

CHAO MENG-FU
Twin Pines Against a Flat Vista

In this painting, done with all the free energy of a sketch, Chao Meng-fu has "written out his ideas" *(hsieh-i)* about pines and rocks against a flat vista, past interpretations of this theme, and the power of the brush used calligraphically to produce illusionistic pictures. On the left edge of the scroll, written over part of the picture, Chao Meng-fu has added a note that ends with the comment:

> As for my own work, I dare not compare it with the ancient masters', but when I look at what the recent painters have done, I daresay mine is a bit different.

Chao's work did initiate a new integration of calligraphic values into painting. The sensitive brushline became a conduit in painting, as it had long been in calligraphy, for the presence of the painter and his responses to the moment and the subject.

In *Twin Pines* Chao consciously worked in the idiom of the tenth-century master Li Ch'eng. The pine trees anchored on the rocky spit send well-articulated branches into the surrounding space. Chao used the "flying white" brushstroke of calligraphy, revealing the paper through split hairs of the brush to give illusionistic depth to the contours of the rock. In outlining the tree trunks, he used the round, fluid brushline of seal and cursive scripts. Compositionally and intellectually, the trees that appear at the beginning of the scroll and the written commentary at the end are paired: They represent equivalent expressions, though differently portrayed, of the artist's thoughts.

47 Twin Pines Against a Flat Vista (detail)
Chao Meng-fu, 1254–1322
Chinese; Yüan dynasty
Handscroll; ink on paper; Overall:
10½ x 42¼ in. (26.7 x 107.3 cm.)
Gift of The Dillon Fund, 1973 (1973.120.5)

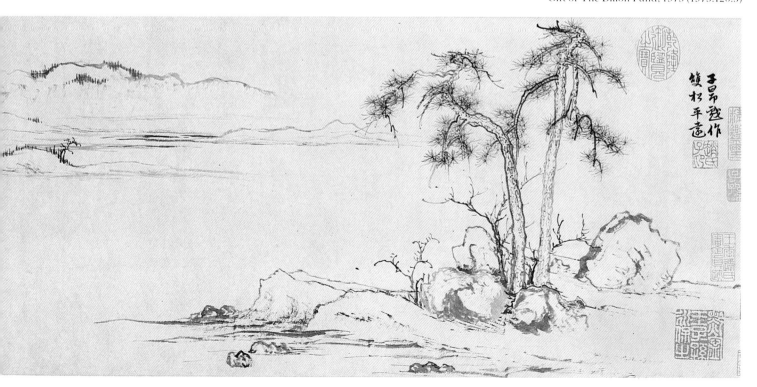

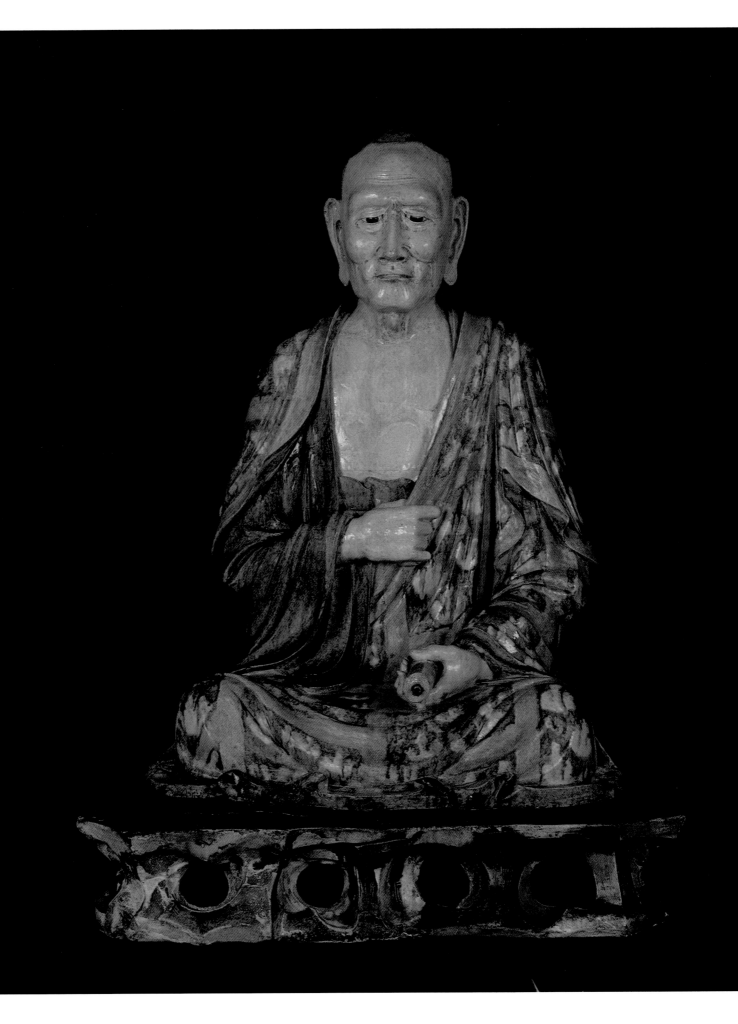

48 *Seated Lohan*, ca. 10th c.
Chinese; late T'ang or early Sung dynasty
Pottery; H. 30 in. (76.2 cm.)
Frederick C. Hewitt Fund, 1921 (21.76)

SEATED LOHAN

Buddhist tradition tells of sixteen, and sometimes eighteen, lohans who were commanded by Buddha to await the coming of the Maitreya, or Future Buddha. This promise of future salvation must have held great appeal to the Chinese Buddhists at the end of the ninth century, for they had just been through a period of great persecution, and a cult built around the guardian lohans gained momentum at this time.

In the Metropolitan's collection there are two statues of seated lohans from such a group, found in mountain caves near I-chou, and dating from this unsettled period. It has been suggested that the statues may have been moved to the caves for safekeeping: This theory is strengthened by the hidden location of the caves at the crossroads of major travel routes. If they were hidden for safety, it is not known why they were never returned to their proper location.

The I-chou lohan seen here probably dates from the very last years of the T'ang, the Five Dynasties period, or the early years of the Sung dynasties. The glazes, which resemble the characteristic three-color glaze of T'ang ceramics, incline some experts to the earlier dates, but there is no real consensus. The high quality of design and use of such sophisticated techniques as reinforcing rods suggest that it was probably made at one of the imperial kilns, where large firing chambers and highly skilled craftsmen were available. The elderly lohan seen here sits crosslegged on a slab of weathered rock. He holds a scroll in his left hand and his expression is one of meditative concentration. Of the original set of figures, only seven survive. Some were smashed beyond repair as they were carried down the mountainside, and one was destroyed during World War II.

WANG CHEN-P'ENG
Vimalakīrti and the Single Doctrine

Throughout the thirteenth century, China suffered successive raids from invading Tartars and Mongols, but it was not until the 1270s that the conquest by the Mongol leader Kublai Khan established foreign domination that endured as the Yüan dynasty until 1368. But despite the resulting mix of Asian cultures, Chinese art flourished, developing new traditions and reestablishing old ones.

Wang Chen-p'eng, an early Yüan master, was the leading exponent of the traditional "plain-drawing" method in both figural and architectural painting. His scroll, *Vimalakīrti and the Single Doctrine*, made in 1308 for the future emperor Jen-Tsung (r. 1312–20), was based on a mid-thirteenth century work by the Chin painter Ma Yun-ch'ing, itself a copy of a work by the earlier artist Li Kung-lin (ca. 1040–1106). Wang's scroll is evidence of the lasting influence of Li Kung-lin, whose "plain-drawing" technique was the base upon which calligraphic artists of the following century founded their own styles. Wang's outstanding achievement was his ability to use the perfectly controlled "iron-wire" technique to create convincing, organic figural forms.

This scroll depicts a passage from the Buddhist scripture, the *Vimalakīrti Sutra*, in which Vimalakīrti, a layman who had achieved supreme enlightenment, engaged Manjusri, the Bodhisattva of Wisdom, in a theological debate. By maintaining silence when asked to explain the ultimate meaning of Buddhist law, Vimalakīrti, according to the sutra, was proven the more subtle debater. The two principal figures are surrounded by bodhisattvas, lohans (ascetics who sought salvation through self-denial), attendants, and guardians. According to the artist's inscription, this monochrome version was prepared for the future emperor's approval and was later executed in color.

49 *Vimalakīrti and the Single Doctrine*,
1308 (detail)
Wang Chen-p'eng, ca. 1280–1329
Chinese; Yüan dynasty
Handscroll; ink on silk; Overall:
15½ x 112 in. (39.4 x 284.5 cm.)
Purchase, The Dillon Fund Gift, 1980
(1980.276)

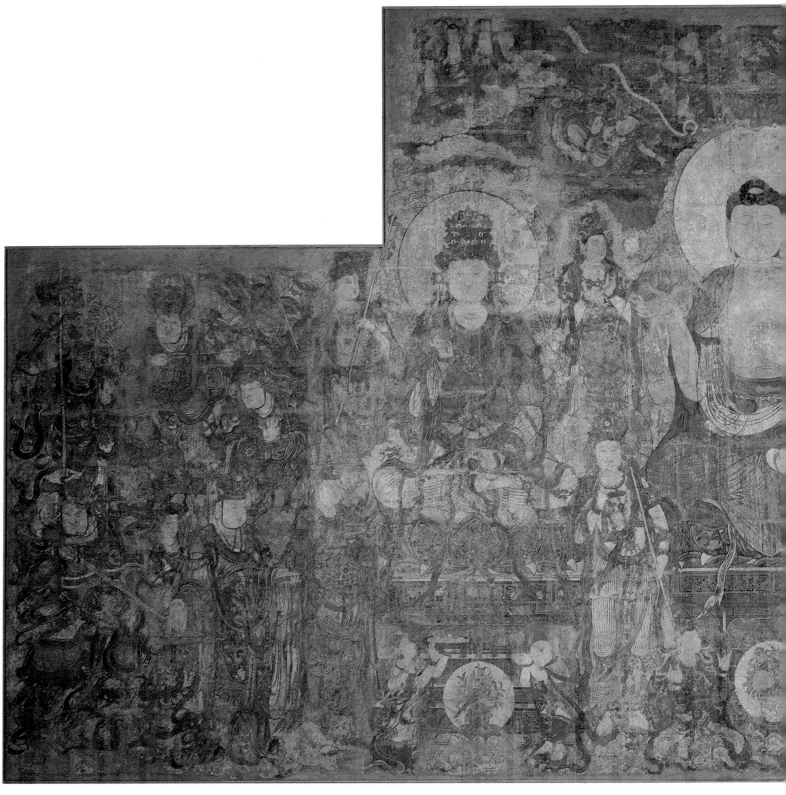

50 *Assembly of the Buddha Sakyamuni,*
ca. second quarter 14th c.
Chinese; Yüan dynasty
Water-based pigments over foundation
of clay mixed with straw;
24 ft. 8 in. x 49 ft. 7 in. (7.52 x 15.12 m.)
Gift of Arthur M. Sackler, in honor of
his parents, Isaac and Sophie Sackler,
1965 (65.29.2)

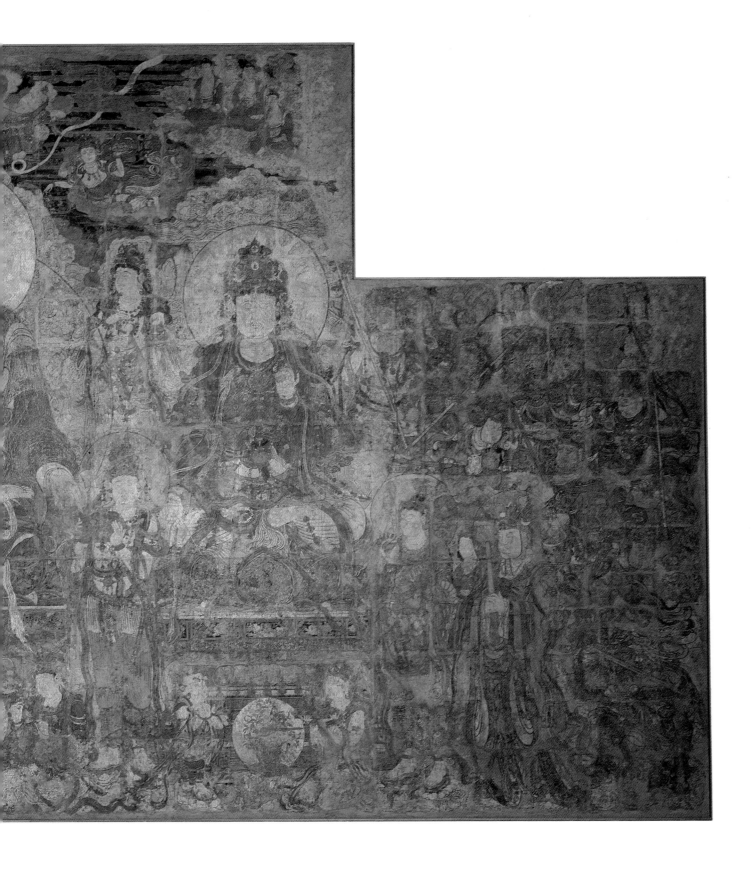

ASSEMBLY OF THE BUDDHA SAKYAMUNI

Buddhist and Taoist temples in northern China during the Yüan and Ming dynasties used the services of professional mural painters who traveled about with their models and copybooks, providing iconographically correct illustrations of various themes. This monumental wall painting from a temple in Shansi province epitomizes the mannered, elegant style of the Fen River school of artists.

The enthroned historical Buddha, Sakyamuni, is flanked by two enthroned and richly jeweled bodhisattvas. The triad is, in turn, surrounded by a host of smaller divine, mythological, and symbolic figures. The farther away these figures stand from the stable central figure the more animated they become, reacting to one another and their surroundings in this opulently garbed group draped in fluttering garments. The expressions have become formulaic, but the harmonious tones and patterns of the roughly symmetrical mural would have been an effective celestial backdrop for the sacred images grouped in front of it.

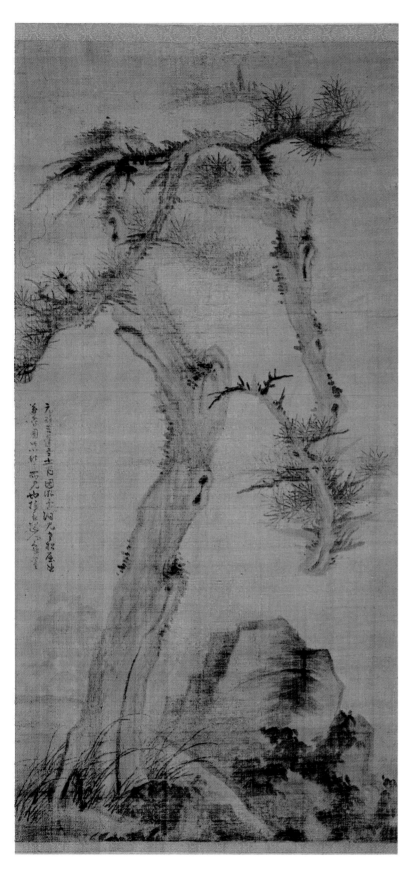

51 Old Pine, 1335
Wu Chen, 1280–1354
Chinese; Yüan dynasty
Hanging scroll; ink on silk;
65⅜ x 32⅜ in. (166 x 82.3 cm.)
Purchase, The Dillon Fund Gift,
1985 (1985.120.1)

WU CHEN
Old Pine

Wu Chen, one of the Four Great Masters of the late Yüan period, lived through a period of great political upheaval in China. The Mongols had invaded the land in the decade before his birth, imposing a harsh regime upon the conquered people. One of the responses generated by this situation was a strengthening of religion: Schools of Confucianism, Taoism, and Buddhism sprang up as a form of cultural protection.

Wu Chen was a well-educated man who, in less turbulent times, would probably have sought greater involvement in the world. As it was, he chose to live the humbly religious life of a hermit, in the mountains of Chekiang province, where he earned his bread by the practice of divination and called himself the Plum Blossom Taoist. Nearly all of his mature paintings were made for people associated with Buddhist or Taoist temples.

Old Pine combines many qualities that were traditionally prized in literati paintings: a noble subject (the old tree was a symbol of endurance and fortitude); personal inspiration and spontaneous execution (he came across the tree while on a journey and painted his impression of it, as noted in his inscription at the left); traditional sources interpreted in an unmistakable personal style (the consistently broad, wet brushstrokes were a hallmark of Wu's hand); and the understated aesthetic of monochromatic ink painting.

52 Woods and Valleys of Mount Yü, 1372
Ni Tsan, 1301–74
Chinese; Yüan dynasty
Hanging scroll; ink on paper;
37½ x 14⅛ in. (95.3 x 35.9 cm.) Gift of
The Dillon Fund, 1973 (1973.120.8)

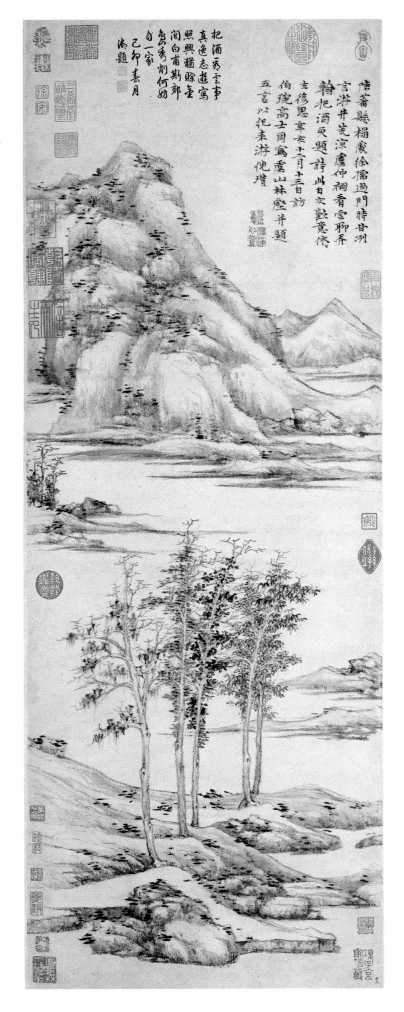

NI TSAN

Woods and Valleys of Mount Yü

Born to great wealth, at mid-life Ni Tsan distributed his possessions and took to wandering about the lakes of the Yangtze delta region in a houseboat to escape the turmoil of the waning years of the Yüan dynasty. Mooring his boat at the abode of friends, he kept the company of like-minded literati—painting, writing, and distilling the spiritual and critical values of Chinese culture in a time of political and social collapse.

Woods and Valleys of Mount Yü is a painting from the last years of Ni's life and is a mature expression of the values he cherished. The sparse composition and use of dry ink allow the luster of the paper to activate the landscape as cool and pure elements of water, air, and space. Each brushstroke and ink tone interacts with this ground, as in calligraphy. Forms are built up by layers of tone laid on by a brush held obliquely to the paper. Dark ink "moss dots" dance over the surface in a final layer of bright accents. Ni's forms are simple and almost abstract; he repeated his compositions again and again. The tender melancholy of this cultivated man standing together with a few companions is "written out" in his painting, expressed in the verse he added at the top:

> We watch the clouds and play with our brushes,
> We drink wine and write poems.
> The joyous feelings of this day
> Will linger after we have parted.

53 Beneficent Rain (detail)
Chang Yü-ts'ai, d. 1316
Chinese; Yüan dynasty
Handscroll; ink on silk; Overall:
10⅝ x 106¾ in. (27 x 271.1 cm.)
Gift of Douglas Dillon, 1985
(1985.227.2)

54 Porcelain Jar, 1426–35
Chinese; Ming dynasty
Porcelain painted in underglaze
blue; H. 19 in. (48.3 cm.)
Gift of Robert E. Tod, 1937
(37.191.1)

CHANG YÜ-TS'AI

Beneficent Rain

Chang Yü-ts'ai, the thirty-eighth Taoist pope, was influential and famous despite the fact that he lived far from the political upheavals of the period, as the Mongols expanded their rule throughout China. The Taoists found favor with the Mongols, who believed in divination and shamanistic practices, and they used the church organization to help them consolidate their power. Chang Yü-ts'ai, despite his remote residence at Taoist religious headquarters at Dragon-Tiger Mountain (Mount Lung-hu) in Kiangsi province, gained widespread admiration for his ability to induce much-needed rain and for subduing a "tidal monster." He also became famous as a painter of dragons —there can be little doubt that the Metropolitan's painting of *Beneficent Rain* must have greatly enhanced his reputation. It is, unfortunately, the only work of Chang's known to have survived.

Under Mongol rule, the prevailing aesthetic was that of the scholar-painter. It emphasized the importance of art as self-expression, and many intellectuals of the period, devoted themselves to the arts and expressed their alienation by means of their compositions.

Chang Yü-ts'ai used brush and a freely applied, graded ink wash to create a sinister, murky atmosphere of thunder-clouds and rain in which his dragons twist and lurk. They incorporate many of the accepted conventions of Sung dynasty dragons as described in contemporary texts: they should have the head of an ox, the muzzle of a donkey, eyes of a shrimp, horns of a deer, the body of a serpent covered with fish scales, and feet of a phoenix. Despite their reptilian appearance, they were considered auspicious creatures, symbolizing the volatility of the elements—an appropriate allegory for the eventful times in China.

PORCELAIN JAR

The design on this splendid blue-and-white jar was painted on the unfired clay body with cobalt oxide, and the piece was then glazed. When fired, the glaze was fused to the body. By the end of the fourteenth century, the production of this kind of ware at the Ching-te Chen kilns in northern Kiangsi province had become an art form, and during the fifteenth century it reached the epitome of grace and sophistication manifested in this vessel.

The Metropolitan's jar is beautifully shaped and painted with a bristling dragon that combines great power with consummate fluidity of movement. His dorsal fins are like the teeth of a buzzsaw and the underlying bone structure of his claws is the result of careful anatomical observation on the part of the craftsman-painter. The reign-mark (the four characters just beneath the neck of the jar) are those of the emperor Hsüan-te (r. 1426–35). This method of signing a piece became popular during Hsüan-te's reign and remained in use thereafter. The dragon was symbolic of the emperor—indeed, the five-clawed dragon was reserved exclusively for works destined for imperial use, and at times its usurpation for any other purpose could be punishable by death. In the case of this jar, the dragon is uncharacteristically portrayed with only three claws, but both the quality of the piece and the reign-mark leave little doubt that it was intended for royal use.

For many years it was thought that the Museum's jar was the only one of its kind in existence, but in 1981 a second piece, obviously made at the same time and place, was offered for sale at Sotheby's in London. In a transaction that created a great stir in the art world, it sold for the then-unparalleled sum of $1.3 million.

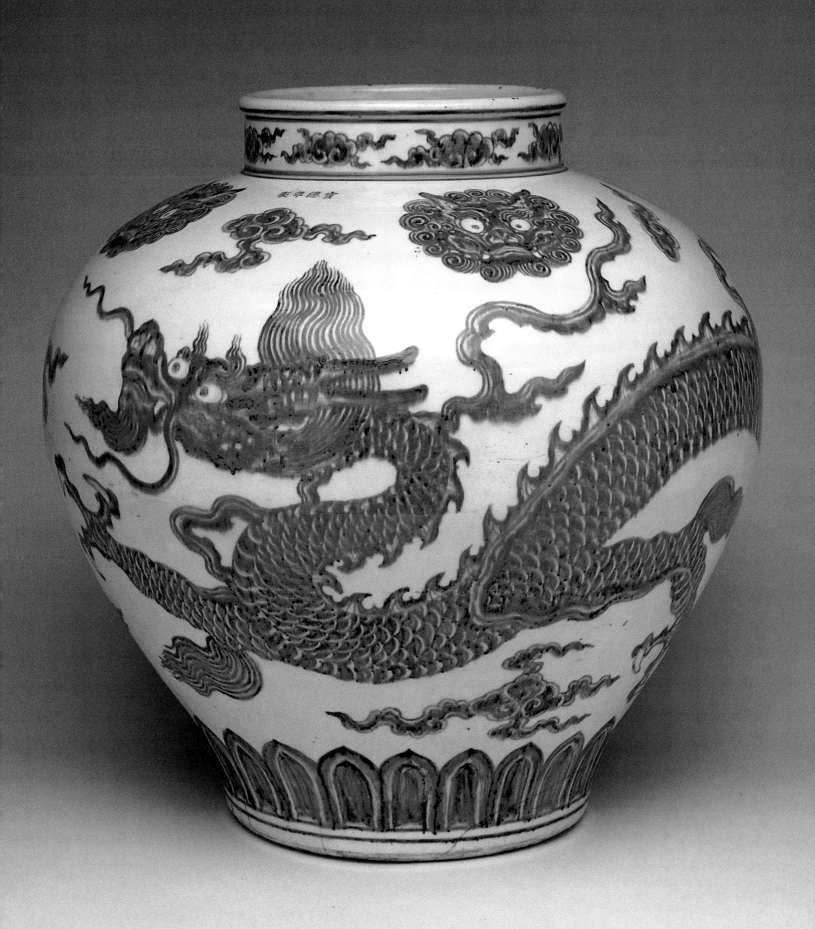

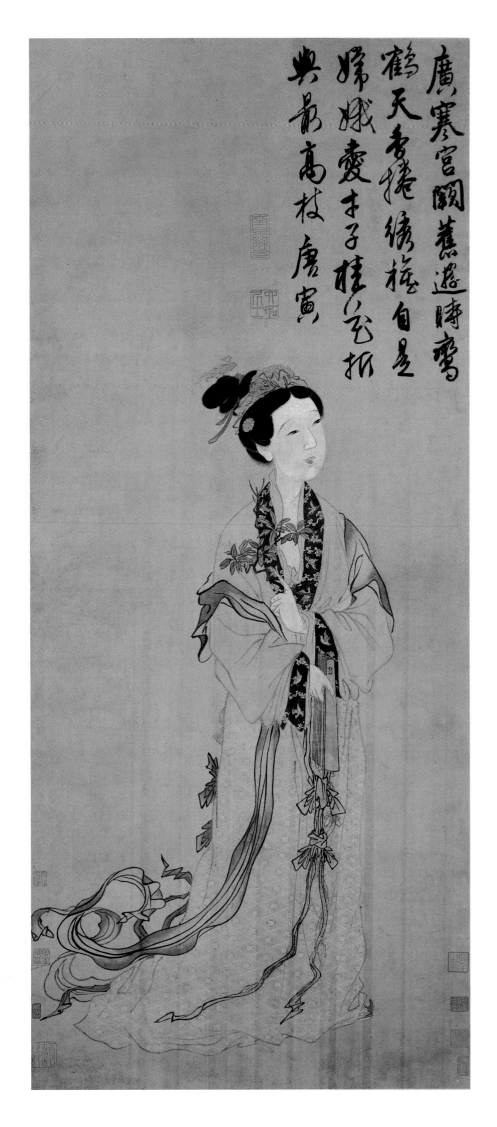

廣寒宮闕舊遊時鸞
鶴天香捲繡旆自是
嫦娥愛才子桂花折
與第高枝唐寅

55 *The Moon Goddess Ch'ang O*
T'ang Yin, 1470–1524
Chinese; Ming dynasty
Hanging scroll; ink and color
on paper; 53¼ x 23 in.
(135.3 x 58.4 cm.) Gift of
Douglas Dillon, 1981 (1981.4.2)

T'ANG YIN
The Moon Goddess Ch'ang O

T'ang Yin was educated to become a scholar-official, but he was disgraced as the result of a scandal that developed around the degree examination. Humiliated, he turned to a dissolute, hedonistic lifestyle, which he maintained by selling his paintings and poetry for a living. Many of his works retell his story of regret, disappointment, and compromise. The supremely accomplished *Moon Goddess Ch'ang O* is a poignant example.

The graceful goddess, who stole the elixir of immortality and resides in the moon, stands like a beautiful courtesan holding a fan and a cassia branch. T'ang Yin's poem at the upper right in his bold and flowing hand reads:

> She was long ago a resident of the Moon Palace,
> Where phoenixes and cranes gathered, and embroidered
> banners fluttered in heavenly fragrance.
> Ch'ang O in love with the gifted scholar,
> Presents him with the topmost branch of the
> cassia tree.

The characters for "cassia" and "nobility" are both pronounced *kuei*. The painting is possibly a portrait of a favorite of T'ang's from the "flower gardens" of Soochow, whom the artist celebrates as a fallen goddess. The intricate drama of his picture restores the lost nobility of both the subject and the painter.

PI-PA

The term *pi-pa*, originally a generic name for Chinese lutes, describes the back-and-forth motion of the player's right hand across the strings. Lutes of various shapes and sizes are mentioned as early as the Han dynasty (206 B.C.–A.D. 220). The four-stringed variety with slender lateral tuning pegs and a shallow, rounded back seems to have originated in Central Asia. The popularity of the *pi-pa* reached its zenith during the T'ang dynasty, when the flourishing Silk Route made for a highly cosmopolitan culture. However, it is still heard today in ensembles, accompanying dramatic narrations and ballads, and in virtuoso pieces with programmatic titles.

The extraordinary carved decoration of this example includes 120 ivory plaques depicting animals, flowers, people, and Buddhist emblems, all symbolizing good luck, longevity, and immortality. A bat, conventional symbol of good fortune, appears at the end of the neck. Instruments of such rare beauty were made as gifts for foreign rulers and for use at court.

56 Pi-pa, 17th c.
Chinese; Ming dynasty
Wood, ivory, various other
materials; L. 37 in. (94 cm.)
Bequest of Mary Stillman
Harkness, 1950 (50.145.74)

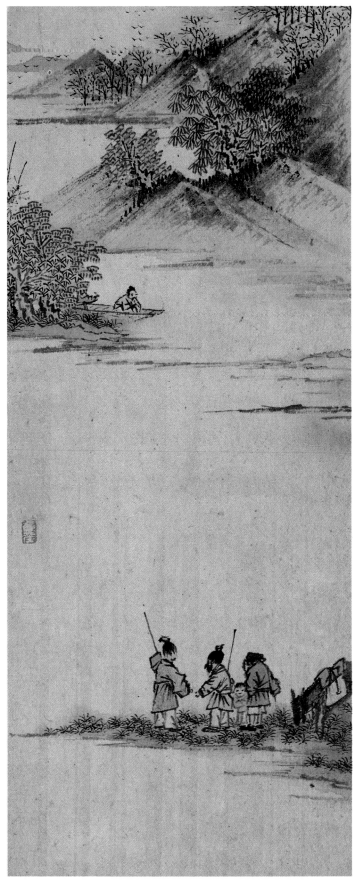

57 Landscapes, Figures and Flowers, 1618–22 (details)
Ch'en Hung-shou, 1598–1652
Chinese; Ming dynasty
Album with 12 leaves; ink and color on paper;
each leaf: 8¾ x 3⁹⁄₁₆ in. (22.2 x 9.1 cm.) Purchase,
Friends of Far Eastern Art Gift, 1985 (1985.121f,j,b,i)

Page 94: text

己未春
洪綬

流黃靡靡秋韻阿㜑櫈聲
士征衣石輪運
洪綬時辛丙夏

CH'EN HUNG-SHOU

Landscapes, Figures and Flowers

(Pages 92–93)

This album of twelve paintings, nine of them dating from 1618 to 1622, was begun when the artist was twenty years old. As if demonstrating the breadth of the artist's learning, it offers a cross-section of subjects and styles from Chinese traditional art. There are eight landscapes, two figural works, and two flower paintings. Six facing pages are inscribed by the artist and six are inscribed by Ch'en Chi-ju (1558–1639).

Within the landscapes there are examples of several different styles: They include old trees and bamboo, in the style of the fourteenth-century master Ni Tsan; the archaic "blue and green" of Ch'ien Hsüan (ca. 1235–after 1307) and the T'ang masters; a mountainscape after Wang Meng (1308–1385); and a solitary elegant peak, like the landscapes of the early seventeenth-century painter Wu Pin. The figure studies are done in the "plain drawing" (pai-miao) style inspired by the Sung master Li Kung-lin, and the two flower drawings show the artist's familiarity with the scholar-gentleman and decorative traditions.

SEATED FIGURE OF BODHIDHARMA

Kiln complexes in the vicinity of the town of Te-hua in Fukien province were the source of a special type of porcelain known in the West as *blanc de chine*. These pieces have an extremely fine-grained vitreous white body, coated with a thick, satiny glaze that ranged in tone from milky white through warm ivory to a faint rose.

This seated figure of Bodhidharma, the Indian sage who brought Ch'an (Zen) Buddhism to China, is a superb example of work produced at the Te-hua kilns. The fine modeling, seen here in the knit brows, the sensitive molding of the cranium, and the expression of devout concentration, idealized but at the same time very human, is a hallmark of the work of Te-hua craftsmen during the seventeenth and eighteenth centuries, as are the fluid folds of the man's robes and the rich perfection of the glaze. The kilns had been active for many centuries, producing mostly cups and bowls, but only at this stage did the production of figures assume an important role.

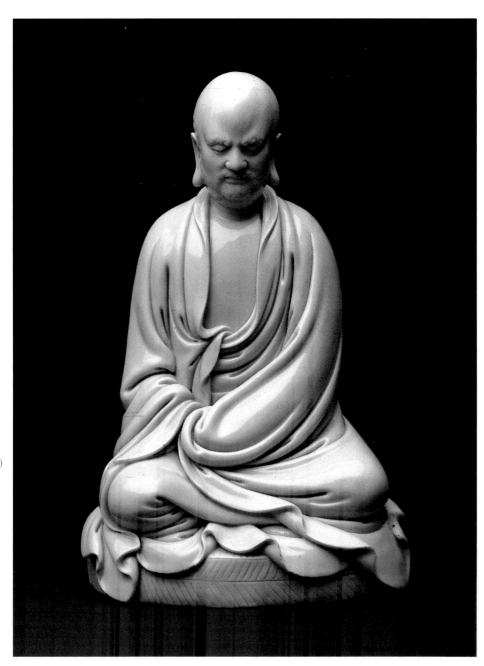

58 *Seated Figure of Bodhidharma*, 17th c.
Chinese; Ming dynasty
Porcelain; H. 11¾ in. (29.8 cm.)
Gift of Mrs. Winthrop W. Aldrich,
Mrs. Arnold Whitridge, and
Mrs. Sheldon Whitehouse, 1963 (63.176)

詰曲憑高胎眾勝閒

安可藉人傳想當射晶

丹成候業巳森之脈甲金

黄海蟠龍松拈生坐

樗菴先生義

弘仁

HUNG-JEN
Dragon Pine on Mount Huang

Hung-jen was a central figure in the Anhwei school of painters, a group bound by a preference for regional scenery as a subject, astringent literati taste, and a loyalty to the defeated Ming dynasty. Like many of his fellow loyalists, Hung-jen became a Buddhist monk to avoid service in the new Manchu realm. The subject of this painting is a tortuously bent pine, clinging to the summit of a granite peak in the Huang mountain range. Besides depicting a characteristic scene in southeastern Anhwei, the painting is an image of a noble and tenacious scholar, bent and twisted by unfolding events, but clinging nonetheless to his native soil. The enduring vitality of the pine is described by Hung-jen in a verse he added to the picture. It speaks of the old pine's bark as scales, and its needles as claws:

> Coiled above a mountain peak, his physique is superb.
> How old is he? What man can tell?
> When the Yellow Emperor was compounding the elixir of
> immortality, at the beginning of time,
> [The pine's] dense scales and claws were already
> fully grown.

Energy seems to flow between rock and pine roots along lotus veins in the bony mountain. Relying on spatial inversions, disorienting scale, and juxtapositions of ink tone, Hung-jen turned the tip of a mountain peak into a monumental composition.

59 Dragon Pine on Mount Huang
Hung-jen, 1610–63
Chinese; late Ming to early Ch'ing dynasty
Hanging scroll; ink and slight color on paper;
75⅞ x 31¼ in. (192.7 x 79.4 cm.)
Gift of Douglas Dillon, 1976 (1976.1.2)

60 Serried Peaks amid Clouds and Mist, ca. 1655 (detail)
Li Tsai, act. late 16th c. to mid-17th c.
Chinese; late Ming to early Ch'ing dynasty
Handscroll, ink and color on paper. Overall.
13½ x 365¾ in. (34.3 x 929 cm.)
Purchase, John M. Crawford Jr. Gift, 1977 (1977.87)

LI TSAI
Serried Peaks amid Clouds and Mist

The painter of this work, Li Tsai, was a native of Fukien active in the middle of the seventeenth century. Virtually nothing is known about his personal life; this magnificent handscroll is left as testimony of his talent, and also of his sense of humor and self-deprecation. In an inscription on the scroll (referring to a famous art collector who lived from 1525 to 1590), he wrote: "In Hsiang Yüan-pien's collection I once saw Ma Yüan's painting, *Layered Peaks among Clouds.* Unfortunately, it was not protected from fire and is already destroyed. Today, in order to conjure up its idea, I have done this painting by blending the methods of the four masters Tung [Yüan], Chu [-jan], Ma [Yüan] and Hsia [Kuei]. [Done in] a winter month of the year *i-wei* [probably 1655] to give my friend Ch'ing-hsia Tao-yu a laugh."

Serried Peaks amid Clouds and Mist combines the monumen-tal, macrocosmic landscape of the Northern Sung painters with the evocative, void-filled mistiness of Southern Sung works. Although experimentation of this sort was quite common at the time, Li Tsai's melding of styles is unique. What is special to Li Tsai is the combination of fantastic elements (the exaggerated range of craggy mountains) with the real-life observation evident in his use of perspective. He traced the paths of receding valleys by means of ever-smaller houses and denoted increased distance by interposing a veil of mist. These methods, already commonplace in Western art, were novel in seventeenth-century China.

That this work was well received may be deduced from the accolade mounted on a blank page at the front of the work. Written by Huang Yüeh (1750–1841), it reads: "Ex-cellent Brushwork and Wonderful Ink."

61 Whiling Away the Summer at the Thatched Hut of the Inkwell, 1679 (detail)
Wu Li, 1632–1718
Chinese; Ch'ing dynasty
Handscroll; ink on paper;
14¹¹⁄₁₆ x 105¾ in. (37.3 x 264.5 cm.)
Purchase, Douglas Dillon Gift, 1977
(1977.81)

Wu Li
Whiling Away the Summer

Wu Li, in common with other orthodox Chinese painters, would almost certainly have made a career in government service had it not been for the fall of the Ming dynasty and the installation of the alien Manchus (the Ch'ing dynasty). One of six artists of the seventeenth century known collectively as the Great Masters, and including the Four Wangs (see Plate 63), Wu Li joined the disciples of the venerable orthodox painter Wang Shih-min (1592–1680), who looked to the great sixteenth-century innovator Tung Ch'i-ch'ang for instruction and inspiration. Wu Li was totally committed to mastering the traditional artistic heritage of his forebears, and wrote: "To paint without Sung and Yüan styles as a foundation is like playing chess without chess pieces. Facing the empty board, where does one begin?"

Tung Ch'i-ch'ang had bequeathed to painting a systematized calligraphic formula transformed into a pictorial language. The early Ch'ing masters used it to create a new pictorial structure. Wu Li demonstrated his genius by transforming the ancient brush idioms into his own, new, personal style. His brushwork was superb, precise, and almost as sharp as an engraving.

The tranquil landscape presented here would appear to be autobiographical, since the artist's inscription reads: "At the first clearing of the spring rain, [I] sat alone in the early dawn at the Inkwell Thatched Hall; and taking the composition of 'Passing the Summer' of the ancients as my teacher, [I painted this]. . . ."

A quiet scholar's cottage, simple in itself, but set in a compound complete with library, servants' quarters, and a lily pond, looks out upon rising boulders, a bamboo grove, and distant mountains and ricefields. A strong breeze blows through the bamboo leaves on the left and carries the mountain mist across the top of the scene. The whole picture is made in a monochrome, elegant silvery-gray tone that is a perfect example of Wu Li's skill in creating a luminous atmosphere with fine gradations of shading.

An interesting footnote to the life of Wu Li is the fact that, in 1681, this conservative, proudly traditional artist converted to Christianity, becoming a priest in 1688, and ending his life as a missionary in Shanghai. These dramatic changes in his personal life, however, seem to have had no influence on his painting style, although the rival claim to his time by missionary work may account for his limited artistic output.

Kung Hsien

Ink Landscapes with Poems

Loyal to the Ming regime, Kung Hsien fled Nanking in 1645, when the city fell to the Manchus. He lost many members of his family and spent the next few years "preserved through reclusion and purified in retirement"—a description taken from one of his own poems. He eventually returned to Nanking in the mid-1650s and came to terms with his identity as a leftover citizen (*i-min*) under the Ch'ing dynasty. His works continued to express his bitterness at the devastation of his homeland.

Kung had a remarkable ability to paint simultaneously with words and images. As a painting teacher who wrote several manuals for painters, he perfected an ink-wash and

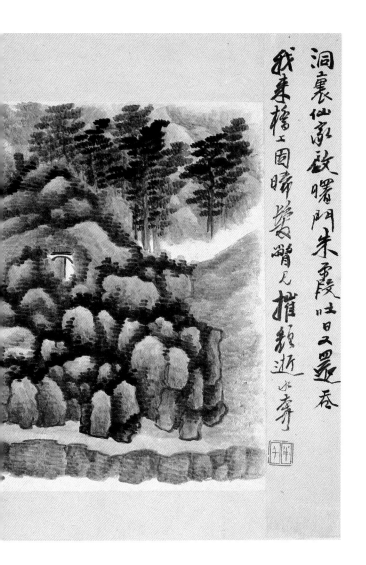

62 *Ink Landscapes with Poems*, 1688 (details)
Kung Hsien, ca. 1619–89
Chinese; late Ming to early Ch'ing dynasty
Album of sixteen paintings; ink on paper;
each leaf: 13¹⁵⁄₁₆ x 20⁹⁄₁₆ in. (35.4 x 52.2 cm.)
Gift of Douglas Dillon, 1981 (1981.4.1h,i,m)

dotting technique that enabled him to achieve both translu-
cency and striking density in his paintings. The album of
paintings, *Ink Landscapes with Poems*, one leaf of which is
illustrated here, was made the year before his death. It
compares his favorite haunts in and around Nanking with
the abodes of the immortals. Basing his brushwork on the
systems taught by the great Tung Ch'i-ch'ang (1555–1636),
who dramatically changed the course of Chinese landscape
painting, Kung treated each leaf as an isolated composition,
perfectly matching painting and poem. Each image has its
own brush vocabulary and, therefore, individual structure
and feeling.

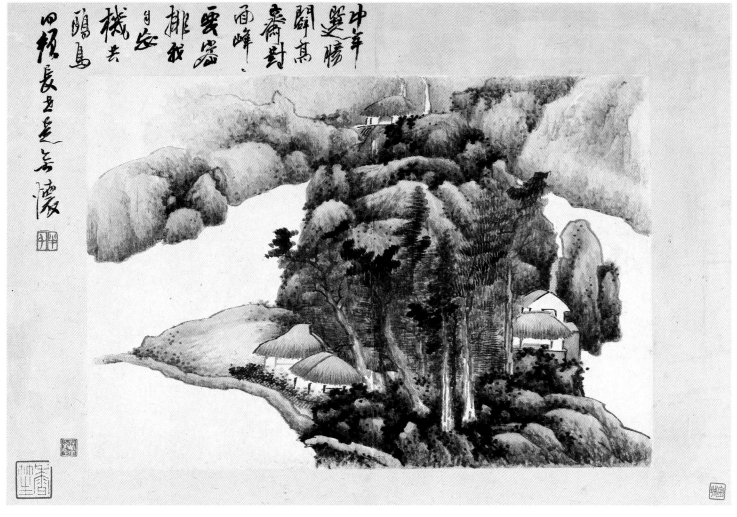

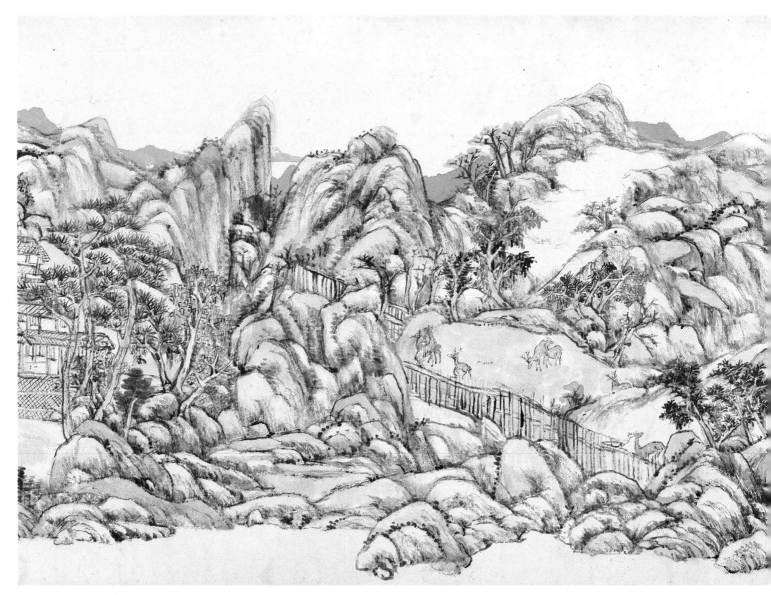

63 *Wang Ch'uan Villa*, 1711 (detail)
Wang Yüan-chi, 1642–1715
Chinese; Late Ming to early Ch'ing dynasty
Handscroll; ink and colors on paper;
Overall: 14⅜ x 214⅞ in. (36.5 x 537.2 cm.)
Purchase, Douglas Dillon Gift, 1977 (1977.80)

WANG YÜAN-CH'I
Wang Ch'uan Villa

Born in the mid-seventeenth century, at the point of tran-
sition from the Ming to the Ch'ing dynasty, Wang Yüan-ch'i
was the last and greatest of a family of scholar-officials
known to posterity as the Four Wangs. Under the Manchus,
founders of the new dynasty, a period of peace and pros-
perity was established, and over the next two-and-a-half cen-
turies, Chinese culture and art flourished. This encouraging
climate did not develop immediately; it took time to allay
the suspicions of the old Chinese families with regard to
their new rulers, and early Ch'ing art was divided into the
conservative "Orthodox school" that clung to the past, and
the individualists who followed new paths.

Collectively, the Four Wangs epitomized the Orthodox
school, but Wang Yüan-ch'i, the youngest of the group, was
the most original, and his work bridged the gap between
the two schools. He turned to the past for inspiration but
revitalized it and used it more in the spirit of *hommage* than
as a technique. His brushwork was bold, and he introduced
arbitrary angles into his landscapes that have led them to be

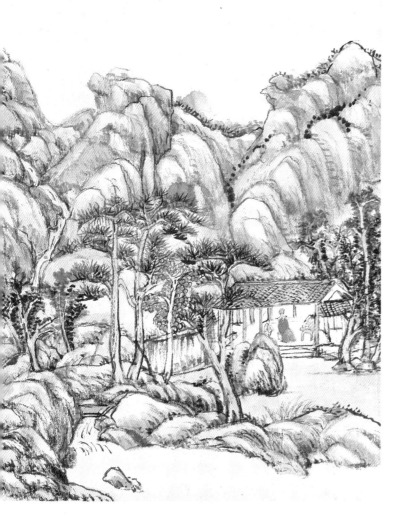

O V E R L E A F :

THE GOD OF WEALTH IN CIVIL AND MILITARY ASPECT
(Pages 102–103)

In his civil aspect, this popular deity is seated on a gilded silver throne, wearing his most sumptuous clothes. His filigreed hat is set with pearls, jade, and kingfisher feathers, and his yellow gown is figured with a four-clawed dragon. He wears a flower-strewn cape on which two lush peonies have been worked so that they lie symmetrically on each shoulder. *The God of Wealth in Military Aspect* is equally impressive, with similarly rich clothing and headdress. They appear to have been made as a pair of icons, and both were obviously intended for a household or temple already enriched by his blessing.

These large figures are decorated in the *famille verte* palette of enamels. These were applied directly to the prefired, or biscuited, body. The technique of "enameling on the biscuit" was developed during the fifteenth century and remained popular thereafter. The finely differentiated decoration of the god's robes demonstrates the advantages of this method of achieving delicate ornamentation.

compared stylistically to the works of the Postimpressionist painter Paul Cézanne.

Wang Ch'uan Villa is a familiar subject of literati painting, based on twenty poems by the T'ang artist and poet Wang Wei (A.D. 699–759), describing scenic views on his country estate. Paintings of Wang Wei's poems can be traced as far back as the tenth century. Wang Yüan-ch'i modestly noted that he had followed the themes of earlier painters, but it is immediately apparent that his work is very different from the earlier painstakingly detailed, episodic versions. He has created a wholly new composition in which the twenty views are unified into a dynamic sequence whose spontaneous structure is echoed in free, crisp brushwork and lucid color.

At the front of the scroll he transcribed the texts of the poems. His crisp *hsing* (semicursive) calligraphy shows the same authority as his painting style, reflecting the confidence imbued by years of training as a scholar and government official. Wang Yüan-ch'i's influence can be clearly seen in the paintings of the following generations.

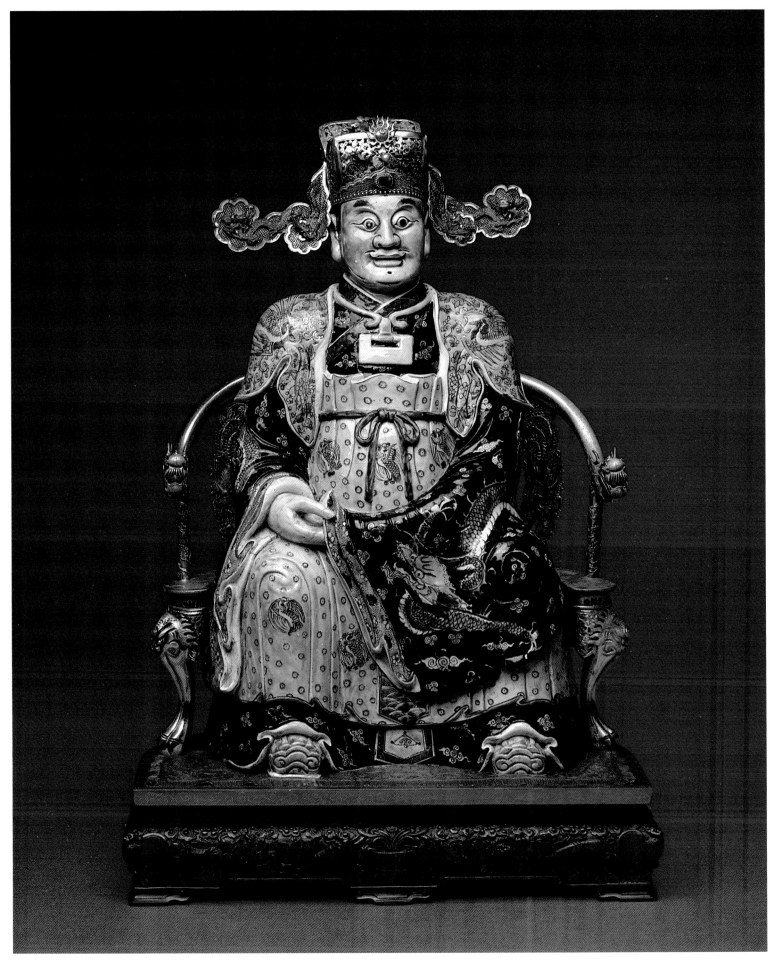

64 The God of Wealth in Military Aspect, late 17th or early 18th c.
Chinese; Ch'ing dynasty
Porcelain painted in polychrome enamels on the biscuit;
H. 22⅞ in. (58.1 cm.)
Bequest of John D. Rockefeller, Jr., 1960 (61.200.12abc)

Page 101:text

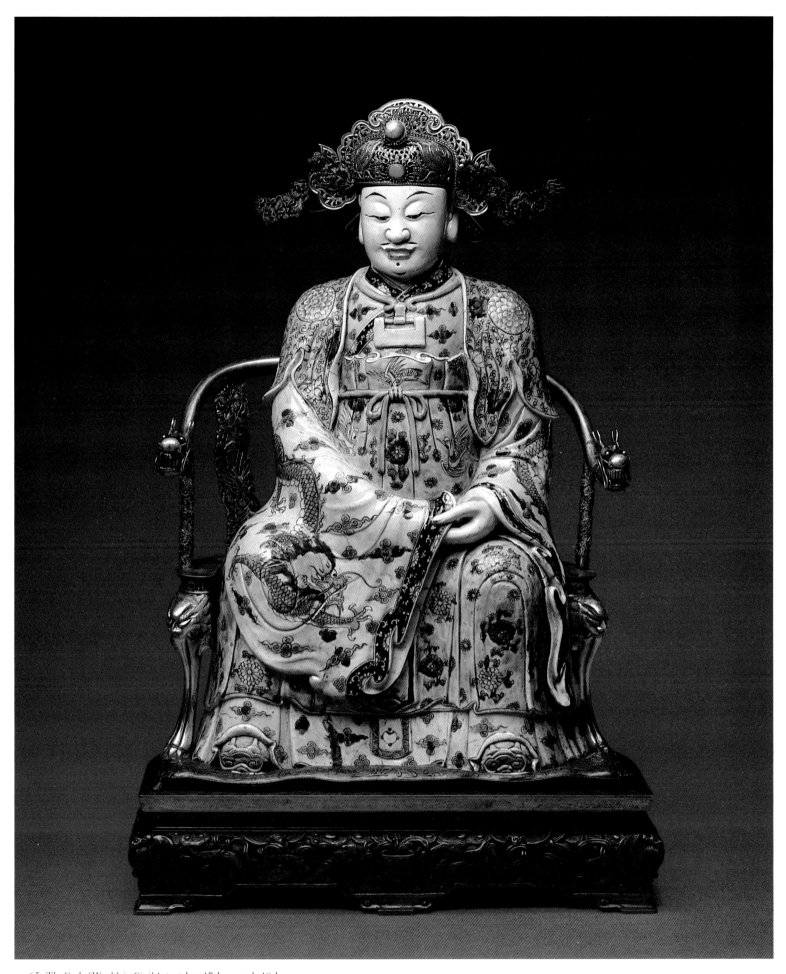

65 *The God of Wealth in Civil Aspect*, late 17th or early 18th c.
Chinese; Ch'ing dynasty
Porcelain painted in polychrome enamels on the biscuit;
H. 23⅞ in. (60.6 cm.)
Bequest of John D. Rockefeller, Jr., 1960 (61.200.11 abc)
Page 101: text

66 *The Sixteen Lohans*, 1667 (detail)
Tao-chi, 1642–1707
Chinese; Ch'ing dynasty
Handscroll; ink on paper; Overall:
18½ x 236 in. (47.2 x 599.4 cm.)
Gift of Douglas Dillon, 1985
(1985.227.1)

TAO-CHI
The Sixteen Lohans

Tao-chi was a member of the Ming imperial family. As a young man, he took refuge in the Buddhist priesthood to escape death during the political struggle at the fall of the Ming dynasty. He remained in seclusion, training himself to paint, throughout the late 1660s and the 1670s, and his great handscroll, *The Sixteen Lohans*, painted in 1667 when he was in his twenties, was created during this time of seclusion. In later life he returned to the outside world, moving to Yang-chow, a city that had become a commercial hub under the Manchus and was now overtaking Soochow as an artistic

center. It sustained a flourishing art market and valued orig-
inality, eccentricity, and skill—all of which Tao-chi had in
abundance. At a time when Chinese painters were experi-
menting with alternative forms of representation and self-
expression, Tao-chi's innovative approach and techniques
reached a receptive audience. He was well received by his
contemporaries, and his influence on the eccentric painters
of the eighteenth century was marked.

The portrayal of a religious subject is a rarity for Tao-chi,
who is largely known for his brilliant visionary landscapes.

In this work he portrayed the guardian lohans who were
ordered by Buddha to live in the mountains and await the
coming of Maitreya, the Future Buddha. His style was pat-
terned on the works of the late Ming painters such as Wu
Pin, although his energetic brushwork, his finely drawn but
animated figures, and the swirling background, have more
immediacy and momentum. He built his forms with simple,
centered strokes, using the movement of his whole arm and
body. His figures are carefully observed, showing such qual-
ities as humor and curiosity and awe.

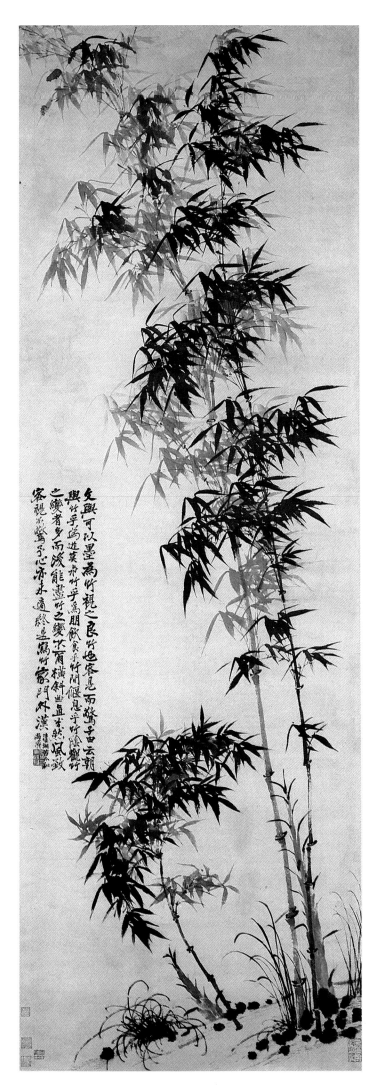

TAO-CHI
Bamboo in Wind and Rain

Despite his years as a priest, Tao-chi's avowed interest was in painting, not Ch'an Buddhism. He sought to realize the unity of *hsin* (heart-mind) with the subjects he painted, and identified intimately and passionately with landscapes and bamboo. On this monumental work, he quoted a description by Su Ch'e (1039–1112) of Wen T'ung, a Northern Sung bamboo painter:

> He dallies amid bamboo in the morning, stays in the company of bamboo in the evening; he drinks and eats amid the bamboo, and rests and sleeps in the shade of bamboo. Having observed all the different aspects of the bamboo, he then exhausts all the bamboo's many transformations....

Bamboo is shown in this painting at several stages of growth—from shoots to lush, low growth, to mature stalks. The gusty wind whips the branches, and the leaves are weighted by rain, but true to its nature, the plant bends without breaking and endures adversity. The energy of the supple plant is felt in every stroke. Beautifully modulated ink creates both space and a unifying medium that brings the picture close to calligraphic display.

Tao-chi's use of a seal referring to himself as "Bitter-melon monk of Ch'ing-hsiang Chi" dates the painting prior to 1697, by which time he had renounced his monastic vows and built a private studio.

67 Bamboo in Wind and Rain
Tao-chi, 1642–1707
Chinese; Ch'ing dynasty
Hanging scroll; ink on paper;
133 x 37¼ in. (337.8 x 94.6 cm.)
Gift of Douglas Dillon, 1984
(1984.475.2)

TAO-CHI
Wilderness Colors

Tao-chi's passionate quest for the essentials of creation led to his theory of *i-hua*, which means both "one stroke" and the "painting of unity." In the single irrevocable stroke, which demarcates and creates, the action of the painter initiates the process of change and renewal.

Tao-chi's album of twelve leaves is a visual enactment of his philosophy. Each leaf is a fresh print of his heart, mind, and hand. The subject of the eighth leaf, like several others in the album, is raw vegetables. The plump eggplants and the reed that binds them are so swiftly and cleanly drawn that we feel the lot was freshly gathered in the market. The drawing, calligraphy, and comments are as vibrantly "raw"

荣辱之风东偏任你畫堂多
塩醬老夫今日聽盖北末濟菜辣
蓬生吞郤別巨根芽
石濤濟枝下

as the vegetables themselves. The ability to transcribe his "raw" nature directly onto "raw" paper in the form of common eggplants and fleshy calligraphy, producing a harmony thoroughly descriptive of life, was Tao-chi's response to the aesthetic debate in the seventeenth century over the value of technical ability in painting and calligraphy. This gentleman who longed for the ordinary things of life often wrote enigmatically, but always, it seems, in search of an original simplicity:

> The perfect man has no method. But it is not that he does not have method; he has the perfect method that is no method.

68 Wilderness Colors: Eggplants (detail)
Tao-chi, 1642–1707
Chinese; Ch'ing dynasty
Album of 12 leaves; ink and color
on paper; each leaf:
10⅞ x 8½ in. (27.6 x 21.5 cm.)
The Sackler Fund, 1972 (72.122h)

69 *The Palace of Nine Perfections*
(Chiu-ch'eng kung), 1691 (detail)
Yüan Chiang, active ca. 1690–ca. 1746
Chinese; Ch'ing dynasty
Set of 12 hanging scrolls; ink and colors
on silk; 81½ x 221¾ in. (207 x 563 cm.)
Purchase, The Dillon Fund Gift, 1982
(1982.125)

Yüan Chiang
The Palace of Nine Perfections

Yüan Chiang was a central figure in a group of professional artists who flourished in Yangchow in the early eighteenth century, at a time when the city had become a leading area of artistic activity. Strongly influenced by earlier painters, especially those of the Northern Sung dynasty (960–1127), his style was nonetheless his own idiosyncratic vision.

According to brief biographies, Yüan Chiang was appointed court painter after 1723, but little is known about his role, since few works survive from these years. Furthermore, he was not sought out or celebrated by the elite: While popular with the newly wealthy merchant class, his exceptional talent was not greatly esteemed by the educated who considered his painting craftsmanship rather than art.

The Palace of Nine Perfections, dated 1691, is one of the largest portable paintings produced at this period. It was made as a screenlike set of scrolls, probably intended to cover the back wall of a large reception hall. It is a tour de force of descriptive detail and imagination, since it is a portrait of the Chiu-ch'eng palace, built during the Sui dynasty (589–618), rebuilt in altered form about two hundred years later, and subsequently totally destroyed. During its glory it served as a summer retreat where the emperor could escape the heat of Sian.

But the painting was also an opportunity to depict a contemporary phenomenon. In 1689, two years before the painting of the Palace of Nine Perfections, the K'ang-hsi emperor paid an imperial visit to the city of Yangchow. A new interest in the Manchu throne may have been kindled by the vast retinue, colorful processions, and the imperial presence. In an appropriately antique fashion, Yüan Chiang made reference to the recent historical event: At the lower right of the painting, outriders pass over a high-arched marble bridge, preceding their emperor, who rides beneath a suspended canopy. Riders follow, each carrying an object of imperial ritual paraphernalia. And, in the section shown here, in the richly appointed halls where the blue-green colors evoke associations with the paradises of the immortals, the staff restlessly awaits the arrival of the emperor.

70 *The Ch'ien-lung Emperor's Southern
Inspection Tour*, ca. 1776 (detail)
Hsü Yang, active ca. 1750–after 1776
Chinese; Ch'ing dynasty
Handscroll; ink and colors on silk;
Overall: 27¾ x 438 in. (70.5 x 1112.5 cm.)
Purchase, The Dillon Fund Gift, 1984
(1984.16)

HSÜ YANG

The Ch'ien-lung Emperor's Southern Inspection Tour

This set of twelve oversize scrolls by the noted Soochow art-
ist Hsü Yang was commissioned by the Ch'ien-lung emperor
(r. 1736–95) to commemorate a major event of his reign—a
tour of southern China made in 1751. This tour served both
as a manifestation of his political presence throughout his
territories and to inspect the conditions of the area. The
commissioning of this documentary work was probably stim-
ulated by a record of a similar tour by the emperor's grand-
father, K'ang-hsi, ninety years earlier. The earlier work, a
vivid record of Manchu court patronage, differed from this

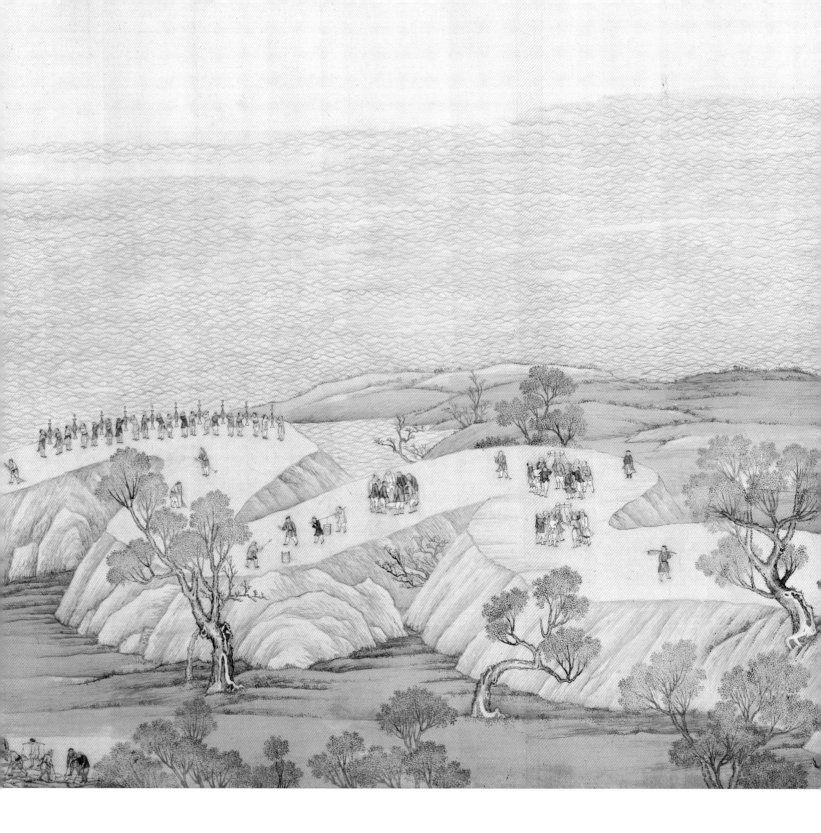

work in that it portrayed virtually the entire route of the K'ang-hsi emperor's tour, whereas Hsü Yang has used each scroll to focus on a single point of Ch'ien-lung's journey.

The scroll seen here is the fourth in the series, and it portrays the inspection of flood control techniques, ranging from the complexity of double sluice gates to the simple imposition of large bundles of reeds to stem the flow of water. The first half of the scroll is devoted to the inspection of the system installed according to the design of the sixteenth-century hydraulic engineer P'an Chi-hsün to con-

trol the waters at the junction of the Huai and Yellow rivers. The intention was to direct the clear water of the Huai River into the silt-laden Yellow River, so as to increase the current and wash some of the sediment out to sea.

The style of the painting, made in about 1776, reveals the influence of the Jesuit artists, especially Giuseppe Castiglione (1688–1766), whose Western style was popular at the court of Ch'ien-lung. This is especially evident in the effort to create a unified panorama and to present anatomically accurate figures.

The Astor Court

The Astor Court is adapted from a small courtyard in a scholar's garden in Soochow, a city inland from Shanghai in southern China. Known as the Garden of the Master of the Fishing Nets, it is one of several famous urban gardens in Soochow built by scholar-officials as a place of refuge from the bustle of city life. Scholars usually designed their gardens themselves, seeking to partake of the rhythms of the seasons, of sun and shadow, of mountains and rivers, within the walled enclosures of their working and living quarters. By ingenious arrangements of rocks, plantings, and pools, pavilions and paths, and poetic evocations of other places and times, they created microcosms limited only by the "peaks and valleys in their bosoms." They reproduced cosmic patterns, using the complementary polarities of yin and yang expressed in tensions between soft and hard, dark and light, fixed and moving, water and mountains.

Within the walls of the Museum, in the heart of a busy city, one enters the Astor Court under a plaque that reads: "In search of quietude." The polarities of yin and yang are immediately experienced as one passes through the round "Moon-gate" into a small, dark vestibule, and then through a rectangular door into the brightness of the open-air garden. The dynamic polarity of water and mountains is the essence of landscape, and a Chinese garden is richly endowed with emblems of both. In the Astor Court, the Cold Spring Pool bubbles at the foot of fantastic limestone rocks set like peaks in a towering range. Rock clusters in the Astor Court are all prized limestone boulders from the bottom of Lake T'ai, where the action of water and sand has sculpted beautiful recesses and contours. The garden architecture also creates space and variety according to the principles of yin and yang. On the west wall of the Astor Court, the Cold Spring Pavilion with its upswept eaves provides a place of rest from which to view the garden and listen to the soothing murmur of the pond. By contrast, the covered walkway along the opposite wall offers views that change with each angle and bend in the path. Alternating rhythms of openness and closure, of light and dark, are carried beyond the walls by a planted light well glimpsed through windows in the walls that are each a different lattice pattern.

Construction of the Astor Court was the first permanent cultural exchange between The People's Republic of China and the United States. Between January and May 1980, twenty-seven Chinese craftsmen and engineers assembled and dressed the pieces of the Court, which had been prepared in China, including pillars, tiles, rocks, and masonry. The lattice and railings of the Ming Room facade (at the north end of the Court) are of ginkgo and camphor, and the beams are fir. Pillars throughout the Court are made of *nan* wood, a rare species of broad-leafed evergreen prized for its resistance to insects and its honey-brown color. The gray terra-cotta bricks and tiles used in the floor and roofs of the Astor Court were fired in an eighteenth-century imperial kiln in China, reopened for the purpose.

Funded by the Vincent Astor Foundation, the courtyard is an elegant and peaceful environment for contemplation of the values of traditional China that produced the art displayed in the adjacent Douglas Dillon Galleries.

71 *The Astor Court*, made possible by The Vincent Astor Foundation

LAY ARISTOCRAT'S ROBE

Tibetans had a keen appreciation for the dragon robes the Manchus had devised as formal attire for their new Ch'ing court. The Manchu dragon robe was based on riding costumes and allowed for considerably greater mobility than did the yards of silk and deep sleeves of the traditional Chinese dress. Dragon robes were cut according to two basic styles—the *ch'ao fu*, modeled on an assembly of coat, aprons, and vest, and the *ch'i fu*, a long, slim garment with closely fitting sleeves, slit in the front and back of the skirt for men, and at the sides for women.

The Tibetans adapted the Manchu robes and the prized Chinese silks for use by their own aristocracy. They particu-larly favored the styles of the early Ch'ing court, such as the five-clawed dragon robe used in this *chuba*, composed of a *k'o-ssu* dragon robe of the K'ang-hsi period and pieces of eighteenth-century floral satins. The five-clawed dragon dominates the ornamentation on the gold field. Manchurian cranes, symbols of longevity, fly over roiling waters along the hem. A robe such as this, in accordance with Lhasa sumptuary laws, could be worn only by princes of the church and certain lay aristocrats. Since few early Ch'ing dragon robes remain, Tibetan *chuba* provide valuable information about early Ch'ing styles before standardization and further Sinification took place.

72 *Lay Aristocrat's Robe (Chuba)*,
18th–19th c.
Tibetan
Tapestry of woven silk yarns
and silk yarn wrapped with gold;
62 x 75 in. (157.5 x 190.5 cm.)
Rogers Fund, 1962 (62.206)

BODHISATTVA OF TRANSCENDENT WISDOM

Tibetan Buddhism developed an elaborate system of meditative visualization techniques to awaken the mind from the passions, delusions, and aggressiveness of the human condition. This splendid temple hanging or *tangka* depicting Manjusri, the Bodhisattva of Transcendent Wisdom, was intended to assist in such meditative practices. It was made in China for the Tibetan market.

Manjusri is the bodhisattva dedicated to fearless proclamation of the Buddhist law. The law is symbolized by the book he holds, and the action of the law by the double-edged sword that cuts through illusion and ignorance. These attributes are supported on lotuses, symbolizing the process by which wisdom emerges from the mire of confusion. Manjusri wears the jeweled ornaments of a celestial being. In his crown and at the top of the *mandorla* around him is an image of the Buddha Akshoba, who embodies the nature of awakened wisdom. Manjusri's *mandorla* is garlanded with delicate appliqué flowers.

Astride his lion, whose mouth opens in a shuddering roar of truth, Manjusri rides through a delightful landscape. An adorer kneels at the left, and an icon of the Blue Manjusri appears on the right. Celestial musicians attend his manifestation on scudding clouds. The universe conjured in this image floods the mind of the practitioner with the warmth and openness of transcendental intelligence.

73 *Bodhisattva of Transcendent Wisdom*, 17th to 18th c.
Chinese; Ch'ing dynasty
Appliqué of various Chinese silks, ansilvered
and gilded leather shapes on satin ground,
embellished with silk cord and embroidery;
12 ft. 11 in. x 7 ft. 8 in. (3.94 x 2.34 m.)
John Stewart Kennedy Fund, 1915 (15.95.154)

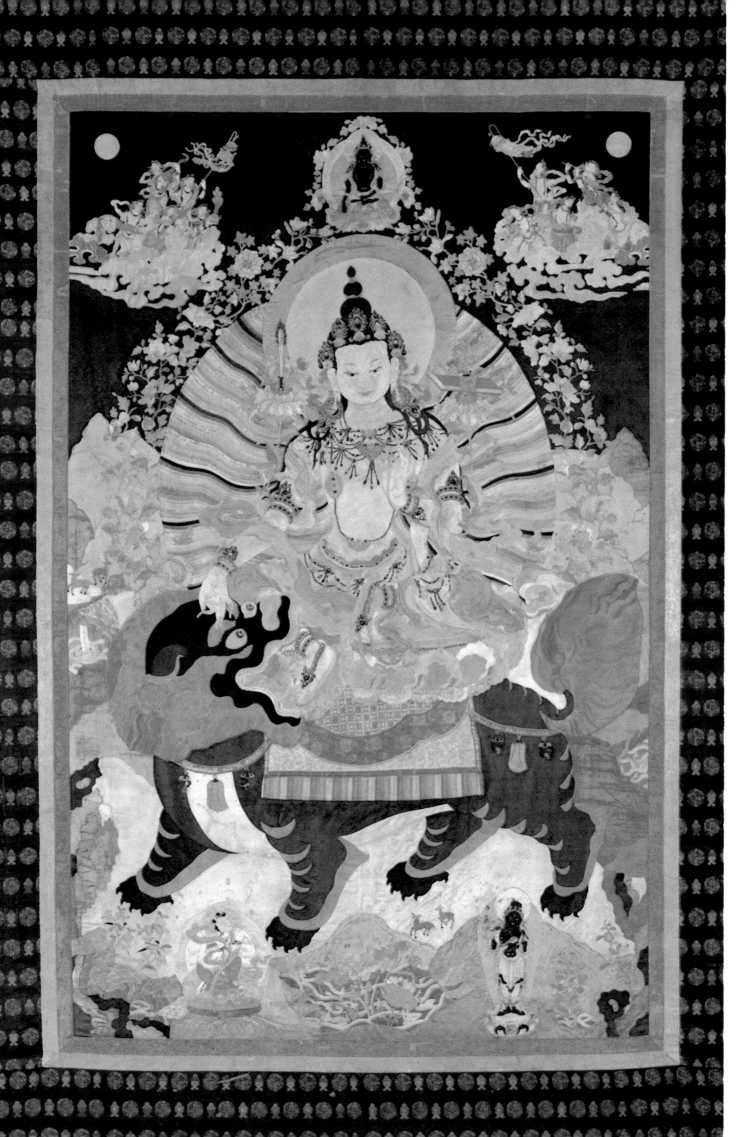

Twelve-Symbol Dragon Robe

The Manchus ruled China as the Ch'ing or "pure" dynasty from 1644 to 1911. Distinctive habits and social patterns coupled with admiration for Chinese culture produced a new official Ch'ing costume, the so-called dragon robe, that combined traditional Chinese symbolism with the simplicity and mobility of the Manchu riding coat. The most common style of dragon robe was known as a *ch'i fu*.

Dragon robes decorated with a set of twelve symbols, such as this particularly fine *ch'i fu*, were among the most ritually significant clothes worn at court. The set of twelve symbols has roots in China's antiquity: It was believed that they traditionally ornamented the robes worn by emperors as they performed yearly rites as intercessors for the people between Heaven and Earth. This Ch'ing twelve-symbol robe was probably intended for such a rite. The nine dragons are five-clawed, a motif reserved for use by the emperor and his family. The twelve emblems, which represent qualities of an emperor worthy to receive the Mandate of Heaven, are: the Sun, Moon, and Constellations; Mountains; the Dragon; the Five-colored Bird; the group including Cups, a Tiger, and a Long-tailed Monkey; the Water-weed; Millet; Fire; an Ax; and the Fu, a symbol that marks the harmonious relationship of ministers and ruler. The robe is embellished with additional requisite motifs: clouds, waves, mountains, symbolizing the Universe. In addition, this robe has *wan* and *shou* medallions, eight Buddhist emblems each with lotus garlanding, Taoist symbols, and bats. The ornament on the blue silk field is an ordered universe, symmetrically disposed about the center seam. This finely worked robe dates from the first half of the eighteenth century.

74 Twelve-Symbol Dragon Robe, first half of 18th c.
Chinese; Ch'ing dynasty
Blue silk warp twill with ornament in couched,
wrapped gold and silver yarns, except for
embroidered pale-blue eyes of dragon;
L., nape of neck to hem, 56⅞ in. (144 cm.)
Gift of Lewis Einstein, 1954 (54.14.12)

Opposite: detail

PAIR OF ROYAL EARRINGS

The place of these earrings in the history of Indian art is assured, not only for their intrinsic beauty, but also because of the light they shed on the superb quality of early gold-smithing in this region. Early Indian statues of both male and female figures were usually portrayed with elaborate jewelry that sometimes seemed fanciful, since very little comparable jewelry from that period survived. The discovery of this pair of earrings provided the first tangible evidence that the jewelry depicted by the sculptors was in fact based on real exemplars, for a very similar pair is shown on a first-century B.C. relief portrait of a Universal Ruler, the *Chakravartin*, from Jaggayapeta.

These earrings, judging from their material worth, the excellence of craftsmanship, and the use of royal emblems (a winged lion and an elephant) as part of their design, were most probably made as royal commissions. Each earring is composed of two rectangular, budlike forms, growing outward from a central, double-stemmed tendril. The elephant and the lion, of repoussé gold, are consummately detailed, using granules, snippets of wire and sheet, and individually forged and hammered pieces of gold. The two pieces are not exactly identical: On the underside they are both decorated with a classical early Indian design of a vase containing three palmettes, but the patterning of the fronds differentiates the two earrings. They are so large and heavy that they must have distended the earlobes and rested on the shoulders of the wearer, like the pair worn by the *Chakravartin*.

75 *Pair of Royal Earrings*, ca. 1st c. B.C.
Indian, probably Andhra Pradesh
Gold; (opposite above) right earring, top surface: L. 3 in. (7.7 cm.);
(opposite below) left earring, bottom surface: L. 3⅛ in. (7.9 cm.);
Gift of the Kronos Collections, 1981 (1981.398.3,4)

Below: Left earring, outer surface

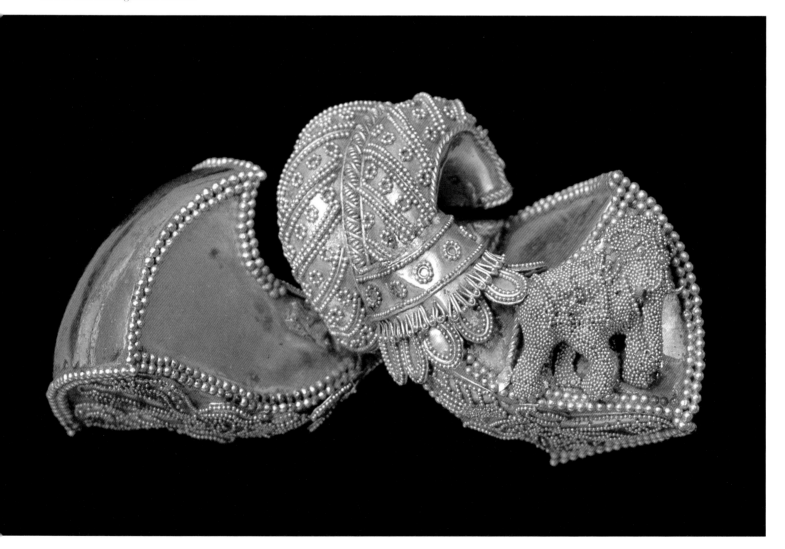

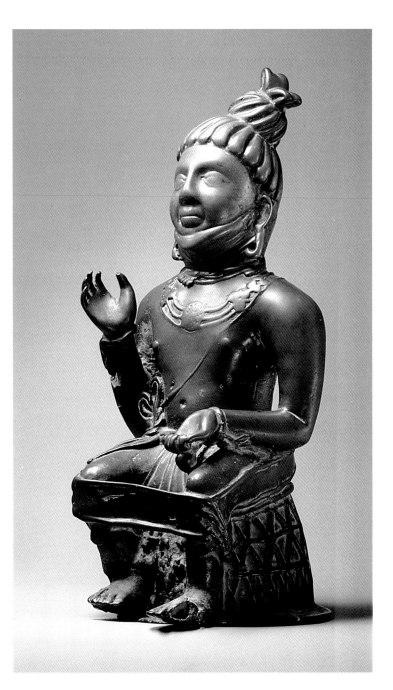

SEATED MALE DEITY

The history of early Indian figural sculpture, from the late Mauryan period to the early Gupta period (second century B.C. to fourth century A.D.) is known to us almost exclusively from stone and clay examples; very few metal sculptures of the period have survived, making the known examples extremely important.

The Museum's sculpture depicts a bearded male figure seated on a wickerwork stool. He is perhaps a *yaksha*, a category of male tutelary deity associated with, among other things, the mineral wealth of the world. Even though his legs are pendent, the deity wears the *yogapatta*, a cloth band used as an aid to support the legs when they are crossed in the difficult yogic meditative posture. His right hand is raised, and he holds what appears to be a very small vessel in his lowered left hand. He wears a torque, bracelets, and the Brahmanical sacred thread diagonally across his chest. His lower garment, a large panel of which falls between his legs, is secured by a double cord knotted at his right. His hair is arranged in a high bun, slightly coiled and pulled to the left side of his head.

This is one of the largest and most ambitious of the surviving early metal sculptures. It seems to have overtaxed the technological capabilities of its workshop; there are many casting faults. The figure remains, however, an object of very great presence, slightly enigmatic in its significance but clearly a sculpture of great importance.

76 Seated Male Deity, ca. 3rd c. A.D.
Indian, Bihar (?)
Bronze; H. 14½ in. (36.4 cm.)
Gift of Frank Weinstein, 1984
(1984.499)

77 Head of a Bodhisattva, Perhaps Siddhartha,
ca. 2nd–3rd c. A.D.
Afghan, Gandharan region
Terra-cotta with inset garnets;
H. 12¼ in. (31.1 cm.)
Purchase, Lita Annenberg Hazen
Charitable Trust Gift, 1986 (1986.2)

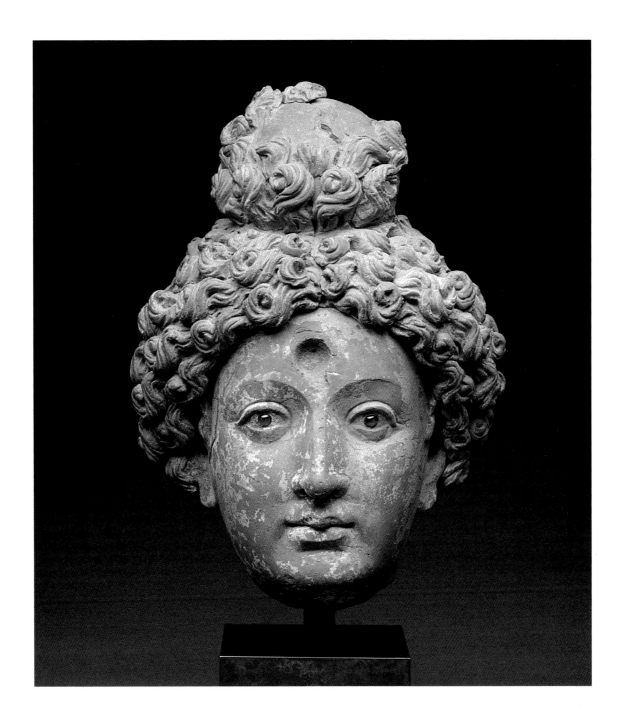

Head of a Bodhisattva, Perhaps Siddhartha

During the period from around the second century B.C. to the first century A.D., the area that is today east Afghanistan had a particularly complex political and cultural history. Following the death of Alexander the Great in 323 B.C., the region was ruled by Hellenistic Seleucid kings, Mauryas from northern India, Greco-Bactrians, Sakas, Indo-Parthians, and Kushans, among others. To extract from this rich mix a sense of specific stylistic progressions remains one of the art-historical problems that seem to have defied solution.

It is clear that the commingling of cultures prompted some very surprising hybrid styles. The one that is generally most familiar derives from the ancient Gandharan empire situated in parts of modern Afghanistan and Pakistan, where Buddhism flourished under the patronage of the Kushan rulers from the first century A.D. through the third. The sculptural styles which evolved in Gandhara were heavily dependent upon Hellenistic and Roman prototypes and thus have a very strong "classical" appearance. It is not clear how long this classical strain persisted, or for that matter, whether the classicizing aspect seen in specific sculptures is attributable to Hellenistic origins or Roman prototypes.

This extraordinary head of a beautiful youth turned Buddhist deity, possibly the Bodhisattva Siddhartha, can well serve as the paradigm for that singular marriage of classical styles and Buddhist iconography. The direct modeling of the pliable clay clearly contributes to the sense of spontaneity and immediacy about this sculpture, but its compelling presence also derives from the inset garnet pupils, which make the face come alive. This very rare embellishment confirms the high order of importance of the original, larger composition from which this head came. The contrasts established by the smooth surfaces of the face, the mass of carefully articulated writhing locks of hair, and the garnet eyes, attest to the artist's high level of aesthetic sensibility.

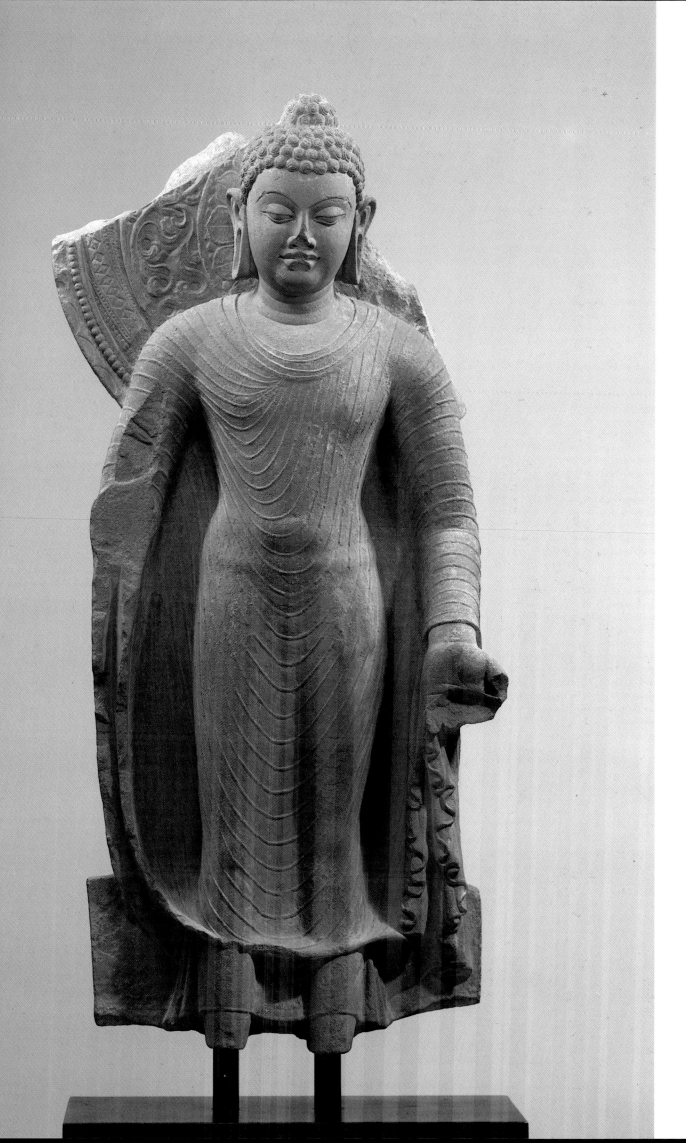

Standing Buddha

The Gupta dynasty, which reigned over a large area encompassing much of northern and central India and part of the Deccan, came to power during the first half of the fourth century A.D. During the next two centuries, which were generally prosperous, the arts and sciences flourished under lavish imperial patronage. The highly refined system of aesthetics made Gupta sculpture, particularly as practiced in its two greatest centers, the holy cities of Mathura and Sarnath, one of the most successful styles in the history of art.

This sculpture of the Buddha exemplifies the style developed in Mathura during the Gupta period. The serene face is full, with rounded cheeks, fleshy lips, almond-shaped eyes, and high, gracefully arched eyebrows. The clinging garment, with a linear pattern of stringlike folds, reveals the well-modeled and elegantly proportioned body beneath. The right hand, now missing, was originally raised in the fear-allaying gesture (*abhaya mudra*) and the lowered left hand holds a portion of the garment. The immutable composure, the calm magnificence, characteristic of the finest early South Asian sculpture, is presented to the worshiper as the ultimate fulfillment.

78 Standing Buddha, 5th c. A.D.
Indian, Mathura
Mottled red sandstone;
H. 33⅝ in. (85.5 cm.)
Purchase, Enid A. Haupt Gift,
1979 (1979.6)

Standing Buddha

Many Gandharan sculptures in stone, clay, and stucco have survived, but sculptures in bronze are quite rare. Some of these bronzes depict the standing Buddha, an icon that served as one of the chief prototypes for early Buddhist images and iconography throughout the Far East and southern Asia. The importance of these small, portable bronze images cannot be overestimated.

This bronze standing Buddha represents the Gandharan style at the height of its maturity. The Buddha is posed on a stepped pedestal. His right hand is raised in the *abhaya mudra* gesture, while his other hand holds the hem of his outer garment. The elaborate body halo, or *mandorla*, which creates a perfect frame for the figure, has an outer perimeter of stylized flames and an attractive floral rinceau. This small sculpture is not only a superb work of art, but is also one of the most important bronze sculptures of the ancient Buddhist world.

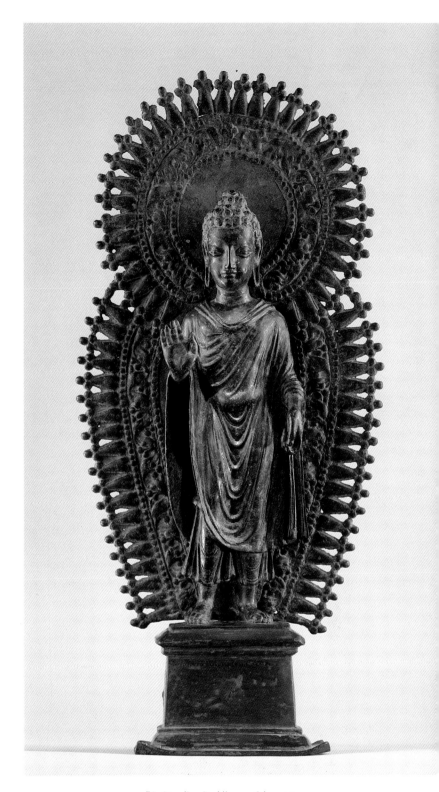

79 Standing Buddha, ca. 6th c. A.D.
Pakistani, Gandhara
Bronze; H. 13¼ in. (33.6 cm.)
Purchase, Rogers, Fletcher, Pfeiffer
and Harris Brisbane Dick Funds and
Joseph Pulitzer Bequest, 1981 (1981.188)

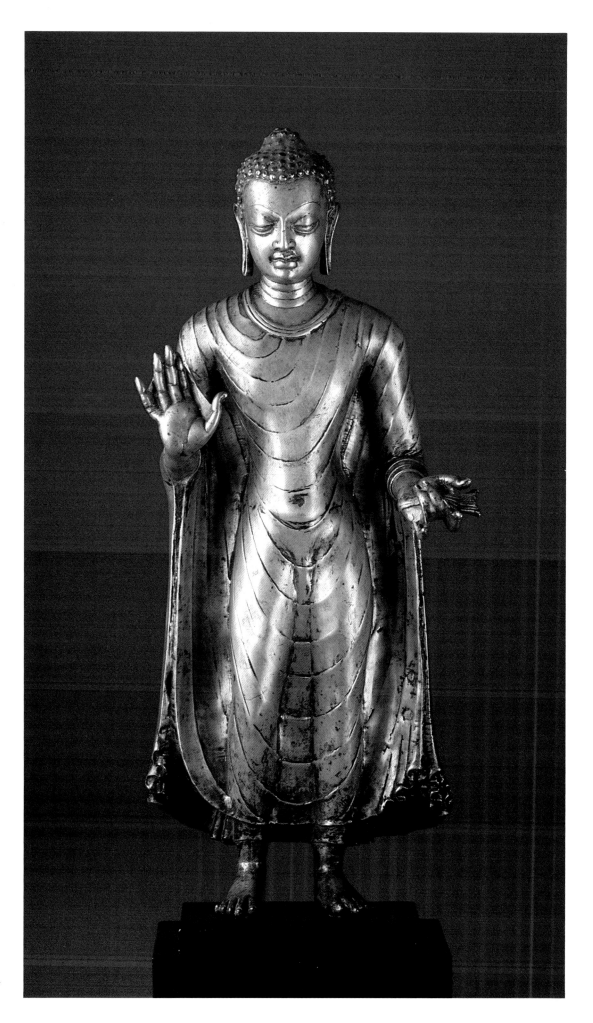

80 Standing Buddha,
first half of 7th c. A.D.
Northern Indian
Bronze; H. 19½ in. (49.5 cm.)
Purchase, Florence Waterbury
Bequest, 1969 (69.222)

STANDING BUDDHA

Dating to the late Gupta period, this image is stylistically dependent on forms developed in Uttar Pradesh and Madhya Pradesh during the sixth century A.D. In its turn, this type of northern Indian sculpture played a major role in the formation of early Nepalese styles. The exact provenance of this statue is unknown, but it is believed to have come out of Nepal. Many Indian Buddhist icons were transported to Nepal and Tibet following the destruction of monasteries in northeast India during the twelfth century.

The Buddha seen here combines stylistic traits from both Mathura and Sarnath, the two most important artistic centers of the period. The clear delineation of the folds of the Buddha's monastic robe follows the Mathuran mode, while the elegant body and facial features seem to reflect the influence of the style that prevailed at Sarnath. The mathematical exactitude and modeling of this image exemplify the aesthetic canons of the day.

PADMAPANI LOKESHVARA SEATED IN MEDITATION

This rare sculpture, probably from the Swat Valley in Pakistan, closely reflects the inspiration of the Gupta idiom of northern India during the sixth century A.D., and represents a transitional stage between those styles and the great eighth-century sculptural traditions of Kashmir. It represents the Bodhisattva Padmapani Lokeshvara, the lotus-bearing manifestation of the Lord of Infinite Compassion—Avalokiteshvara—who can be identified by the lotus he holds, as well as by the small image of the Buddha Amitabha, his "spiritual father," which is seen in his chignon. His relaxed posture is known as *lalitasana*, and his gaze suggests a contemplative mood. The pensive bodhisattva was an important cult image in Asia, and this enigmatic pose is found in many different contexts and eras throughout the area. It is, however, clear that the prototype came from India. This particular type of pensive image can be traced directly to Kushan period sculptures from Gandhara and Mathura.

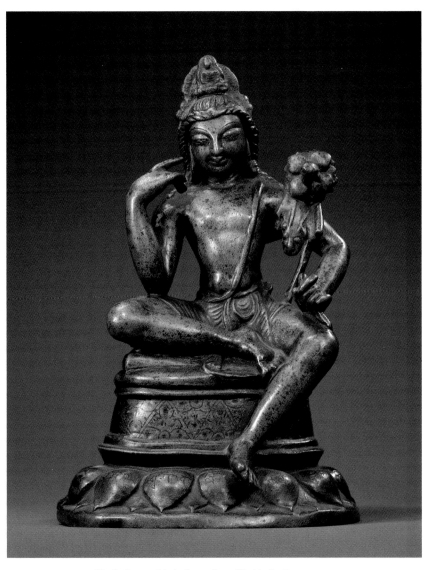

81 Padmapani Lokeshvara Seated in Meditation,
first half of 7th c. A.D.
Pakistani, Swat Valley region, or Indian, Kashmir
Bronze inlaid with silver and copper;
H. 8¾ in. (22.2 cm.) Purchase, Harris Brisbane Dick
and Fletcher Funds, 1974 (1974.273)

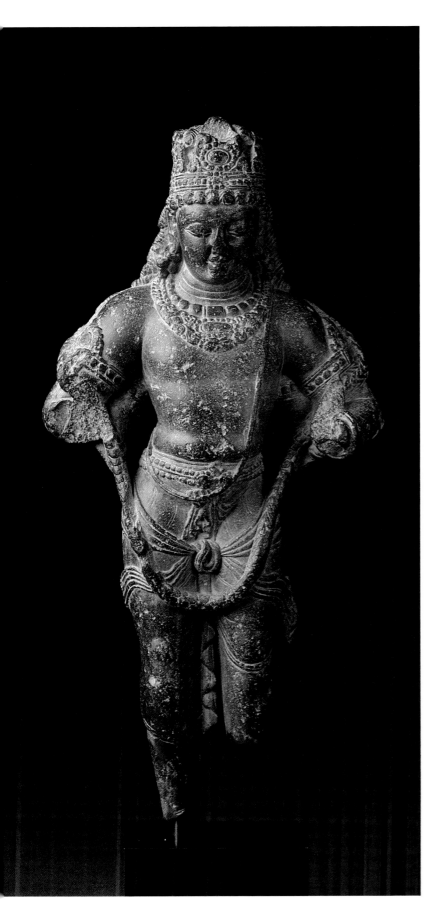

STANDING FOUR-ARMED VISHNU

In Indian sculpture it is usual for the body to be conceived of as a container or vessel for the sacred breath, which expands from within, making the skin so taut that the musculature is concealed. Kashmiri sculpture, on the other hand, follows Gandharan traditions, which usually render the standing bodhisattva as a figure with a full, well-muscled chest. The tradition is clearly continued by this four-armed Vishnu. He stands in a slightly hipshot posture, wearing a three-lobed tiara with two pleated ribbons falling from a knot at the back of his head. He is elaborately bejeweled, and his auspicious symbol, in the form of a slightly raised lozenge, appears on his chest. All this rich surface decoration is in marked contrast to the rippling muscles of the chest and the other areas of bare flesh. The majestic presence of this image is enhanced by a sense of inner spiritual strength.

This Vishnu appears to be transitional, retaining the sculptural vigor of earlier styles while foreshadowing the fully developed Kashmiri styles of the second half of the eighth century. It is not only one of the earliest Kashmiri stone examples found in Western collections, it is also one of the finest.

STANDING FOUR-ARMED DURGA

This standing four-armed female deity is flanked by two small male attendants on a stepped pedestal. The deity is richly adorned with jewels and wears a trilobed tiara. Her elaborate costume includes the pointed tunic so often worn by females in Kashmiri sculptures. All of this is rendered with an unusual and meticulous precision, providing a useful description of costume of the period. The deity holds a sword in her lower right hand and a bell with attached ribbons in her lower left. Her raised front right hand is missing but was probably held in the fear-allaying gesture, and in her raised front left hand she holds what appears to be the head of a ram, but which probably represents a rhyton. Incised on her forehead is a vertical third eye. These characteristics identify the deity as Durga, a form of the goddess Devi.

82 Standing Four-Armed Vishnu,
late 7th c. A.D.
Indian, Kashmir
Stone; H. 18¾ in. (47.5 cm.)
Gift of The Kronos Collections,
1982 (1982.462.9)

83 Standing Four-Armed Durga,
late 9th c. A.D.
Indian, Kashmir
Stone; H. 12⅜ in. (31.4 cm.)
Gift of Mr. and Mrs. Perry J.
Lewis, 1984 (1984.488)

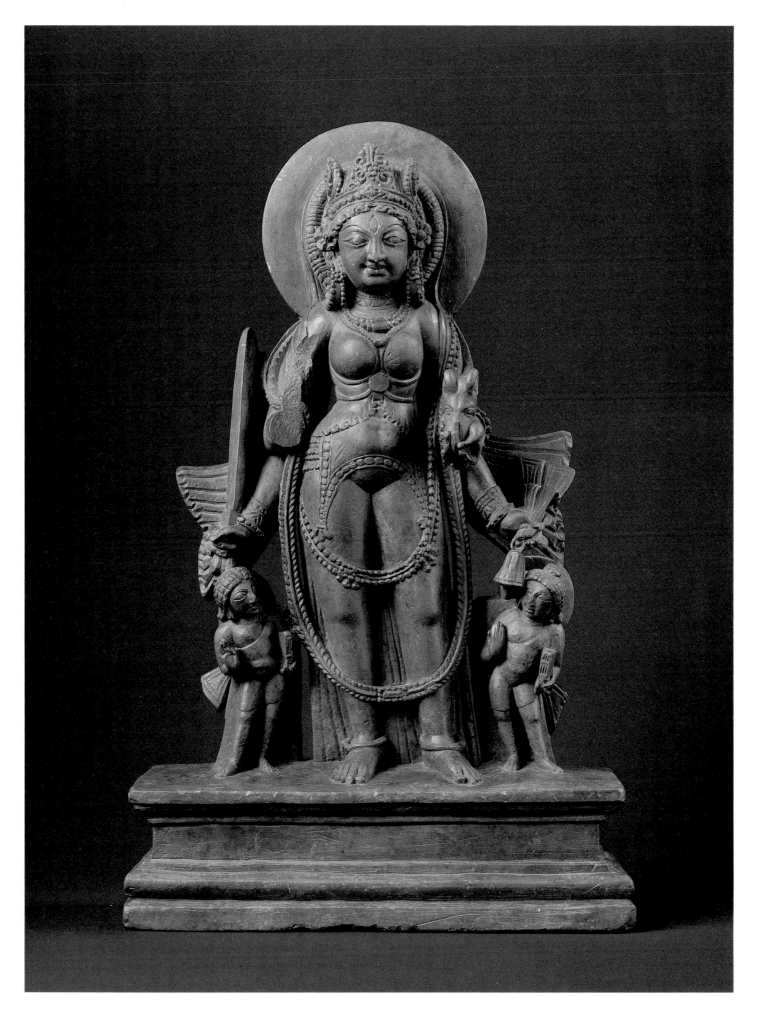

84 Reliquary
late 9th–early 10th c. A.D.
Indian or Pakistani, Kashmir region
Bone with traces of polychrome and cold gold;
5⅜ x 4⅜ in. (13.6 x 11.1 cm.)
Gift of The Kronos Collections, 1985 (1985.392.1)

RELIQUARY

Among the rarest and most beautiful ivory carvings from any culture are the famous eighth-century examples, probably numbering fewer than fifty, from Kashmir. These are clearly the products of extraordinarily sophisticated and technically skilled ivory-carving workshops. The recent discovery of this remarkable bone carving, dating no earlier than the ninth century, testifies to the continuation of skills that had been thought to have died out by this time, and extends the ivory-carving tradition by at least a century.

Carved from an approximately triangular section of bone,

believed to be from an elephant, this object with three scenes depicted on it, was probably part of a reliquary. The first two scenes show the miraculous birth of Siddhartha, later to become the Buddha, and the temptation of Siddhartha as he meditated at Bodhgaya immediately prior to attaining enlightenment and becoming the Buddha. The third scene, illustrated here, seems to be by a different hand. It is clearly the main scene of the carving, showing a rare representation of the crowned and jeweled Buddha seated cross-legged on a lion throne.

LINGA WITH HEAD OF SHIVA

In Indian sculpture and that of countries influenced by Hindu theology, worship of the *linga* (phallic emblem) is understood to be worship of the great generative principle of the universe, conceptualized as one great aspect of Lord Shiva. The *linga* is usually the most sacrosanct icon of a Shaivite temple, housed in the main sanctuary. It can be plain, or have carved on it one to five faces of Shiva.

The *linga* seen here is an orthodox representation of an *ekamukhalinga*, which has one face of Shiva. His hair is arranged in a double bun, decorated with a crescent moon, one of his common attributes, signifying the movement of time; individuated locks of wavy hair spread outward in a partial embrace of the phallus. The god is wearing earrings and a necklace, and the vertical third eye is seen on his forehead. The work is a masterpiece of the Shahi school of eastern Afghanistan, which worked almost exclusively in white marble and produced some extraordinary Hindu sculptures during the seventh through the ninth centuries. Only a small number survive to attest to this remarkable production.

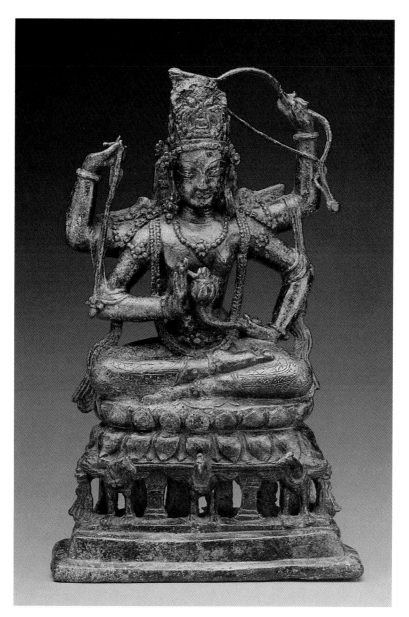

85 *Linga with Head of Shiva*, 9th. c. A.D.
Afghan, Shahi period
White marble; H. 22⁷⁄₁₆ in. (57 cm.)
Rogers Fund, 1980 (1980.415)

86 *Vajradharma Lokeshvara*, 9th c. A.D.
Pakistani, Swat Valley region
Bronze inlaid with silver; H. 15½ in.
(39.4 cm.) Gift of
Mrs. Abby Aldrich Rockefeller, Jr.,
1942 (42.25.20)

VAJRADHARMA LOKESHVARA

Of great iconographic rarity and unusually large size, this image was one of the first Swat Valley bronzes to be seen in the West. The seated bodhisattva can be identified as Vajradharma Lokeshvara by the peacocks on the pedestal, the orthodox vehicle for this deity, and by the singular gesture of opening the lotus flower at his breast. Additionally, he holds a bow and arrow and has in his headdress a representation of his spiritual preceptor, the Buddha Amitabha. The bodhisattva also has associations with the more important Manjushri, who often holds the bow and arrow, and who in rare cases also has the peacock as his vehicle.

It is only in the past few decades that the bronzes of the Swat Valley have been properly identified and their importance appreciated.

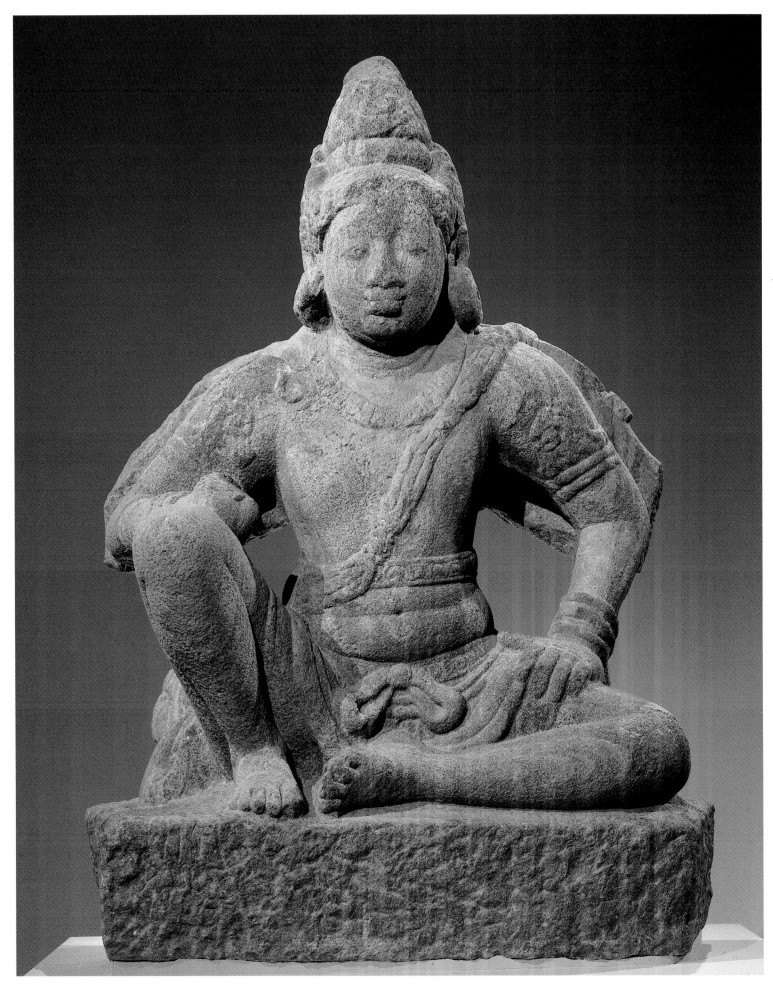

87 *Garuda Seated in Royal Ease,*
second half of 8th c. A.D.
Indian, Tamil Nadu, Madurai region
Granite; H. 54¼ in. (137.8 cm.)
The Alice and Nasli Heeramaneck Collection.
Gift of Alice Heeramaneck, 1983 (1983.518)

Opposite: back view *Page 132:* text

GARUDA SEATED IN ROYAL EASE *(Pages 130-131)*

While less well known than other southern dynasties, the Pandyas, ruling from around Madurai, left a small but nevertheless superb sculptural legacy. This rare Pandya sculpture represents the great bird, Garuda, seated in the posture of royal ease *(maharajalilasana)*. The only avian characteristics depicted here are his wings, the tips of which are broken off. Carved completely in the round, the figure has a noble and serene presence. The modeling is skillful and sensitive; large volumes harmoniously join to create a sense of organic expansion. The large, round head supported by powerful shoulders suggests the great strength of the royal bird, who serves as the vehicle for the Hindu god Vishnu. In the original temple setting, this statue would have stood near to Vishnu.

Of the many varieties of granite found in the Pandya area, this striated stone with its orange tinge is particularly appealing and is an added embellishment to a superb sculpture.

BRAHMA

This large seated representation of Brahma, first member of the Hindu trinity and creator of the world, is a very distinguished example of Chola period stone sculpture. The Cholas ruled from the Tanjore area of Tamil Nadu, slightly northeast of the Pandyas of Madurai, and during their long and powerful reign, Hindu temples of considerable importance were erected throughout the empire. This Brahma originally came from such a temple.

The four-headed, four-armed deity is seated in the relaxed posture known as *lalitasana*, on a double-lotus pedestal. He holds the rosary and a lotus bud and makes the gesture of allaying fear with one raised hand. He is dressed in garments and jewelry typical of early Chola sculptures. The large masses are carefully balanced to create an image of great harmony and compositional integrity, whose volumes combine with a naturalistic logic.

88 Brahma, 10th c.
Indian, Tamil Nadu, Tanjore region
Stone; H. 58 in. (147.3 cm.)
Egleston Fund, 1927 (27.79)

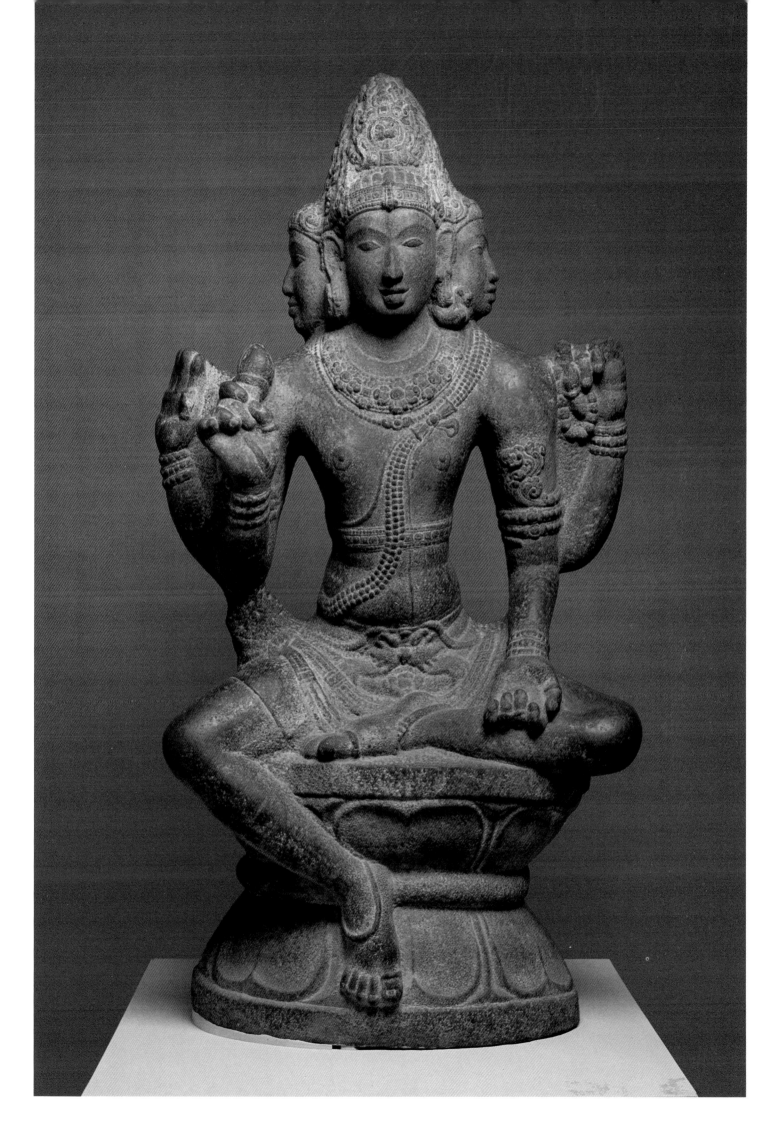

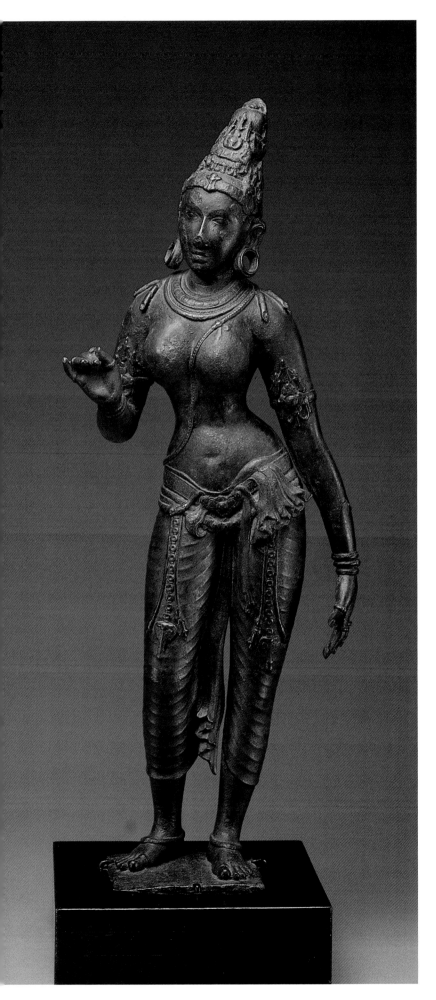

STANDING PARVATI

This sculpture of Parvati, made in tenth-century southeast India, at the beginning of the Chola dynasty, represents one of the greatest treasures in the Metropolitan Museum, and is surely one of the finest Chola representations of Parvati to be found outside India. The genius and obvious skills of her creator have resulted in a timeless conceptualization of the goddess, and a female figure of surpassing beauty and grace.

Parvati, consort of the god Shiva and mother of the elephant-headed god, Ganesha, stands in the graceful *tribhanga* (thrice-bent) pose, one arm delicately positioned at her side, the other raised. She is richly adorned with jewelry; her hair is piled high and secured with ornaments. The lyrical, rhythmic carriage and the soft, yet firm lines of her body suggest the ideal of the divine and eternal female.

89 Standing Parvati, first quarter of 10th c.
Indian, Tamil Nadu, Tanjore region
Bronze; H. 27⅜ in. (69.5 cm.)
Bequest of Cora Timken Burnett, 1956
(57.51.3)

STANDING VISHNU

The god Vishnu has figured throughout the development of Hindu traditions as one of its three chief deities. In later Hindu theology, Brahma was the Creator, Shiva was the Destroyer, and Vishnu, the Preserver. He is most commonly portrayed, as in this tenth-century southern Indian sculpture, holding militant attributes befitting his protective role. In his upper right hand he is holding a *chakra*, a flaming disk that was a martial implement; his upper left hand displays a conch shell (used as a trumpet in battle); his lower left hand makes the gesture of holding a mace; and his lower right hand displays the traditional fear-allaying gesture. He is crowned and heavily bejeweled, and across his chest he wears the sacred thread *(yajnopavita)* worn by all upper-cast Hindus.

The superb quality of this sculpture exemplifies the high standards achieved by early Chola sculptors. Such works were normally kept in the sanctuaries of temples. They were provided with rings at the four corners of the base so that they could be strapped to a platform and carried during ceremonial processions. The upright prongs at each side originally supported a halo.

90 Standing Vishnu, third quarter of 10th c.
Indian, Tamil Nadu, Tanjore region
Bronze; H. 33¾ in. (85.7 cm.)
Purchase, John D. Rockefeller 3rd Gift,
1962 (62.265)

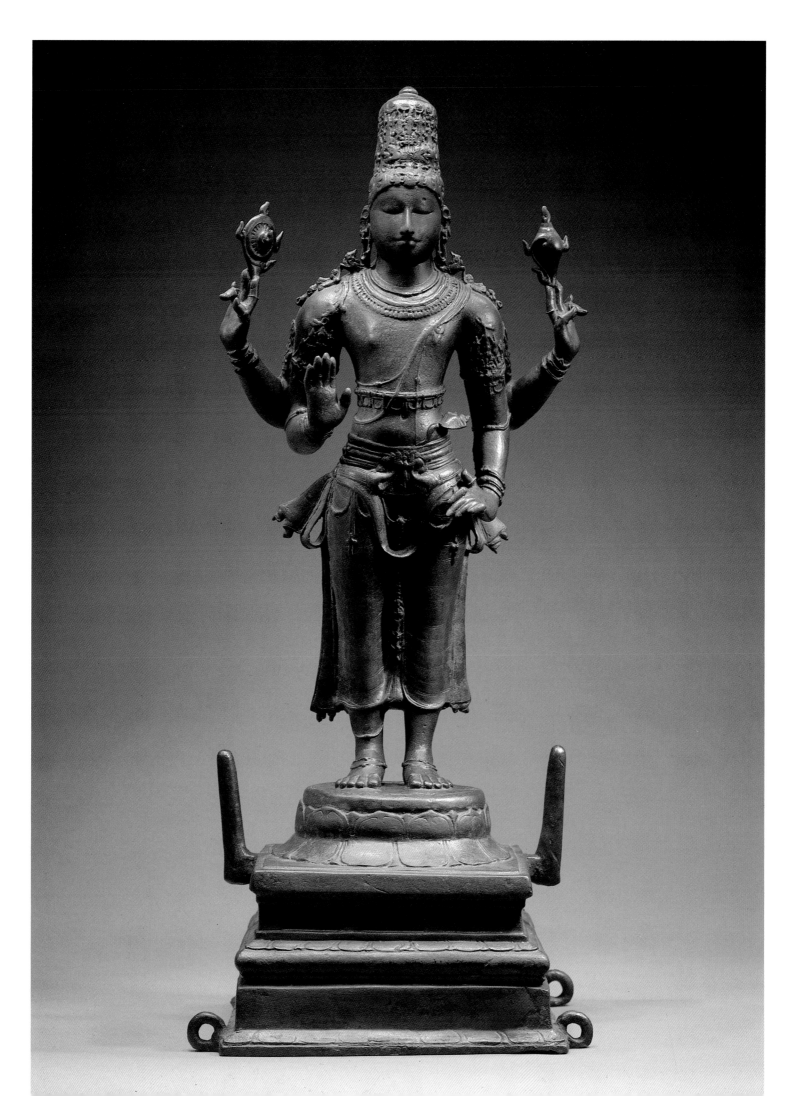

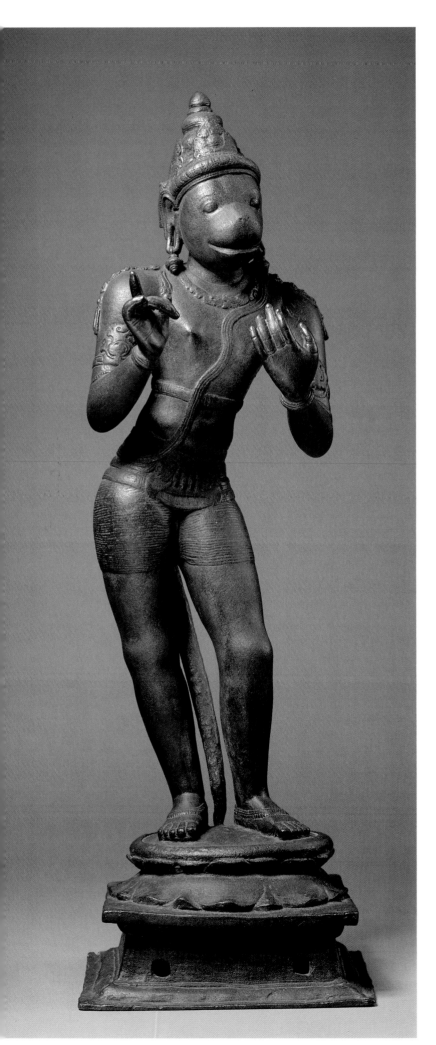

STANDING HANUMAN

The story of Hanuman, the leader of the great monkey clan, is not only one of the most charming and appealing in all Hindu theology, it is also of great didactic and moral value. As recounted in the Hindu epic, the *Ramayana*, the courage and loyalty of Hanuman make him the supreme example of those virtues. In Chola bronze sculpture, Hanuman is almost always depicted standing and bent slightly forward, as if in obeisance before Rama. He is usually part of a larger group that includes Rama, his brother Lakshmana, and Sita, the wife of Rama.

Standing on a double-lotus pedestal on a tiered base, Hanuman is shown in graceful *contrapposto*, his left leg bent and the weight of his body resting on his rigid right leg. He leans forward and gestures as though engrossed in conversation. Except for his thick tail and simian face, he is represented as human. Hanuman is dressed in a *dhoti* and wears a crown and the usual jewelry of the period. The sacred thread is worn diagonally across his chest.

Chola representations of Hanuman are rare, and this example is probably the finest one known. It is therefore a sculpture of major importance as well as a wonderful example of Chola artistry at its apex.

91 *Standing Hanuman*, 11th c.
Indian, Tamil Nadu, Tanjore region
Bronze; H. 25⅜ in. (64.5 cm.)
Purchase, Bequests of Mary Clarke Thompson, Fanny Shapiro, Susan Dwight Bliss, Isaac D. Fletcher, William Gedney Beatty, John L. Cadwalader and Kate Read Blacque, by exchange; Gifts of Mrs. Samuel T. Peters, Ida H. Ogilvie, Samuel T. Peters and H. R. Bishop, F. C. Bishop and O. M. Bishop, by exchange; Rogers, Seymour and Fletcher Funds, by exchange; and other gifts, funds and bequests from various donors, by exchange, 1982 (1982.220.9)

YASHODA AND KRISHNA

Krishna, whose legend is told in Books Ten and Eleven of the great Hindu epic, the *Bhagavata Purana*, was threatened as a baby by the wicked tyrant Kamsa. To protect him, his parents, Devaki and Vasudeva, hid him with a cowherd and his wife, Yashoda. He survived to become the hero of many well-loved stories, and also the mischievous young man portrayed in Plate 101.

Depictions of Yashoda holding her foster-son, Krishna, are rare, especially in sculptural form. Here she is seen nursing the infant god, cradling his head with one hand while the other gathers him close. This is assuredly one of the most intimate and tender portrayals in the history of Indian art. One quality that makes the otherwise secular scene iconic is the way in which Yashoda gazes directly toward the worshiper.

The date of this sculpture is problematic, and no evidence is available to replace its fourteenth-century date.

92 *Yashoda and Krishna*, ca. 14th c.
Indian, Karnataka
Copper; H. 13⅛ in. (33.3 cm.)
Purchase, Lita Annenberg Hazen Charitable Trust Gift, in honor of Cynthia Hazen and Leon Bernard Polsky, 1982 (1982.220.8)

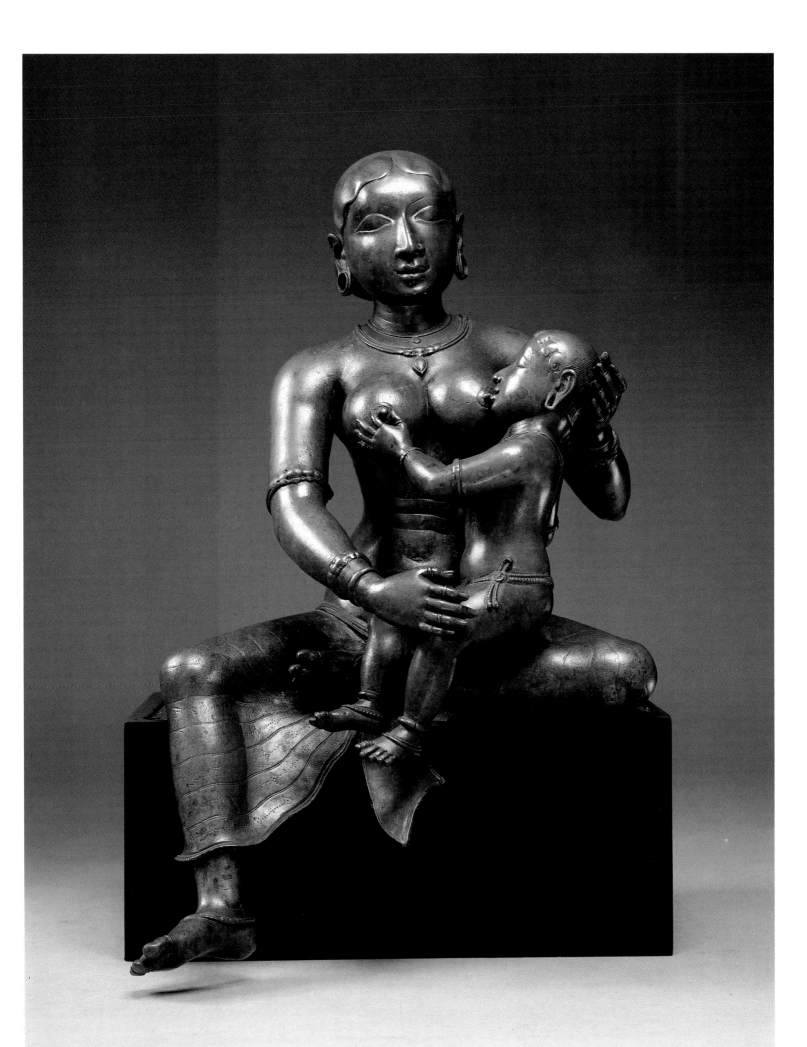

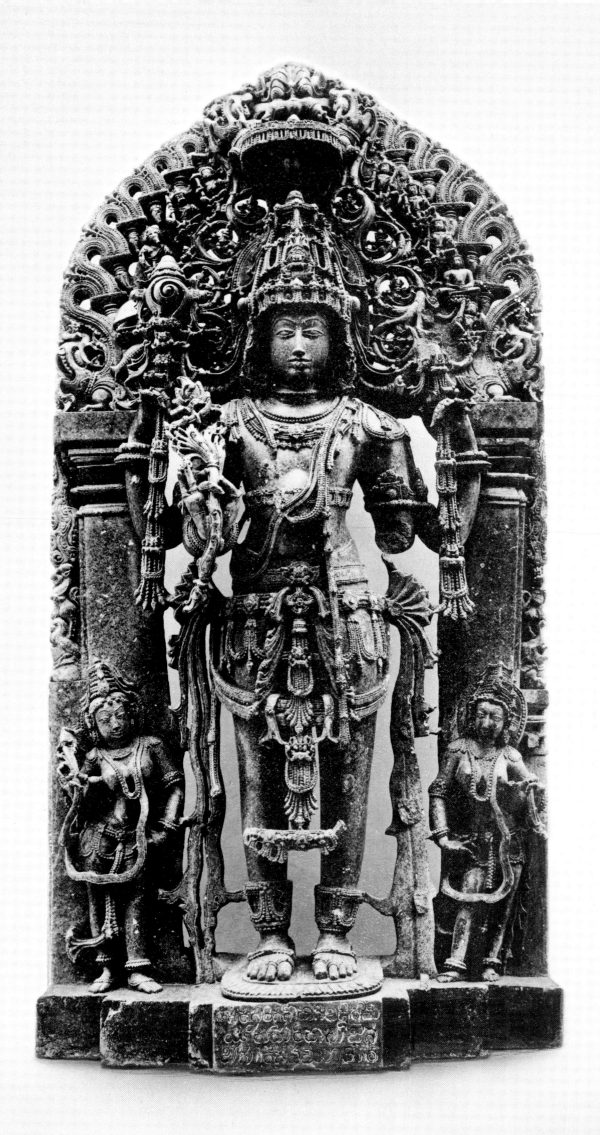

DASOJA OF BALLIGRAMA
Standing Vishnu

The Hoysala rulers of the Mysore area of southwest India began to establish power during the eleventh century. They consolidated their kingdom early in the twelfth century, and began an active program of temple construction—those at Belur and Halebid probably being the most famous.

This large image of Keshava, one of the twenty-four manifestations of Vishnu, is a Hoysala masterpiece. Vishnu is in the hieratic *samabhanga* posture, with both feet uniformly placed on a flat lotus pedestal. He is flanked by his consorts, Shridevi and Bhudevi. The upper portion of the sculpture has a decorative outer perimeter composed of the stylized tails of two *makaras*, mythological composite aquatic creatures who symbolize auspiciousness. Surrounding Vishnu's head are his ten *avataras;* starting from the right is Matsya, the fish avatar, and going clockwise, the final avatar is a seated Kalki with a sword and shield.

Hoysala sculpture is quite distinctive; its style is unlike that of other Indian sculpture. It sometimes appears stolid and heavy, a tendency which even its emphasis on pierced, open-work canopies and fretwork cannot conceal. Figures are at times so overwhelmed by their own bulk and heavy decoration that little sense of movement can be conveyed. Most Hoysala sculpture is pierced and drilled, concerned with the play of light over highly decorative surfaces rather than with pure forms. However, since the Museum's Vishnu was carved early in the evolution of Hoysala style, these tendencies are displayed in moderation.

This great image of Vishnu is unique in the Museum's collection because it is inscribed with the name of its carver. On the bottom register, in the center, an inscription records the image as the work of the sculptor Dasoja of Balligrama, an artist known to us from other inscribed images at Belur, where he and his son Chavana worked.

93 Standing Vishnu, ca. 1115–25
Dasoja of Balligrama
Indian, Karnataka, probably Belur
Potstone; H. 56½ in. (143.5 cm.)
Rogers Fund, 1918 (18.41)

SHALABANJIKA

Integrated into the sculptural schema of the facades of Indian temples is a host of seductive females whose identifications are not always apparent. Some are associated with nature's material bounties; others serve as demigod-consorts and companions to the gods. The presence of a tree, whose curved trunk can be seen in the background, and the blossoming branch in the woman's hand suggest that she is one of the former. In this statue, the attenuated elegance of the styles prevalent from the eleventh to twelfth century has been replaced by a heavier system of proportions. Judging from the style, this sculpture probably came from the famous Surya Temple at Konorak.

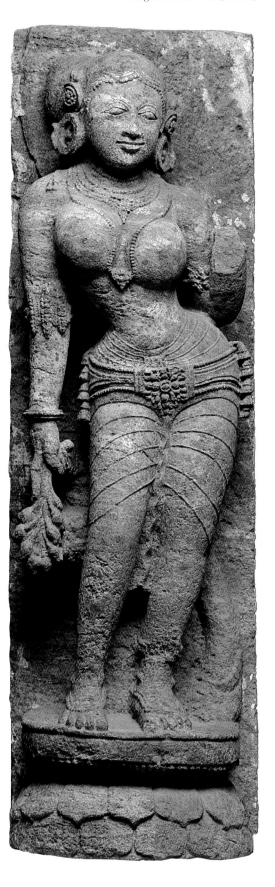

94 Shalabanjika, ca. mid-13th c.
Indian, Orissa, probably Konorak
Stone; H. 42½ in. (126.3 cm.)
Rogers Fund, 1965 (65.108)

Manuscript Cover

It has long been accepted that the Pala school of painting of eastern India owed its derivation to the western Indian cave paintings at Ajanta, Bagh, and Ellora. But there was a gap of about one hundred and fifty years between the last Ellora paintings and the earliest surviving manuscript paintings of the Pala school. Until the discovery of this manuscript cover, there was no known painting that could easily connect these traditions. Consequently, its role as the missing link is crucial to the study of Indian painting.

Pala manuscripts were painted on palm leaves that were protected by wooden covers, the inner faces of which were generally illustrated. This cover consists of a long horizontal section of wood with two holes inset with metal. The outer surface of the cover may have been decorated, but it is impossible to tell, because it is encrusted with organic matter ritually applied during worship. The inside is painted with five scenes, four from the life of Buddha.

Since eight great events in the life of Buddha are commonly depicted, it is safe to assume that the other four were portrayed on the missing cover. The fifth and central scene is of the seated Prajnaparamita, goddess of transcendent wisdom, flanked by two bodhisattvas. The prominence of this scene indicates that the manuscript contained in the cover was probably the *Ashtasahasrika Prajnaparamita Sutra (The Perfection of Wisdom in Eight Thousand Verses)*, one of the most important Buddhist texts of the period.

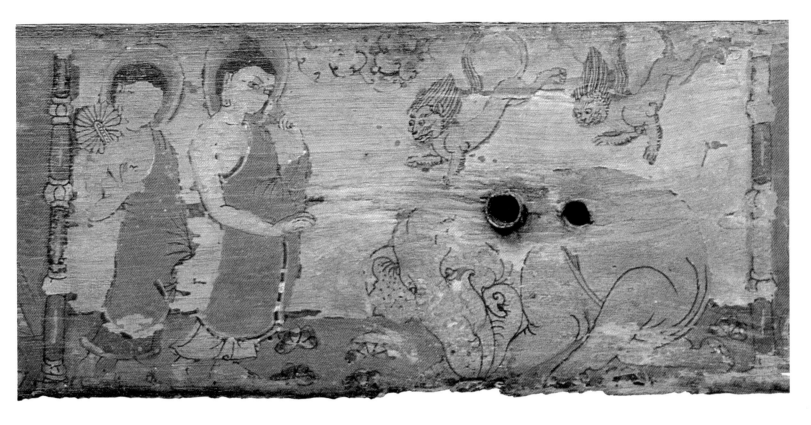

95 *Manuscript Cover,* 9th c. A.D.
Indian
Ink and colors on wood with metal insets;
2¼ x 22⅜ in. (5.7 x 56.8 cm.)
Gift of The Kronos Collections and
Mr. and Mrs. Peter Findlay, 1979 (1979.511)

Above, below, and opposite top: details

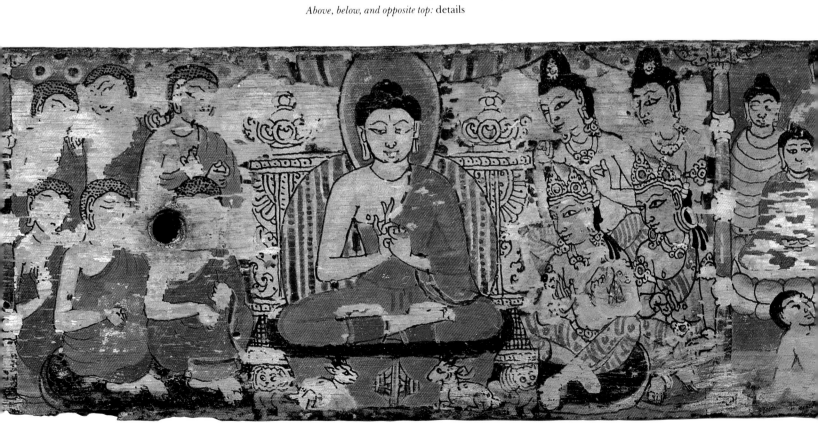

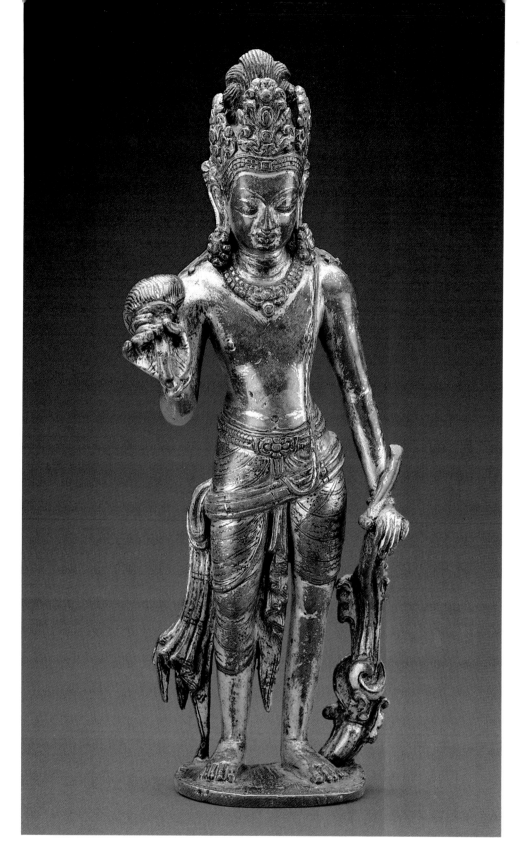

96 *Standing Bodhisattva*,
late 8th–9th c. A.D.
Nepalese
Gilded copper; H. 12 in. (30.4 cm.)
Gift of Margery and Harry Kahn,
1981 (1981.59)

STANDING BODHISATTVA

This standing bodhisattva is among the finest examples of early Nepalese sculpture. Skillfully modeled, the bare-chested bodhisattva stands in a subtle contrapuntal posture. The right leg is slightly relaxed, with the weight of the body resting on the rigid left leg. He holds a fly whisk in his raised right hand and the stem of a lotus (the upper portion of which has not survived) in his left hand. The deity is dressed in the orthodox fashion of the period, with the usual complement of jewelry; the sacred thread goes from the left shoulder to the right knee, and a sash, slung diagonally across the abdomen, terminates in full drapery folds with pointed ends. The complex arrangement of the garments balances the elaborate lower portion of the lotus stem. The elegant proportions of this tall figure are emphasized by the high chignon and tripartite tiara. In its original setting, the bodhisattva must once have attended a Buddha. The symmetry of the group would have been established by a companion bodhisattva who completed the trinity.

SEATED YOUTHFUL MANJUSHRI

Manjushri, the Bodhisattva of Transcendental Wisdom and the Buddhist patron deity of Nepal, is often described in Buddhist scriptures as a young prince (*kumarabhuta*). In this representation he is given a youthful physiognomy and wears a tiger-claw necklace and specific tripartite hairdo, both appropriate for a young man. These, as well as the bell earrings, are also worn by Karttikeya, the son of Shiva and Parvati, and in cases where other identifying attributes are missing, it is possible for the images of these deities to be confused. But here Manjushri holds a blue lotus in his left hand, a symbol not shared with Karttikeya; originally it may have supported a manuscript.

Manjushri is seated in the pose of relaxation (*lalitasana*) on a rectangular pedestal with lions at its front corners, set on a double-lotus base. He wears bells as earrings, the sacred thread, and orthodox jewelry, and he holds a citron in his lowered right hand. The orginal body halo is missing. The pedestal is a variant of Pala types and helps to establish stylistic allegiance to India. This very beautiful and rare icon is one of the earliest known Nepalese representations in bronze of this popular god. On the basis of style it can be assigned to the late ninth, or perhaps to the tenth century.

97 *Seated Youthful Manjushri*, late 9th–10th c. A.D.
Nepalese
Copper; H. 6⁹⁄₁₆ in. (16.7 cm.)
Gift of Mr. and Mrs. A. Richard Benedek, 1978
(1978.394.1)

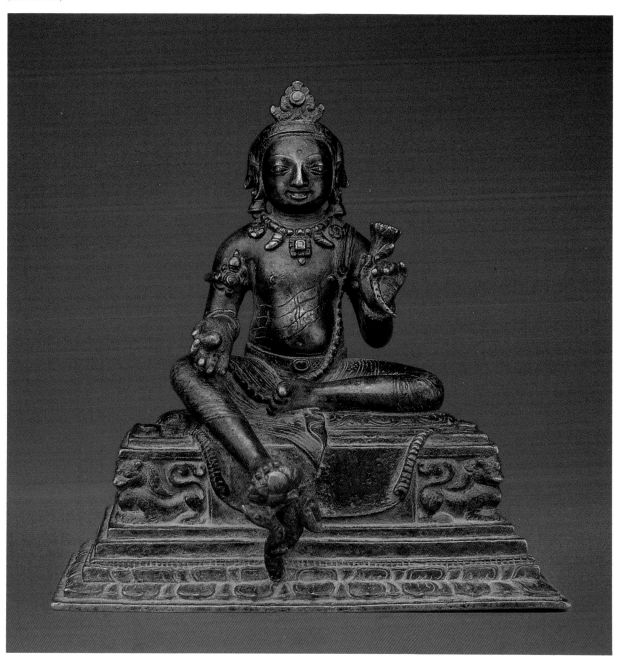

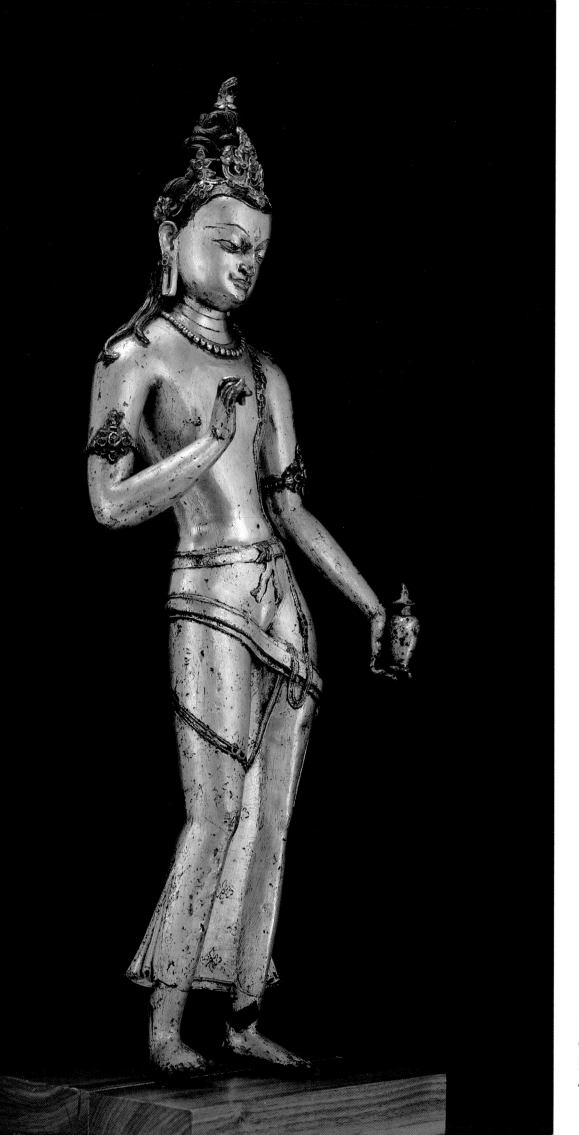

98 *Standing Maitreya,* 9th–10th c. A.D.
Nepalese
Gilded copper with polychrome;
H. 26 in. (66 cm.)
Rogers Fund, 1982 (1982.220.12)

Page 146: text

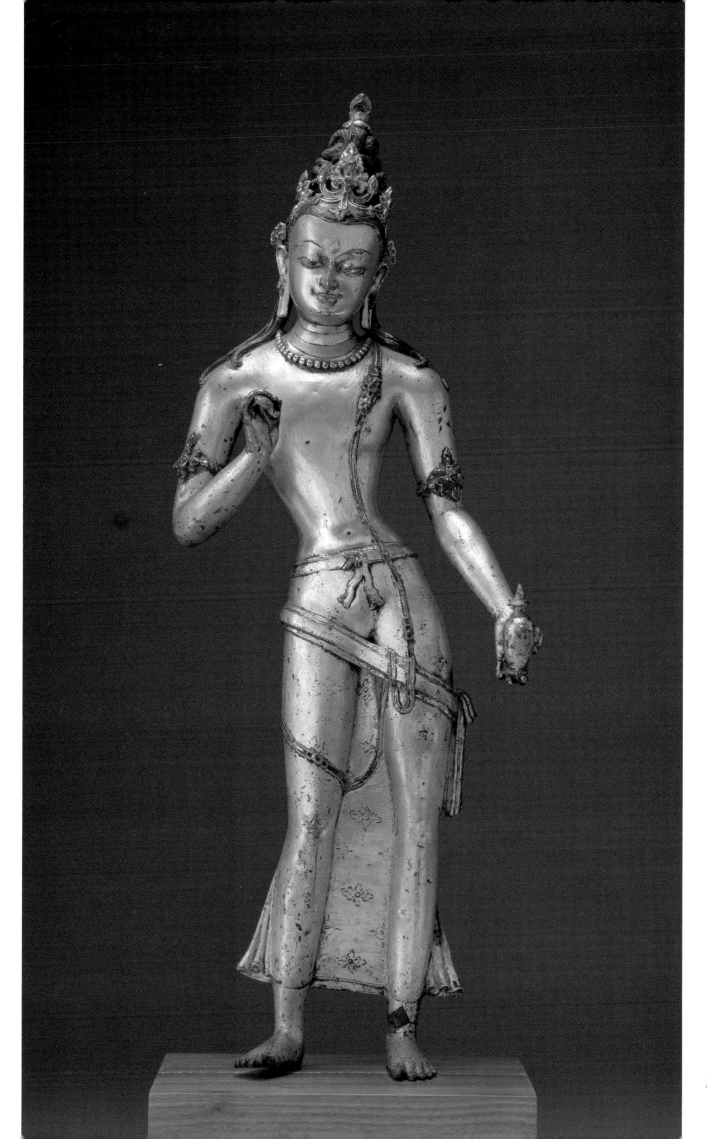

STANDING MAITREYA *(Pages 144-145)*

Throughout most of its early history, Nepal seems to have maintained close cultural relations with India. This is reflected in Nepalese art styles. In this sculpture, the elegance of the Pala style at Nalanda is apparent, but is combined with a wholly Nepalese aesthetic. Maitreya, the messianic bodhisattva, stands in a pronounced *tribhanga* (thrice-bent) posture. The sensual exaggeration of the pose is most unusual for Nepalese art of this early period. In his lowered left hand Maitreya holds a vessel; in his raised right hand he may originally have held a rosary. He is dressed in a long skirt with simple incised decoration; a sash is slung diagonally from his right hip to left thigh. He wears the sacred thread across his chest and is adorned with the usual jewelry of the period.

The representation of Maitreya is an extraordinarily radiant, elegant, and sensuous sculpture. Not only is this one of the largest of the early Nepalese bronzes in the West, it is the only example of such refined elegance combined with an almost austere economy of surface decoration. A master sculptor with a highly developed aesthetic sensibility produced an image combining a deep spiritual presence with a most beautifully arranged system of volumes.

Maitreya achieved a wide popular following throughout the Buddhist world. His devotees aspired to be reborn in his paradise, or to be present when he descended to earth to become the Buddha of the next great *kalpa*, or "world-age."

MANDALA OF CHANDRA, GOD OF THE MOON

This *mandala* (ritual diagram) shows the planetary divinity Chandra, god of the moon, seated in his chariot drawn by seven geese. The deity holds two white lotuses and is dressed in the fashion of southern India, wearing neither boots nor tunic. Flanking him in his chariot are two female attendants shooting arrows to dispel the darkness of the night. In front of Chandra, the charioteer holds the reins of the seven geese. Behind him can be seen the elaborate back of his throne and a lavishly decorated body halo. In the first circle surrounding the main image, superimposed over stylized lotus petals, are the *navagrahas* (nine planets) seated on their animal mounts. The perimeter circle is composed of multicolored stylized flames. Seated at the four corners are four bodhisattvas, each flanked by dancing women. The uppermost register shows five seated Buddhas, representing the Tathagatas (cosmic Buddhas), flanked by two more bodhisattvas. The bottom register has two scenes of ritual consecration and portraits of the family of the donor. At the center of the bottom register is a scene with musicians and dancers. Chandra is painted white, and his attendants and chariot are all placed against a white ground.

This painting is particularly important since it seems to be the earliest Chandra *mandala* known. In addition, it is most skillfully executed, representing Nepalese painting at its best.

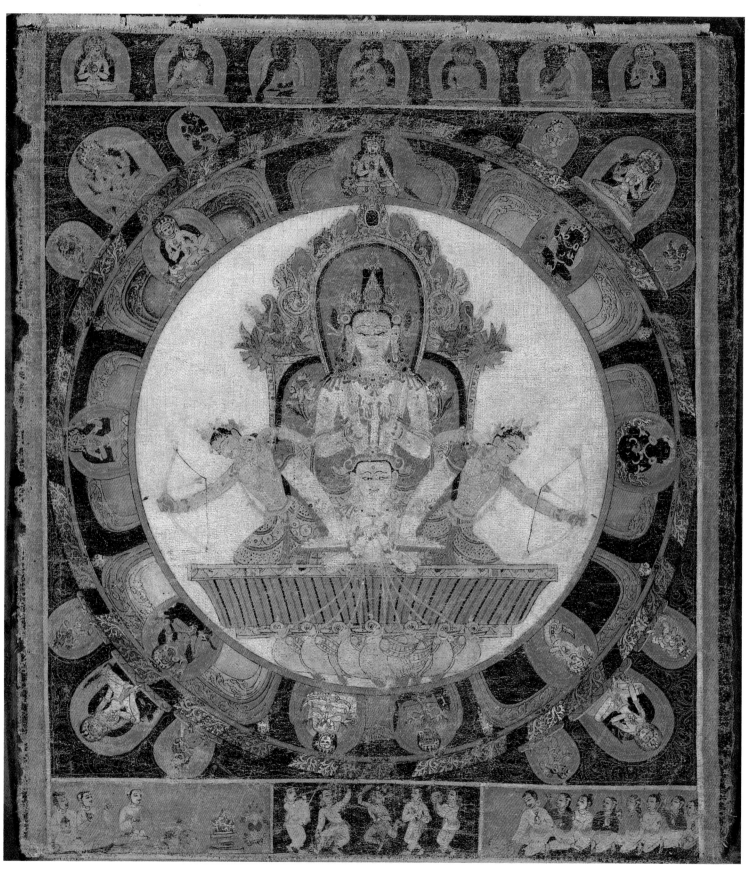

99 *Mandala of Chandra, God of the Moon,*
late 14th–early 15th c.
Nepalese
Opaque watercolor on cloth;
16 x 14¼ in. (40.6 x 36.2 cm.) Gift of
Mr. and Mrs. Uzi Zucker, 1981 (1981.465)

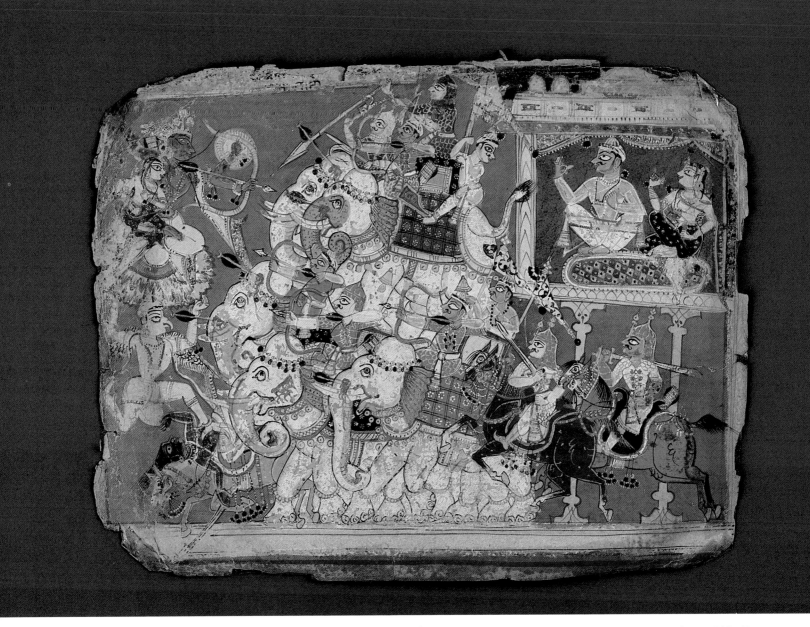

100 Krishna Battles the Demon Naraka, ca. 1530–40
Indian, probably Delhi-Agra region
Page from a dispersed *Bhagavata Purana* manuscript;
opaque watercolor on paper; 7 x 9⅛ in. (17.8 x 23.2 cm.)
Purchase, Lita Annenberg Hazen Charitable Trust Gift,
1985 (1985.34)

KRISHNA BATTLES NARAKA

The later history of painting in India revolved around interests very different from those associated with the earlier palm-leaf manuscript tradition. Format and medium changed, and subject matter was greatly expanded.

The first chapter in this later history is most provocative in that it concerns a group of fully developed indigenous Indian styles practiced prior to the establishment of the great court ateliers of the Mughal dynasty in the second half of the sixteenth century. These styles have been accepted as having enough in common to constitute a basic pictorial idiom free from Mughal influence.

The pre-Mughal style is represented by a group of manuscripts and individual paintings often referred to as the *Chaurapanchasika* group, after a Sanskrit manuscript of lyric love poems. A small group of rare illustrated manuscripts datable from around 1515 to 1575 has been associated with the *Chaurapanchasika* style.

One of these manuscripts, perhaps as well known as the one from which the series was named, is an illustrated excerpt from the great Hindu epic, the *Bhagavata Purana (Ancient Story of God)*. The Hindu religion relies for its texts on a body of ancient works that developed through the centuries and that incorporates elaborate theological commentary and a wealth of complex legends. Books Ten and Eleven of the *Bhagavata Purana* are the source for the life of Krishna.

This manuscript has been dated to around 1535 on the basis of stylistic extrapolation. The pre-Mughal styles have a freshness, vivacity, and vitality that make them particularly appealing. Working with a limited palette and a relatively naive sense of composition and figural arrangement, the artists produced pictures of enormous charm and directness. The page seen here displays the bold patterning, large areas of contrasting flat colors, and sense of two-dimensionality common to the illustrations in this manuscript. It is one of the more lively and accomplished of the set.

PAGE FROM THE ISARDA *BHAGAVATA PURANA*

Krishna, an avatar of the god Vishnu, is certainly one of India's most popularly loved gods. Stories of Krishna's youth are perhaps particularly appealing because he manifested such recognizably human traits and foibles.

In this boldly composed picture, a group of *gopis* (female cowherds) are begging the young god to return their clothing, which he has playfully stolen. Krishna is perched in a tree in the upper left corner, and the river in which the young women are bathing runs diagonally across the page.

Some of the *gopis* continue to play in the river while others respectfully implore Krishna to stop teasing them. The painting is part of a manuscript known as the Isarda *Bhagavata Purana*, which is believed to have been painted between 1560 and 1570, and is named for the town of Isarda, south of Jaipur. Like the previous painting, done about twenty-five years earlier, this is an example of the pre-Mughal *Chaurapanchasika* style of painting. This skillful work uses innovative concepts of compositional logic and space.

101 *Gopis Beseeching Krishna to Return Their Stolen Clothing*, ca. 1560
Indian
Page from the dispersed Isarda *Bhagavata Purana*;
ink and colors on paper; 7⅝ x 10⅛ in. (19.4 x 25.7 cm.)
Gift of The H. Rubin Foundation, Inc., 1972 (1972.260)

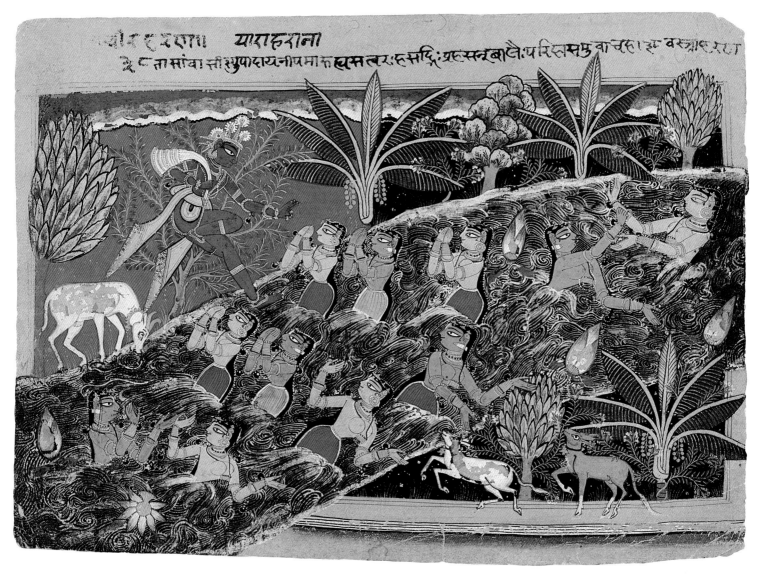

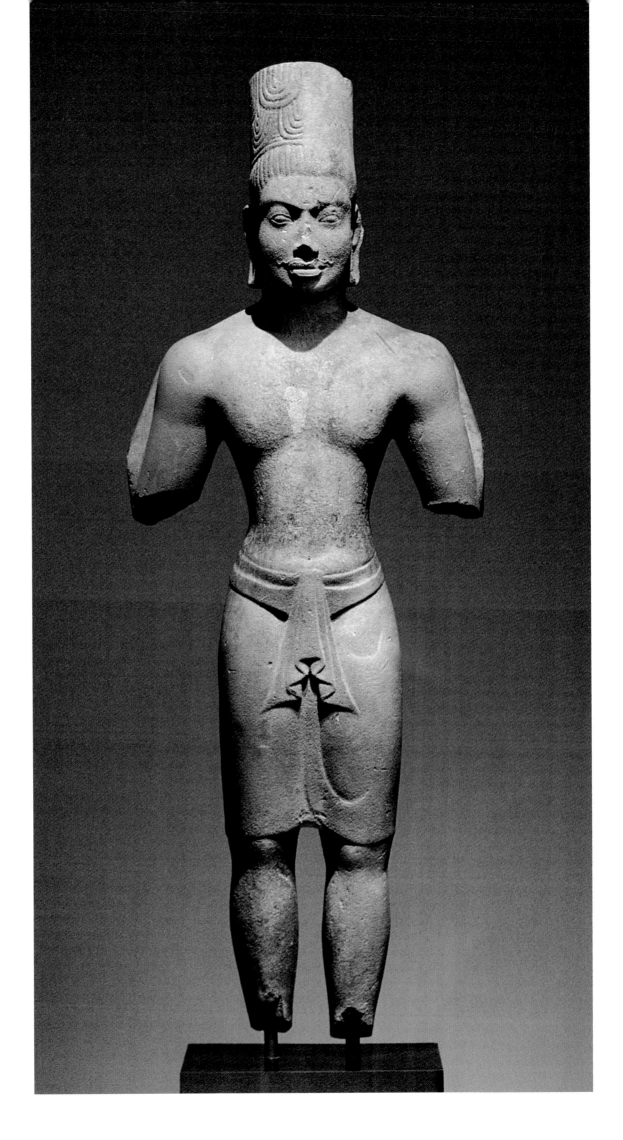

102 Hari-Hara, ca. late 7th–early 8th c. A.D.
Cambodian, Pre-Angkor period
Calcareous sandstone; H. 35½ in. (90.1 cm.)
Purchase, Laurance S. Rockefeller Gift and
Anonymous Gift, 1977 (1977.241)

HARI-HARA

Comparatively few fine Cambodian sculptures survive from the Pre-Angkor period, which lasted from around the sixth century A.D. until the Khmer empire established its capital at Angkor in the ninth century. This Hari-Hara is a particularly rare and beautiful example. Pre-Angkor sculptures are characterized by a sensitive integration of sculptural volumes and the naturalistic treatment of the body. These works, the majority of which are Hindu, were stylistically influenced by art produced during the late fifth and early sixth centuries in India.

Hari-Hara is a syncretic Hindu deity combining the aspects and powers of Shiva and Vishnu—an iconography that was popular in Southeast Asia during the Pre-Angkor centuries. The right half of the body is that of Shiva, and the left side is of Vishnu. This standing four-armed Hari-Hara follows the orthodox traditions for both halves of the body. The Shiva side has the standard high hairdo with piled-up locks, and half of the all-seeing vertical third eye carved on the forehead. The side representing Vishnu is coiffed with the high, undecorated mitre that is one of the god's common attributes. The figure originally had four arms that held symbols of the respective deities. He wears a *sampot* (the short garment worn by males) with part of the cloth drawn between the legs and fastened behind at the waist.

Precise dating of this piece is not possible since the chronology and stylistic sequences of early Cambodian art have not yet been satisfactorily charted. But the style indicates that it dates from the late seventh to the early eighth century A.D.

STANDING GANESHA

Ganesha's elephant head was the result of an angry encounter with his father, Shiva. Shiva cut off Ganesha's head and instructed the gods to replace it with the head from the first living creature they encountered, which turned out to be that of a passing elephant. Ganesha is the deity who controls obstacles—inventing them or removing them—and the one who is worshiped before any serious undertaking. Here he wears a short *sampot*, part of which falls down the center front to form a flaring pleated panel.

Like the statue of Hari-Hara, this sculpture is from the Pre-Angkor period, and is naturalistically modeled, with an emphasis on the full volumes of body and head. The quality of the carving is so high and the spirit of this delightful god so well captured that this Ganesha is clearly of prime importance among the few remaining examples of the period.

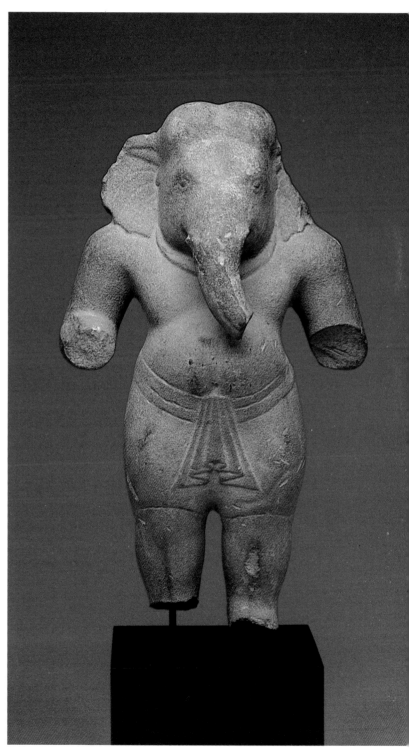

103 Standing Ganesha, ca. late 7th–early 8th c. A.D.
Cambodian, Pre-Angkor period
Calcareous sandstone; H. 17¼ in. (43.8 cm.)
Rogers, Louis V. Bell and Fletcher Funds, 1982
(1982.220.7)

PRESENTATION BOWL (?)

The elaborate narrative frieze surrounding this remarkable vessel suggests that it was intended as an object of considerable importance. Its use, however, remains a mystery. The figurative style of the bowl seems to derive from third-to-fourth-century A.D. Indian sculpture from Andhra Pradesh, specifically Amaravati and Nagarjunakonda. However, details of dress and hairstyle seem to indicate a Southeast Asian origin, possibly Malaysia.

The workmanship of this bowl is clearly the product of an advanced and very accomplished workshop with a strongly developed narrative style. The continuous frieze around the entire body of the top section of the vessel depicts two scenes, neither of which has been specifically identified. One is of a procession leaving a walled city; the other is of a palace courtyard with musicians and a dancer performing for a nobleman and his consort, who are seated on a raised platform with attendants and spectators. The bottom of the bowl is incised with a motif of lotus leaves inextricably associated with Asian religious art. The base has eight pot-bellied, dwarflike creatures. To date, nothing similar to this object is known.

FOUR-ARMED AVALOKITESHVARA

In 1964, a group of Buddhist bronzes was discovered at Pra Kon Chai, Buriram province, in Thailand. Reflecting Cambodian, Indian, and Mon influences in an unequal admixture, they are the mature products of important workshops with obvious connections to Si Tep and Lopburi, major centers for sculpture in central Thailand. This piece, the largest and one of the finest of the trove, depicts Avalokiteshvara, the Bodhisattva of Infinite Compassion. Avalokiteshvara can assume different forms in accordance with the spiritual needs of his devotees. However, he is always identified by the image of the Buddha Amitabha seated in his hairdo. In Southeast Asia, perhaps during the sixth century, there developed, quite independent of Indian influences, a cult specifically devoted to the four-armed Avalokiteshvara. The importance and popularity of this cult is attested to by the number of icons that survive.

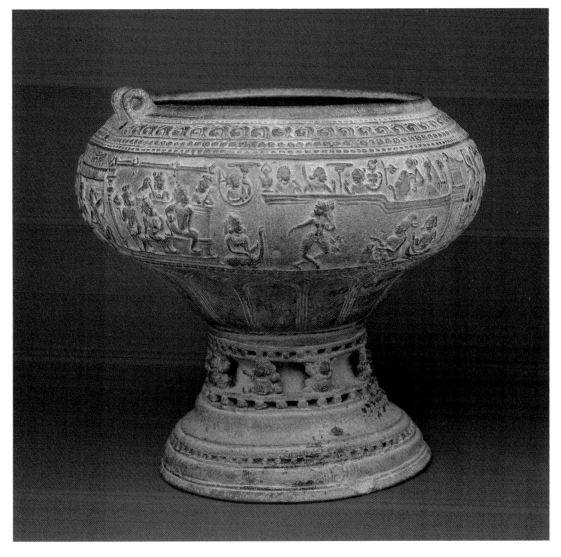

104 Presentation Bowl (?),
ca. 7th–8th c. A.D.
Malaysian (?)
Bronze; H. 8¼ in. (20.9 cm.)
Rogers Fund, 1975 (1975.419)

105 Four-Armed Avalokiteshvara,
ca. second quarter of 8th c. A.D.
Thai, Pra Kon Chai
Bronze; eyes inlaid with silver
and black glass or obsidian;
H. 56 in. (142.2 cm.)
Rogers Fund, 1967 (67.234)

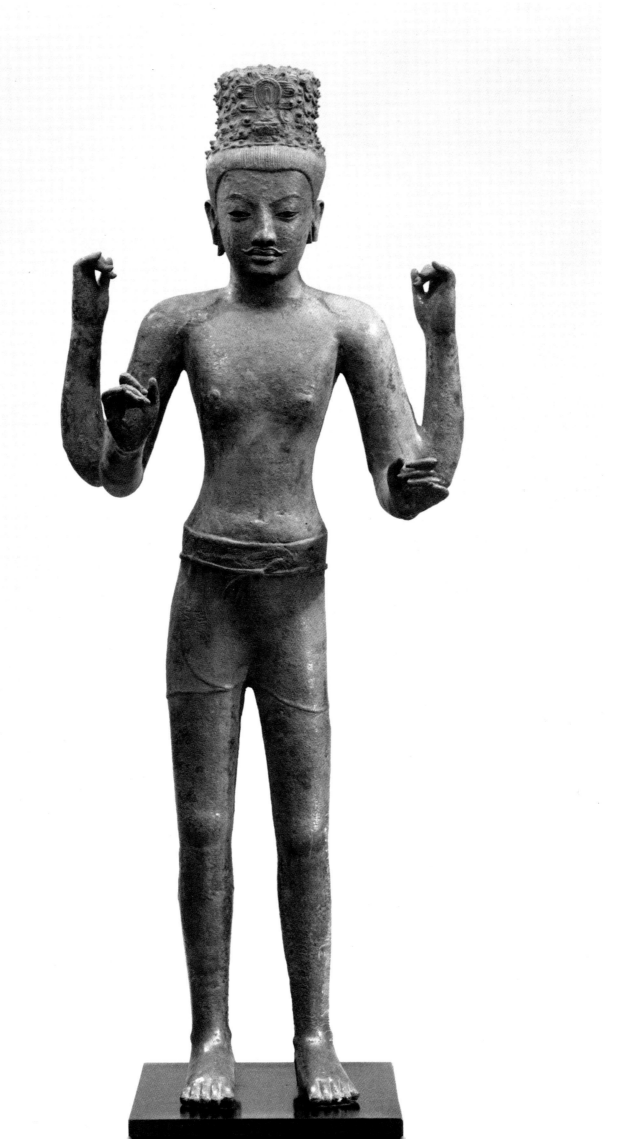

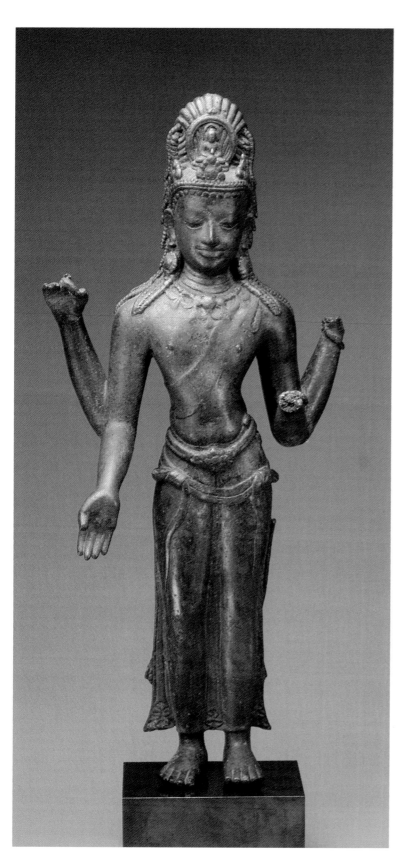

106 *Standing Four-Armed Avalokiteshvara,*
ca. 9th c. A.D.
Indonesian or Thai
Bronze; H. 22¼ in. (56.6 cm.)
Rogers Fund, 1982 (1982.64)

STANDING FOUR-ARMED AVALOKITESHVARA

The early styles of the very important but enigmatic king-
dom of Shrivijaya, whose main capital may have been on
the island of Sumatra but which ruled over a much larger
area, continue to defy precise isolation and categorization.
Shrivijaya and its eighth- and ninth-century rulers, the
Shailendra dynasty, are known to us through inscriptions,
but the history of this empire remains to be written. Their
art seems to owe some stylistic allegiance to India, as well as
to earlier Southeast Asian styles, which is not surprising,
and it seems to have influenced the sculpture of southern
Thailand and even that of the province of Yunnan in China
in the twelfth and thirteenth centuries. That Shrivijaya was
a very important political unit within Southeast Asia is clear,
but the reasons for its importance have not yet been clarified.

The sculptural styles of peninsular Thailand are so closely
allied to some Shrivijaya styles that it is sometimes uncertain
whether a specific sculpture is more accurately described as
Peninsular Thai or Shrivijayan, as is the case with the pres-
ent sculpture, purported to have been found in peninsular
Thailand. Indeed, some scholars believe that the capital of
Shrivijaya was in peninsular Thailand.

This sculpture shows the deity standing in a graceful *con-
trapposto.* He is dressed in a long skirt fastened below the
waist by a jeweled clasp. A girdle of ribbons is worn around
the hips, with the ribbon ends hanging down the thighs. A
sash is draped diagonally across the chest, and a three-lobed
tiara, earrings, and a necklace form the orthodox comple-
ment of jewelry for the period. The deity wears a high chi-
gnon composed of individual locks of hair, with the ends
resting on his shoulders. The unusually large size, the sen-
sitive, gently swelling volumes, and the fine detailing make
this sculpture both historically important and aesthetically
satisfying.

107 *Standing Brahma,*
end of 9th–first quarter of 10th c.
Cambodia, Khmer period, Bakheng style
Stone; H. 47½ in. (120.7 cm.)
Purchase, Fletcher Fund, 1935 (36.93.3)

Opposite right: back view *Page 156:* text

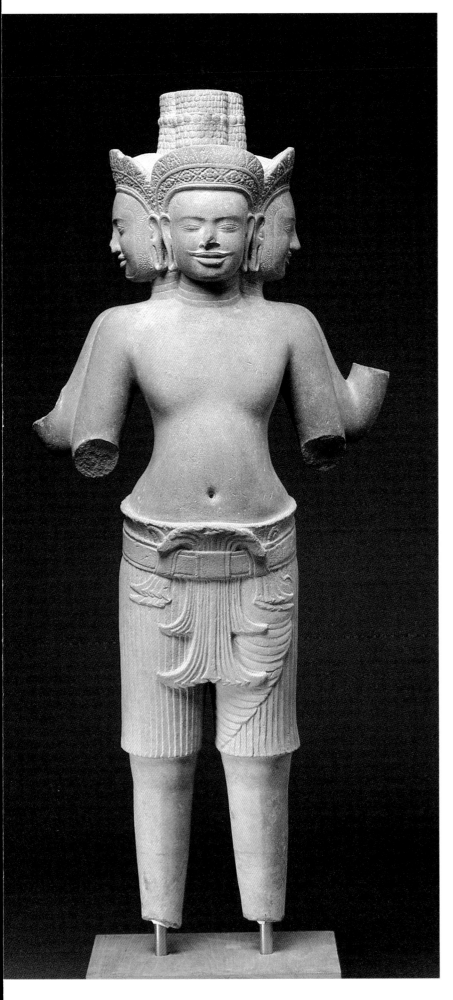
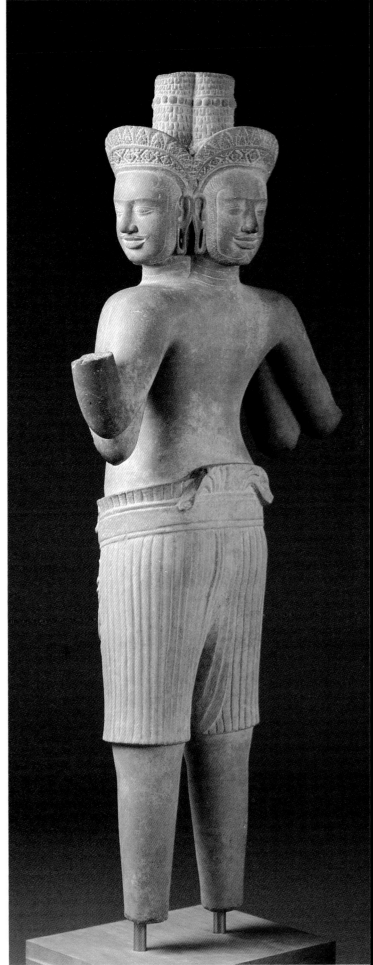

Standing Brahma (Page 155)

A very important group of six Khmer stone sculptures, acquired in 1935, forms the nucleus of the Metropolitan Museum's small collection of Cambodian art. The earliest work in the group is this representation of a four-armed, four-headed Brahma found at Angkor, around Prasat Prei, to the south of the large man-made reservoir called the Western Baray.

Khmer court styles were highly conservative, particularly in the three-dimensional sculpture of the Angkor period, from the ninth to the thirteenth century. Most were hieratic, iconic, motionless, with both feet uniformly planted on their pedestal. Only the different hand positions broke up the strict symmetry of the images, and surface decoration was minimal.

Considering the austerity of the style, it is extraordinary that the Khmer artists were able to accomplish so much, so brilliantly. They relied for their successes on the most basic of contrasts, and a very pure modeling. The large expanses of bare flesh, molded with considerable precision into smooth and powerful volumes and usually encased, through a high polish, in a taut, vibrant skin, provide a visual contrast to the linear patternings of the garments, face, and crown. The sculptors developed a formalistic art of remarkable purity: The statues were self-contained, self-sufficient, and did not rely on any background or thematic concern.

The sculpture seen here, a highly refined image of the four-armed Brahma, displays all the ingredients that can be found in the art of its period. The *sampot* in the Bakheng style of the early tenth century (named after the Bakheng temple), shows the pleated "double-anchor" or "fishtail" pendants in front, with the outer one hanging over and lower than the inner one. The unusual silhouette of the torso ends abruptly at the very full hips, where it is encased in a garment of unexpected thickness. The transition from bare flesh to the rich linear patterning of the garment is abrupt, providing a visual jolt that is common to most Khmer sculpture. The meticulous precision with which this sculpture was fashioned, its harmonious volumes and dignified presence, make it one of the most impressive sculptures in the Museum's collection.

Kneeling Female Deity

This extraordinary sculpture is surely one of the most important and beautiful Khmer bronzes outside Cambodia. Kneeling with her left leg beneath her and right knee raised, she lifts her hands above her head in a gesture of adoration. She wears a pleated sarong secured by a sash with jeweled pendants. The left hem of the sarong is folded over, creating a frontal panel of cloth resting between the legs and terminating in the "fishtail" silhouette reminiscent of earlier Khmer styles. In addition, she wears jeweled armlets, bracelets, anklets, and a necklace. Her hair is arranged in vertical bands of a quatrefoil pattern alternating with a bead motif, and originally there was a topknot on her head. The precision of detail of jewelry, dress, and hairdo shows a particularly high level of metalworking technique.

Her eyes are inlaid silver, the pupils and eyebrows hollowed out to receive additional inlays, now missing, perhaps of black glass. There seem to be traces of a gold foil, suggesting that this noble lady may originally have been totally encased in a gold skin, a technique not unusual in this part of the world.

This regal beauty is superbly modeled of soft generalized forms, with a surface made taut as if by an inner expanding energy. Strong but harmonious visual rhythms and contrasts of form are established by the sharp, diamond-shaped silhouette of the raised arms and the graceful arrangement of the masses of the lower part of the body. The upward visual thrust of the hands has its counterpart in the thrust of the right knee toward the spectator. Altogether this is a magnificently poised and balanced sculpture, successfully conceived from every viewing angle.

The statue dates to around the middle of the eleventh century and is in the style of the Baphuon temple (ca. 1010–80), which can be considered the "classic" phase of Khmer sculpture.

108 Kneeling Female Deity, ca. mid-11th c.
Cambodian, Khmer period, Baphuon style
Bronze with traces of gold, inlaid with
silver; H. 17 in. (43.2 cm.)
Purchase, Bequest of Joseph H. Durkee,
by exchange, 1972 (1972.147)

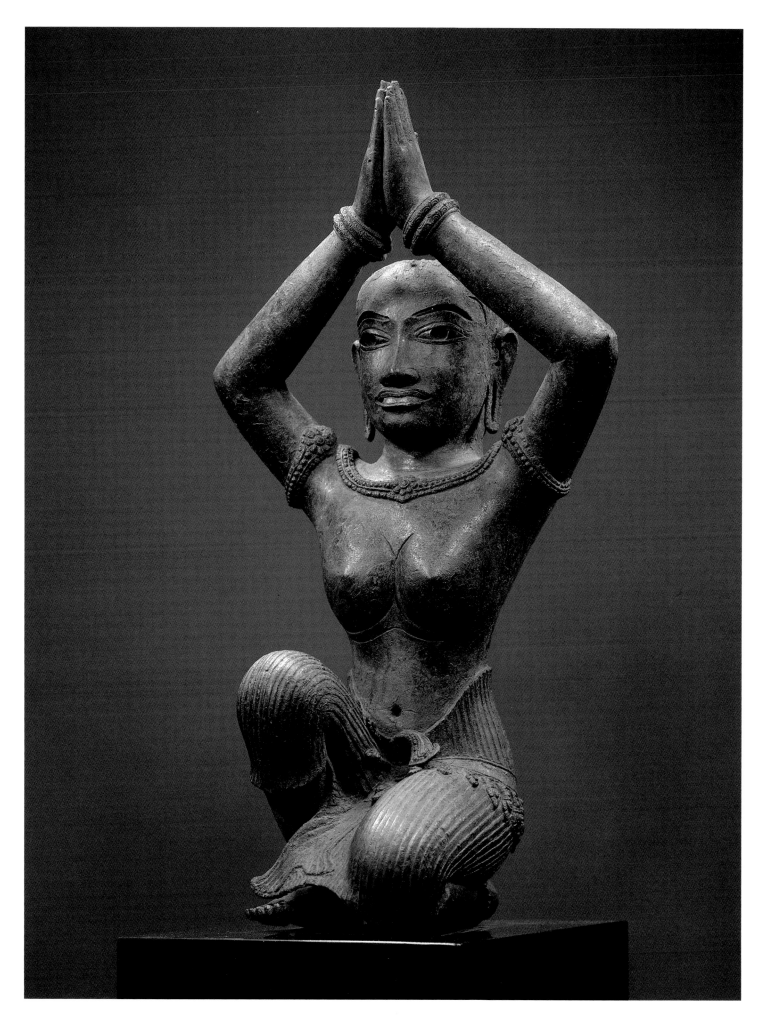

109 Guardian Lion, 11th–12th c.
Thai, Khmer style
Stone; H. 42⅞ in. (109 cm.)
Fletcher Fund, 1979 (1979.406)

O V E R L E A F :

GUARDIAN LION

Guardian lions are integral to the sculptural scheme of virtually all Khmer temples. They flank the main approaches to the sanctuary, placed along stairways and on terraces. These huge, formidable creatures are often the first sculptures to be seen when approaching a temple.

The lion was an important part of traditional Khmer iconography, which revolved around the authority of the king. Lions symbolize royalty, strength, and courage, and as guardians, suggest both divine and royal protection. Consequently, they were believed to ward off evil, and malevolent beings. In this context the lion is the guardian of sacred precincts and the personal symbol of the Khmer god-kings.

The same sculptural skills were lavished on these animals as on figural sculpture. Since lions are not native to the Thai-Cambodian area, artists treated them conceptually, often transforming them into iconic, heraldic creatures. This lion is a wonderful great beast, bursting with power. Altogether superbly constructed, it is composed of forceful volumes —full and harmonious. Contrasts between the smooth, bulging body and the decorative patterning of mane, eyebrows, ears, and so forth, are worked out in a masterful fashion. The carving is crisp and precise without being dry. Alert and attentive, the grimacing beast is a truly regal symbol and a potent guardian of sacred grounds.

Stylistically, this sculpture belongs to the eleventh or early twelfth century. Guardian lions are sometimes a bit difficult to date with close precision, but this particular example retains all the sculptural vigor and power of those found at the Khmer sites of the Bakheng and Banteay Srei, dating to the tenth century.

HEVAJRA *(Page 160)*

This colossal bust of the Tantric Buddhist deity, Hevajra, is claimed to have been found near the East Gate (The Gate of the Dead) of Angkor Thom, the great walled city of Jayavarman VII (r. ca. 1181–1220). Built within the Angkor complex, Angkor Thom was the final major monument of Khmer civilization.

Recent studies suggest that the mutilated lower part of this sculpture, in a dancing posture, still survives at Angkor. If this sculpture was, in fact, intended as a representation of the dancing Hevajra, there would have been eight arms on each side. Quite a few small bronze sculptures of this deity exist to provide the appropriate iconography. This seven-headed sculpture should originally have had one more head on top to bring the total to eight—the orthodox number for Hevajra. However, since the sculpture is unfinished, it is unclear if the top head ever existed.

The magnificent serenity of the major face is in marked contrast to the frank, almost staring aspect of the others. The god's compassionate gaze from its original height must have been awe-inspiring to worshipers. Even in its fragmented condition this monumental sculpture has a powerful impact.

110 Hevajra, end of 12th–
beginning of 13th c.
Cambodia, Angkor period
Stone; H. 52 in. (132.1 cm.)
Fletcher Fund, 1935 (36.96.4)

Page 158: text

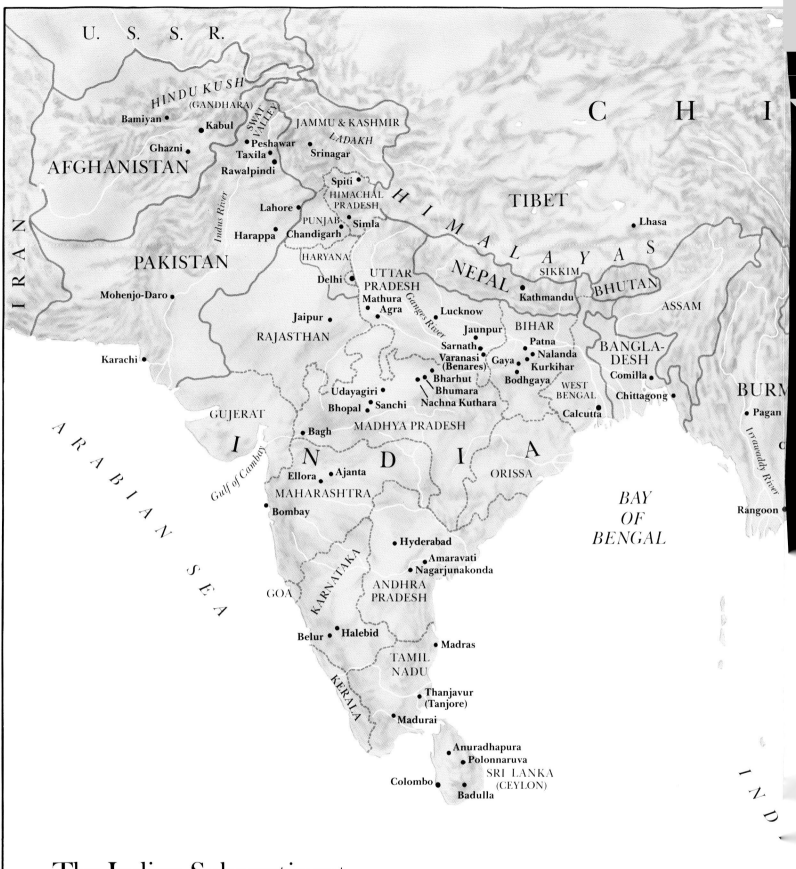

U. S. S. R.

HINDU KUSH
(GANDHARA)

Bamiyan •

• Kabul

Ghazni •

Taxila •
• Peshawar
Rawalpindi •

SWAT VALLEY

JAMMU & KASHMIR

LADAKH

• Srinagar

AFGHANISTAN

CHI

I R A N

Indus River

PAKISTAN

Lahore •

Harappa •

Spiti •

HIMACHAL
PRADESH

• Simla

PUNJAB
Chandigarh •

HARYANA

HIMALAYAS

TIBET

• Lhasa

NEPAL

SIKKIM

BHUTAN

Mohenjo-Daro •

Delhi •

UTTAR
PRADESH

• Kathmandu

ASSAM

BANGLA-
DESH

BURM

Karachi •

Jaipur •

RAJASTHAN

Mathura •
• Agra

Ganges River

• Lucknow

• Jaunpur

Sarnath •
Varanasi •
(Benares)

BIHAR

• Patna

Gaya • • Nalanda
Kurkihar •

• Comilla

• Chittagong

• Pagan

K A R A C H I

Bharhut •
Udayagiri •

Bhumara •
• Sanchi
Nachna Kuthara

Bodhgaya •

WEST
BENGAL

• Calcutta

Irrawaddy River

Bhopal •

GUJERAT

I

Bagh •

MADHYA PRADESH

Gulf of Cambay

ARABIAN SEA

Ellora •
• Ajanta

N

D

I

A

ORISSA

Colombo •

MAHARASHTRA

Bombay •

• Hyderabad

BAY
OF
BENGAL

Rangoon •

• Amaravati
• Nagarjunakonda

KARNATAKA

GOA

ANDHRA
PRADESH

Belur •
• Halebid

• Madras

KERALA

TAMIL
NADU

Thanjavur •
(Tanjore)

• Madurai

• Anuradhapura
• Polonnaruva

SRI LANKA
(CEYLON)

Colombo •
• Badulla

I N D

The Indian Subcontinent
and Southeast Asia

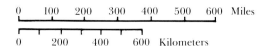

National boundaries
Indian provincial boundaries

0 100 200 300 400 500 600 Miles

0 200 400 600 Kilometers

MAURYA PERIOD

SHUNGA PERIOD

SHAKA-PARTHIAN PERIOD

KUSHAN PERIOD

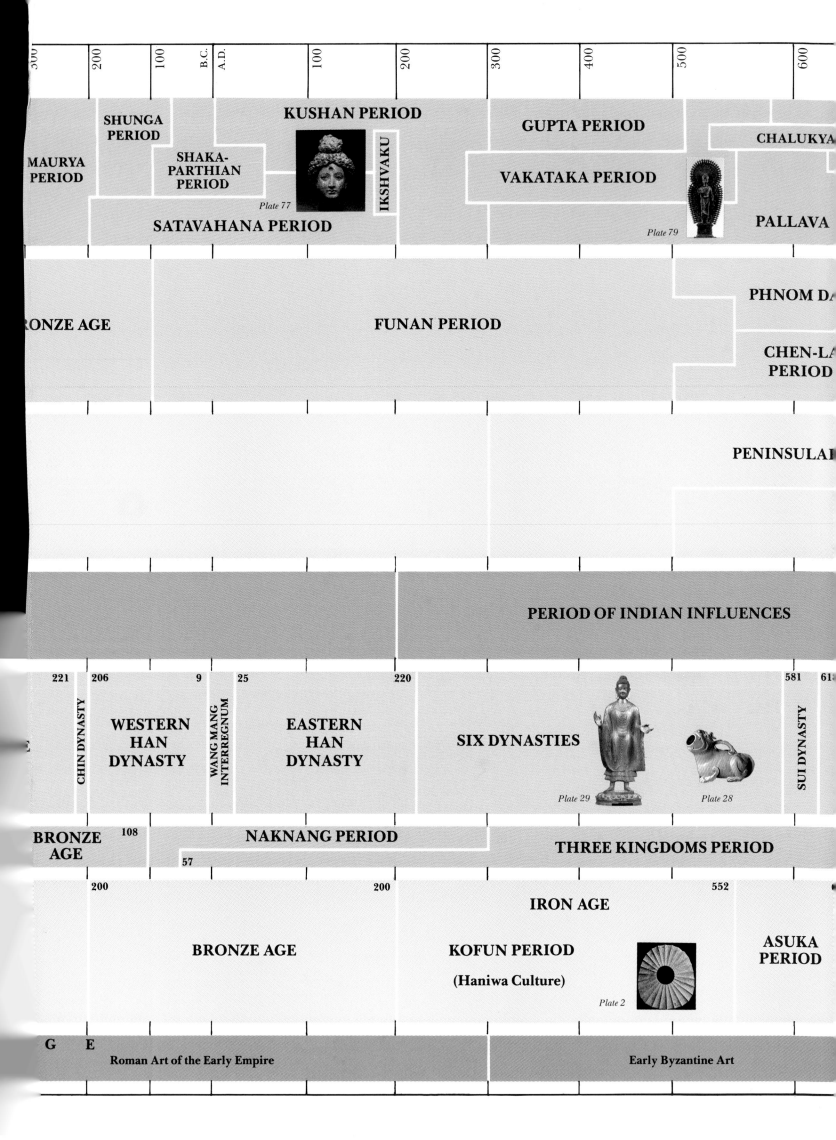

Plate 77

IKSHVAKU

SATAVAHANA PERIOD

GUPTA PERIOD

CHALUKYA

VAKATAKA PERIOD

Plate 79

PALLAVA

BRONZE AGE

FUNAN PERIOD

PHNOM DA

CHEN-LA PERIOD

PENINSULA

PERIOD OF INDIAN INFLUENCES

221 | 206 | 9 | 25 | 220 | 581 | 618

CHIN DYNASTY

WESTERN HAN DYNASTY

WANG MANG INTERREGNUM

EASTERN HAN DYNASTY

SIX DYNASTIES

Plate 29

Plate 28

SUI DYNASTY

BRONZE AGE

108

NAKNANG PERIOD

57

THREE KINGDOMS PERIOD

200 | 200 | 552

IRON AGE

BRONZE AGE

KOFUN PERIOD

(Haniwa Culture)

Plate 2

ASUKA PERIOD

G | E

Roman Art of the Early Empire

Early Byzantine Art

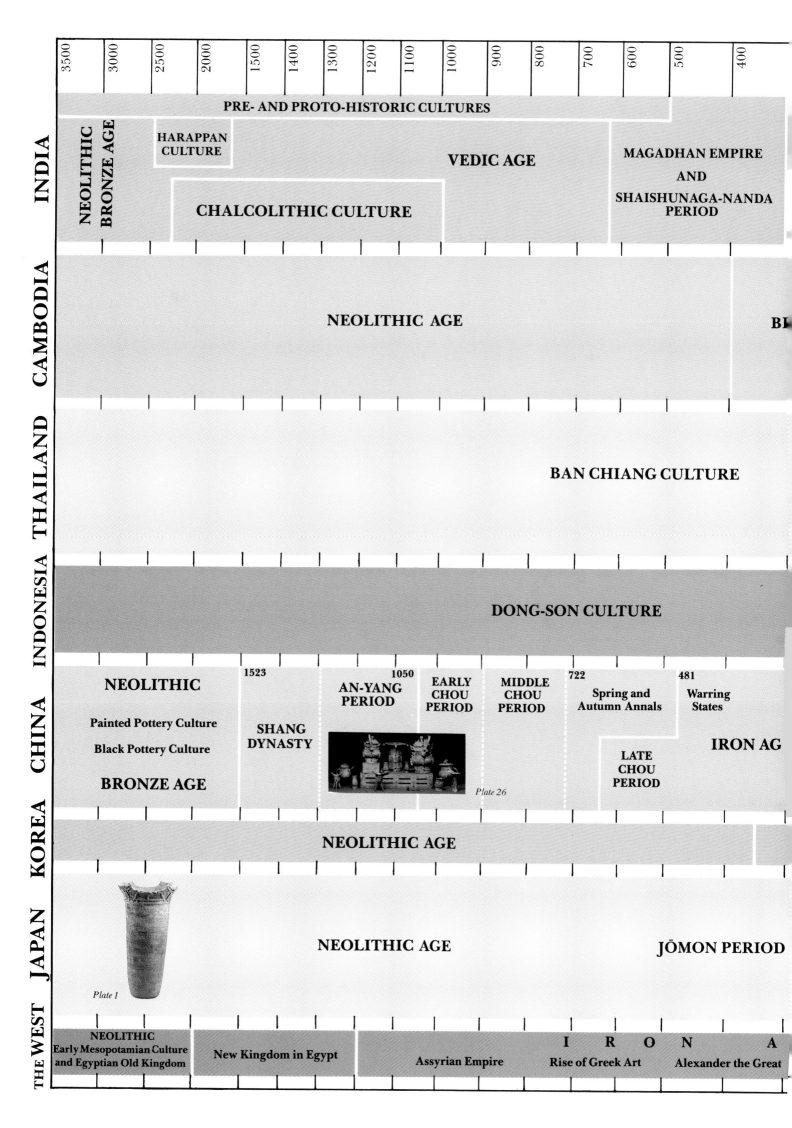

| | 3500 | 3000 | 2500 | 2000 | 1500 | 1400 | 1300 | 1200 | 1100 | 1000 | 900 | 800 | 700 | 600 | 500 | 400 |

PRE- AND PROTO-HISTORIC CULTURES

INDIA

NEOLITHIC

BRONZE AGE

HARAPPAN CULTURE

CHALCOLITHIC CULTURE

VEDIC AGE

MAGADHAN EMPIRE
AND
SHAISHUNAGA-NANDA PERIOD

CAMBODIA

NEOLITHIC AGE

Bl

THAILAND

BAN CHIANG CULTURE

INDONESIA

DONG-SON CULTURE

CHINA

NEOLITHIC

Painted Pottery Culture

Black Pottery Culture

BRONZE AGE

1523

SHANG DYNASTY

AN-YANG PERIOD

Plate 26

EARLY CHOU PERIOD

1050

MIDDLE CHOU PERIOD

722

Spring and Autumn Annals

LATE CHOU PERIOD

481

Warring States

IRON AG

KOREA

NEOLITHIC AGE

JAPAN

NEOLITHIC AGE

JŌMON PERIOD

Plate 1

THE WEST

NEOLITHIC
Early Mesopotamian Culture and Egyptian Old Kingdom

New Kingdom in Egypt

Assyrian Empire

I R O N A

Rise of Greek Art

Alexander the Great

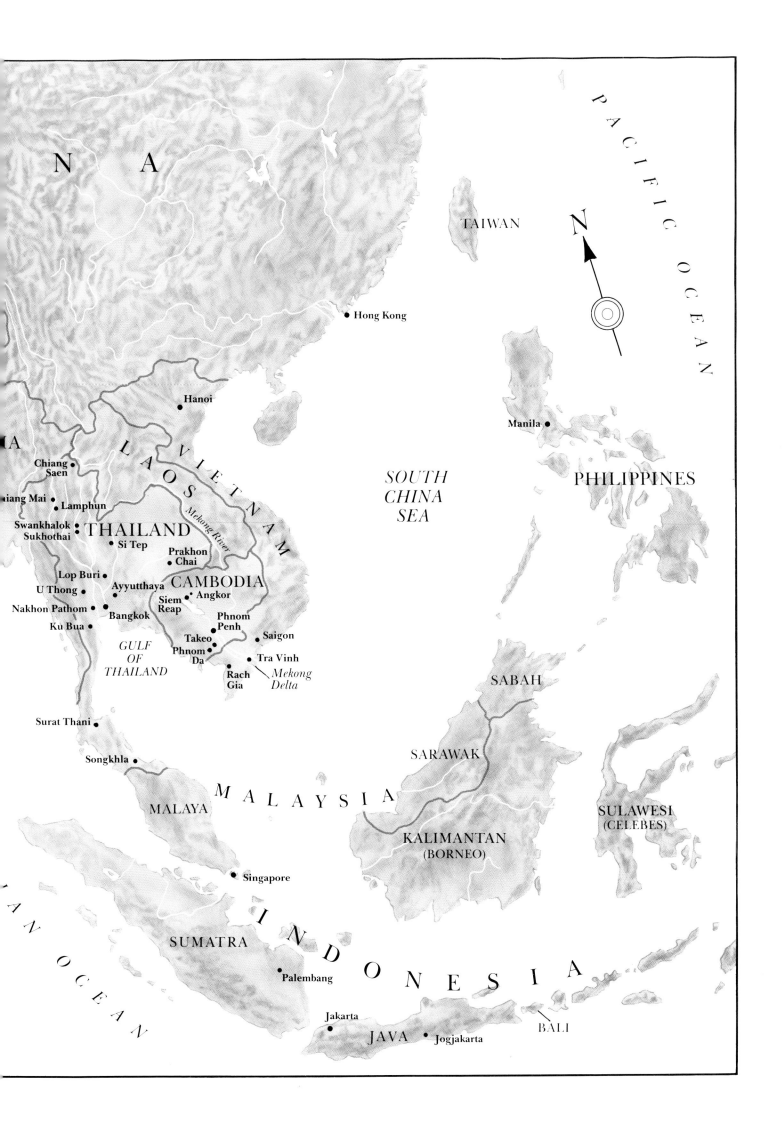

PACIFIC OCEAN

N A

TAIWAN

N

• Hong Kong

Hanoi •

Chiang
Saen •

iang Mai •
• Lamphun

Swankhalok
Sukhothai : **THAILAND**

LAOS

VIETNAM

Mekong River

SOUTH
CHINA
SEA

Manila •

PHILIPPINES

• Si Tep

Prakhon
• Chai

Lop Buri •

U Thong •

Ayyutthaya •

CAMBODIA

• Angkor

Siem
Reap •

Nakhon Pathom •

Ku Bua •

• Bangkok

Phnom
• Penh

Takeo •

Phnom
Da •

Rach
Gia •

• Saigon

• Tra Vinh

*Mekong
Delta*

SABAH

*GULF
OF
THAILAND*

Surat Thani •

SARAWAK

Songkhla •

M A L A Y S I A

MALAYA

SULAWESI
(CELEBES)

KALIMANTAN
(BORNEO)

• Singapore

I N D O N E S I A

N O C E A N

SUMATRA

• Palembang

Jakarta •

JAVA • Jogjakarta

BALI

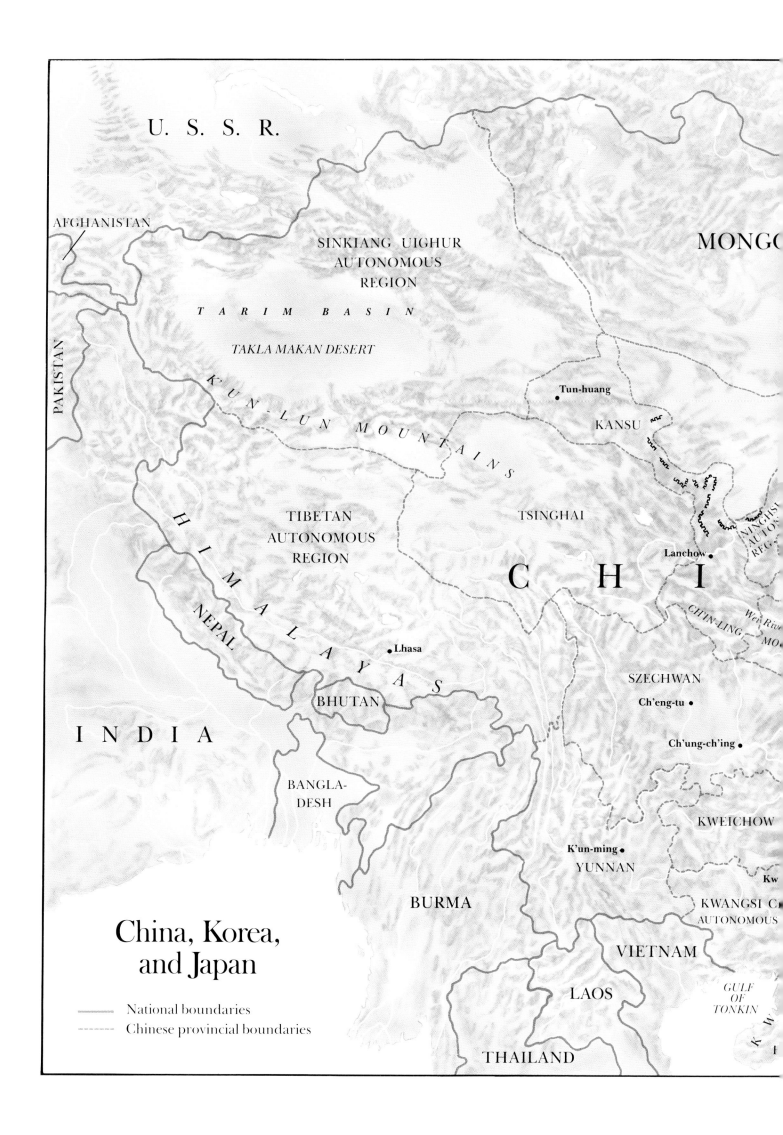

U. S. S. R.

AFGHANISTAN

MONGO

PAKISTAN

SINKIANG UIGHUR
AUTONOMOUS
REGION

TARIM BASIN

TAKLA MAKAN DESERT

Tun-huang

KANSU

KUN-LUN MOUNTAINS

TSINGHAI

NINGHSI
AUTON
REG

Lanchow

C H I

TIBETAN
AUTONOMOUS
REGION

CHIN-LING

Wen Rive

MO

H I M A L A Y A S

NEPAL

SZECHWAN

Ch'eng-tu

Lhasa

BHUTAN

Ch'ung-ch'ing

I N D I A

BANGLA-
DESH

KWEICHOW

K'un-ming

YUNNAN

Kw

BURMA

KWANGSI C.
AUTONOMOUS

China, Korea,
and Japan

VIETNAM

*GULF
OF
TONKIN*

LAOS

——— National boundaries

- - - - Chinese provincial boundaries

THAILAND

K

K W

Timeline dates across top: 1400 | 1500 | 1600 | 1700 | 1800 | 1900

INDIA

VIJAYANAGAR PERIOD

SULTANATE OF DELHI

MUGHAL DYNASTY

Plate 101

BRITISH PERIOD
(Independence in 1947)

RAJPUT KINGDOMS

CAMBODIA

THAILAND

TH-CENTER)

LAN NA (NORTH)

AYYUTTHAYA (CENTER)

RATANAKOSIN

INDONESIA

MODJOPAHIT PERIOD

PERIOD OF MUSLIM DOMINATION

CHINA

1368

...AN ...ASTY

MING DYNASTY

1644

CH'ING DYNASTY

1911

Plate 54 *Plate 55* *Plate 56* *Plate 64* *Plate 72*

KOREA

1392

YI (LI) DYNASTY

1910

JAPAN

1392 NAMBOKUCHO PERIOD

MUROMACHI PERIOD

1573 MOMOYAMA PERIOD

1615 EDO PERIOD

1868

Plate 14 *Plate 16* *Plate 18* *Plate 24*

THE WEST

Renaissance

Baroque

Rococo

Impressionism and
Post Impressionism

700 800 900 1000 1100 1200 1300

PANDYA PERIOD

PERIOD | CHOLA PERIOD

KARKOTA PERIOD | UTPALA | CHANDELLA PERIOD

GURJARA-PRATIHARA PERIOD | SENA PERIOD

PALA PERIOD

PERIOD | HOYSHALA PERIOD

EASTERN GANGA PERIOD

Plate 92

PERIOD

Plate 102

KULEN | PREAH KO | BAKHENG | KOH KER | PRE RUP | BANTEAY SREI | KHLEANG | BAPHUON | ANGKOR VAT | ANGKOR THOM | SACK OF ANGKOR

BAKONG

Plate 108

STYLES

Plate 105

MON STYLES

KHMER STYLES | OF CAMBODIA

Plate 109

SUKHOTHAI (NOF

LOP BURI (CENTER)

SHRIVIJAYA PERIOD

CENTRAL JAVANESE PERIOD

Plate 106

KADIRI PERIOD

SINGASARI PERIOD

906 | 960 | 1127 | 1279

T'ANG DYNASTY | FIVE DYNASTIES | NORTHERN SUNG PERIOD | SOUTHERN SUNG PERIOD | YÜ DYN

Plate 31 | *Plate 33* | *Plate 35* | *Plate 39*

668 | 918

SILLA KINGDOM | KORYU KINGDOM

794 | 897 | 1185 | 133

JOGAN PERIOD | FUJIWARA PERIOD | KAMAKURA PERIOD

NARA RIOD

HEIAN PERIOD

Plate 3 | *Plate 4* | *Plate 5* | *Plate 9*

Charlemagne | Romanesque Art | Gothic Art

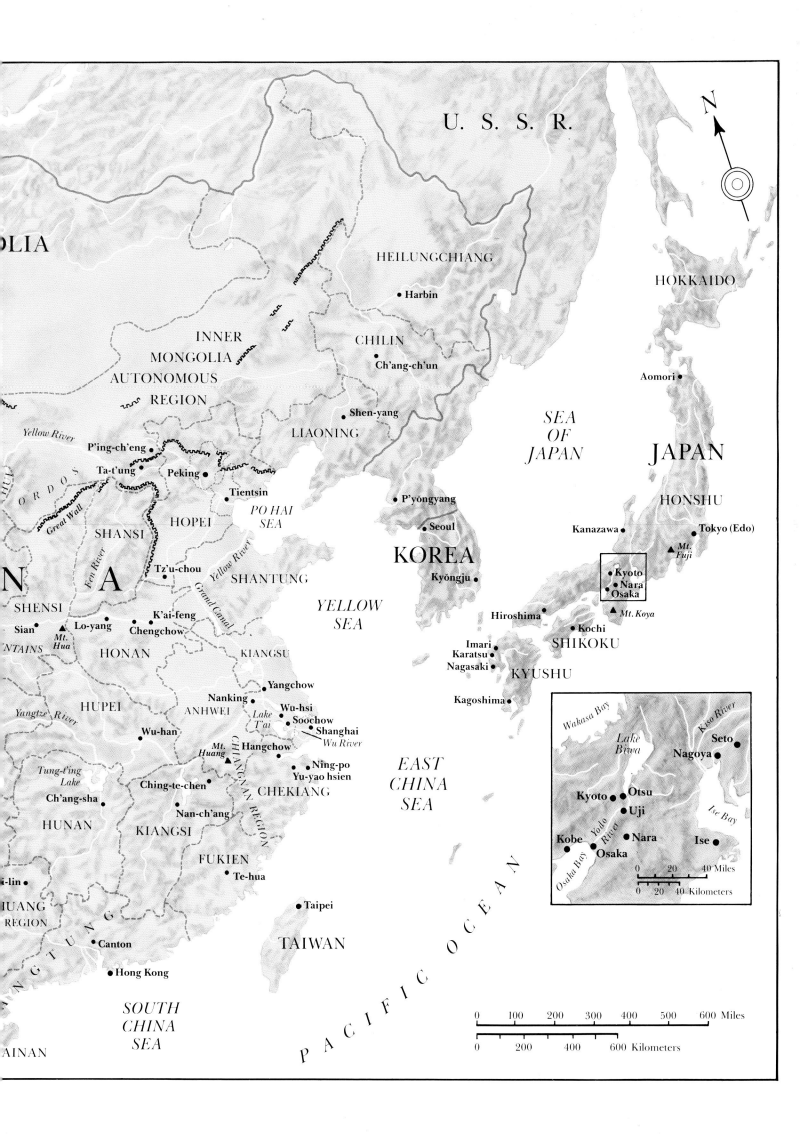

U. S. S. R.

N

OLIA

HEILUNGCHIANG

• Harbin

INNER
MONGOLIA
AUTONOMOUS
REGION

CHILIN

• Ch'ang-ch'un

Yellow River

P'ing-ch'eng •

Ta-t'ung •

Peking •

HUI

ORDOS

Great Wall

SHANSI

HOPEI

Fen River

Tz'u-chou •

SHENSI

• Sian

NTAINS

▲ *Mt. Hua*

Lo-yang •

Chengchow •

K'ai-feng •

HONAN

NA

Yellow River

Grand Canal

SHANTUNG

PO HAI SEA

LIAONING

Shen-yang •

Tientsin •

P'yŏngyang •

• Seoul

KOREA

Kyŏngju •

YELLOW SEA

SEA
OF
JAPAN

HOKKAIDO

Aomori •

JAPAN

HONSHU

Kanazawa •

Tokyo (Edo) •

▲ *Mt. Fuji*

• Kyoto
• Nara
Osaka

▲ *Mt. Koya*

Hiroshima •

• Kochi

SHIKOKU

Imari •
Karatsu •
Nagasaki •

KYUSHU

Kagoshima •

KIANGSU

HUPEI

Yangtze River

Wu-han •

Tung-t'ing Lake

Ch'ang-sha •

HUNAN

Yangchow •

Nanking •

ANHWEI

Wu-hsi •
Soochow •

Lake T'ai

Shanghai •

Wu River

Hangchow •

Ning-po •
Yu-yao hsien •

CHEKIANG

▲ *Mt. Huang*

CHIANGNAN REGION

Ching-te-chen •

Nan-ch'ang •

KIANGSI

*EAST
CHINA
SEA*

i-lin •

HUANG

REGION

FUKIEN

Te-hua •

KWANGTUNG

• Canton

• Hong Kong

• Taipei

TAIWAN

*SOUTH
CHINA
SEA*

AINAN

PACIFIC OCEAN

Wakasa Bay

Lake Biwa

Kiso River

Seto •

Nagoya •

Kyoto •

Otsu •

Uji •

Yodo River

Kobe •

Osaka •

Nara •

Ise •

Ise Bay

Osaka Bay

| 0 | 20 | 40 Miles |

| 0 | 20 | 40 Kilometers |

| 0 | 100 | 200 | 300 | 400 | 500 | 600 Miles |

| 0 | 200 | 400 | 600 Kilometers |

THE METROPOLITAN MUSEUM OF ART NEW YORK · THE METROPOLITAN MUSEUM OF ART NEW YORK